THE
EVERYDAY ART
OF
INDIA

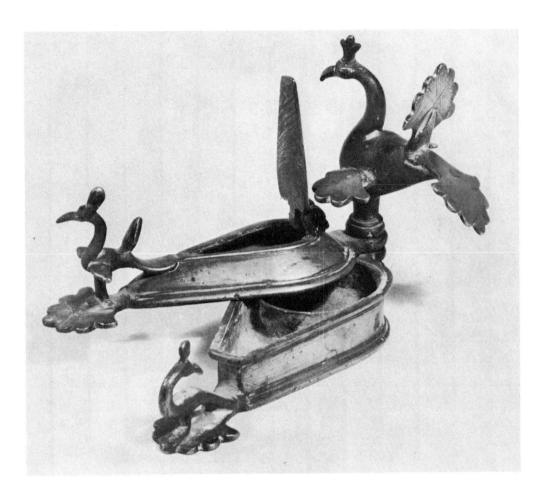

Cosmetic container whimsically adorned with peacocks (a common motif for such containers in southern India) and divided into two *yoni*-shaped compartments. The top section forms a lid and pivots on a pin at the base of the large peacock. The top compartment is secured by the pressure of the beak of the small peacock. Brass. $4\frac{3}{4}$ inches long \times $3\frac{1}{2}$ inches high. Nineteenth century.

THE
EVERYDAY ART
OF
INDIA

by ROBERT F. BUSSABARGER

and BETTY DASHEW ROBINS

ANDREW TAU, photographer

DOVER PUBLICATIONS, INC., NEW YORK

Published in Canada by General Publishing Company, Ltd., 30 Lesmill Road, Don Mills, Toronto, Ontario.
Published in the United Kingdom by Constable and Company, Ltd., 10 Orange Street, London WC 2.

The Everyday Art of India is a new work published for the first time by Dover Publications, Inc., in 1968.

Layout by Robert F. Bussabarger

Standard Book Number: 486-21988-7
Library of Congress Catalog Card Number: 68-20951

Manufactured in the United States of America
Dover Publications, Inc.
180 Varick Street
New York, N.Y. 10014

PREFACE

The authors wish to thank the many friends, museum officials, craftsmen, librarians and professors from India, the United States and Great Britain who aided so generously in the compilation of the material for this book. Also we extend our appreciation to the University of Missouri Research Council for support in the preparation of the photographs and the manuscript, and especially to Dr. Arthur J. Robins and Mrs. Robert F. Bussabarger for help in editing the text.

All pictures not taken by Mr. Tau are credited separately.

The map of India (pp. viii and ix) shows the location of all places mentioned in the book.

The Table of Pertinent Dates (p. xi) situates in time the historical periods and rulers mentioned.

The Glossary (pp. 195–200) provides brief explanations of all other proper names and native words mentioned.

The Index (pp. 201–205) gives page references not only to the different categories of proper names, but also to various types of objects (bowls, lamps, etc.) and motifs (elephants, swastikas, etc.).

Indian names familiar to American readers are cited in the usual English form (Krishna, Vishnu, Shiva, etc.); the Glossary furnishes the scholarly transcriptions of these names (Kṛṣṇa, Viṣṇu, Śiva, etc.). For other Indian names of persons and objects every attempt has been made in the text to provide modern scholarly transcriptions (from the Sanskrit form, generally; sometimes from Hindi, Urdu or other local languages). In most cases, however, *ch* has been used instead of *c* for this palatal sound, and *ri* instead of *ṛ*. No accents have been placed on any geographical names.

Readers unfamiliar with this transcription system will not go far wrong if they pronounce the consonants as in English and the vowels as in Italian. The consonants *ṣ* and *ś* are pronounced approximately like the English *sh*.

R. F. B.
B. D. R.

v

Nested turned wooden rice-measuring bowls with embossed brass double *haṁsa* birds, lotus and other auspicious exterior embellishments made to order by craftsmen in Suri, Birbhum District, West Bengal. 16 inches high.

CONTENTS

MAP OF INDIA AND PAKISTAN

showing places mentioned in

The Everyday Art of India

Cities (and towns, villages and sites) are identified on the map by the numbers in the listing below, which is alphabetical by states (and countries), with the cities (etc.) alphabetical within the states (etc.); most villages (and some sites)—placed within parentheses—have the same numbers as the towns they adjoin.

TIBET

BHUTAN

NEPAL

SIKKIM

KASHMIR

KULU VALLEY

HIMACHAL PRADESH

PUNJAB

UTTAR PRADESH

(WEST) PAKISTAN

Indus R.

Ganges R.

Jumna R.

Ganges R.

RAJASTHAN

MARWAR

GUJERAT

KUTCH

SAURASHTRA

KATHIAWAR

BOMBAY

EAST KHANDESH

WEST KHANDESH

DECCAN

MADHYA PRADESH

RAIPUR

CHHOTANAGPUR

BIHAR

WEST BENGAL

Hooghly

SUNDERBUNDS

ORISSA

(EAST) PAKISTAN (EAST BENGAL)

ASSAM

TRIPURA

MANIPUR

NAGA PRADESH

NAGA HILLS (Naga tribes)

NORTH EAST FRONTIER AGENCY

ANDHRA PRADESH

1 Hyderabad
2 Kondipalli
3 Tirupati

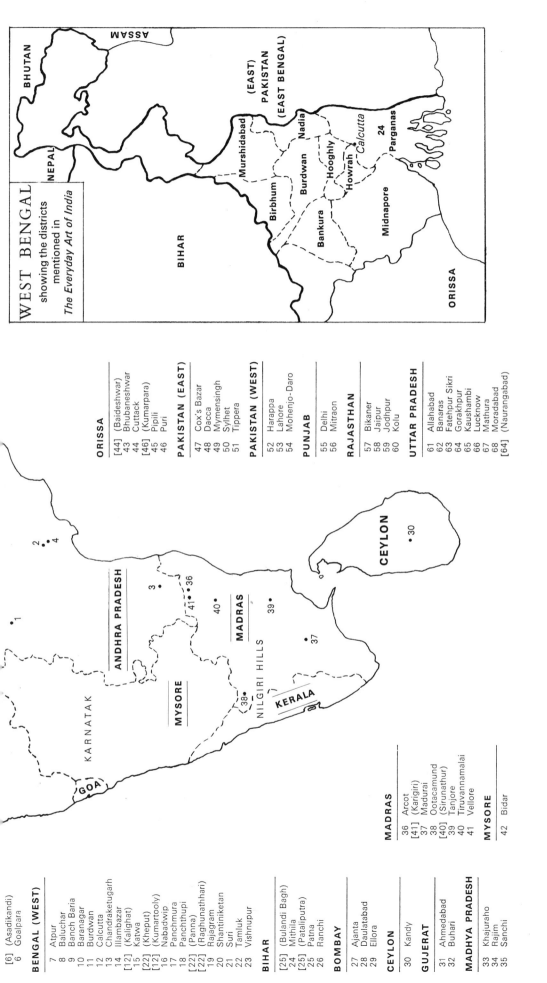

WEST BENGAL
showing the districts
mentioned in
The Everyday Art of India

BENGAL (WEST)
[6] (Asadikandi)
6 Goalpara
7 Atpur
8 Baluchar
9 Banch Baria
10 Baranagar
11 Burdwan
12 Calcutta
13 Chandraketugarh
14 Illambazar
[12] (Kalighat)
15 Katwa
[22] (Kheput)
[12] (Kumartooly)
16 Nabadwip
17 Panchmura
18 Panchthupi
[22] (Panna)
[22] (Raghunathhari)
19 Rajagram
20 Shantiniketan
21 Suri
22 Tamluk
23 Vishnupur

BIHAR
[25] (Bulandi Bagh)
24 Mithila
[25] (Pataliputra)
25 Patna
26 Ranchi

BOMBAY
27 Ajanta
28 Daulatabad
29 Ellora

CEYLON
30 Kandy

GUJERAT
31 Ahmedabad
32 Buhari

MADHYA PRADESH
33 Khajuraho
34 Rajim
35 Sanchi

MADRAS
36 Arcot
[41] (Karigiri)
37 Madurai
38 Ootacamund
[40] (Sirunathur)
39 Tanjore
40 Tiruvannamalai
41 Vellore

MYSORE
42 Bidar

ORISSA
[44] (Baideshwar)
43 Bhubaneshwar
44 Cuttack
[46] (Kumarpara)
45 Pipili
46 Puri

PAKISTAN (EAST)
47 Cox's Bazar
48 Dacca
49 Mymensingh
50 Sylhet
51 Tippera

PAKISTAN (WEST)
52 Harappa
53 Lahore
54 Mohenjo-Daro

PUNJAB
55 Delhi
56 Mitraon

RAJASTHAN
57 Bikaner
58 Jaipur
59 Jodhpur
60 Kolu

UTTAR PRADESH
61 Allahabad
62 Banaras
63 Fatehpur Sikri
64 Gorakhpur
65 Kaushambi
66 Lucknow
67 Mathura
68 Moradabad
[64] (Naurangabad)

TABLE OF PERTINENT DATES

To avoid confusion, this table includes only the historical periods mentioned in this book. All dates are given approximately; those before the Maurya dynasty are necessarily conjectural.

c. 3000–1500 B.C.: Indus Valley civilization
(chief archeological sites: Mohenjo-Daro and Harappa)

c. 1500–900 B.C.: Early Vedic period
(Aryan invasion; composition of *Rig Veda*)

c. 900–500 B.C.: Later Vedic period
(composition of *Atharva Veda* and other texts)

c. 600–300 B.C.: Rise of Jainism and Buddhism
(Mahāvīra Jina, the twenty-fourth Jain *tīrthaṅkara*, and Gautama Buddha both died about 500 B.C.)

c. 350–150 B.C.: Composition of the *Rāmāyaṇa* and *Mahābhārata*

c. 320–185 B.C.: Maurya dynasty
(capital at Pataliputra [Patna]; Aśoka, 272–232, an ardent Buddhist convert)

c. 185–25 B.C.: Śunga dynasty

c. 320–600 A.D.: Gupta dynasty

c. 1000–1850 A.D.: Rājput period (Kshatriya Rāj)

c. 1500–1850 A.D.: Moghul Empire
(Mohammedan dynasty; reign of Humāyūn 1530–40 and 1555/6; reign of Akbar 1556–1605)

INTRODUCTION

The art of India is familiar to many people as being exotic, vast and diverse, but numerous facets of it are not widely known. The temples of southern India, the bronze images from Madras and the Rājput-Moghul paintings are established classics of Indian art; however, there are numerous art forms that have received less attention in most surveys of Indian production. Unfortunately, they have been deemed neither important to the main cultural patterns nor significant art forms in themselves. That the common, everyday artifacts are nevertheless of great importance to the full appreciation of Indian art will be shown by the illustrations of them and description of their origins and purposes presented in this book.

The illustrations included here feature some of these less well-known objects, such as the small images, utensils, toys and paintings which generally relate to the humble purposes of everyday living. Examples have been taken from the regions where particular artifacts and materials are most prominent; a comprehensive or complete coverage has not been attempted. Regional contrasts, not any implied superiority, are exemplified by these selections, and omissions were unavoidable, given the multitude of possible examples. These art works have been classified here by materials and techniques into the five categories: clay, metal, wood, fiber and painting.

Indian artistic idioms are derived from the sacred paraphernalia of Hinduism, Buddhism, Jainism, Mohammedanism and tribal religions, as well as from distinctly secular articles of adornment and utility. All idioms but those of the Muslims show a profusion of illustrated human forms. An exception to this Muslim prohibition is the work done within the secular atmosphere of the Moghul courts. For the Muslim overlords, a fusion of Hindu and Islamic forms created the Moghul idiom, characterized by the predominant use of floral, calligraphic and geometric designs. Hindus, on the other hand, without taboos against human imagery, continued to use their turbulent motifs of gods, animals and vegetative forms. Shapes and surface features of the Persian-Islamic culture were assimilated, however, and permanently changed the Hindu-oriented style.

The traditional art of India, inclusive of its many facets, is primarily a result of the collective efforts of unknown craftsmen. Although there were many who attained personal recognition for their masterly works, their names have been obscured by the passage of time and the general lack of emphasis on the individual artist. Stylistic features recognizable as belonging to individual masters are rare. Nevertheless, the quality of human warmth prevails in all these objects.

Conscious production of works of art has had little or nothing to do with the creation and utilization of most traditional Indian artifacts. The principle of "art for art's sake" was antithetical to the Hindu culture until the Moghul emperors introduced aspects of it into their court art and international influences helped to develop the individual approach of the modern Indian artist. Therefore, the main purpose of the "art" object has been to serve a religious end. Since the Hindu religious system pervades the whole of life, even the most utilitarian artifact has religious significance. For example, the coolie who digs earth for road beds leaves in the pit a measuring column that is *liṅga*-shaped. And yet the concept that each object must be worthy of its dignified, inspirational and religious ends has affected the production standards of countless artifacts in such a way that they can be identified as artistic.

The modern Indian cultural attitude, however, has been ambivalent toward such values. The new age of industry and mass production has confused the organic unity between the craftsman and his product which had so long obtained unselfconsciously. India's contemporary consumer tends to be indifferent to the humanistic attributes of indigenous handmade crafts. Machine-made goods, mostly unartistic textiles, plastic and aluminum vessels and the like—popular, prestigious, and relatively economical—are taking over the bazaars. Fine old brass pots are melted to make bright new ones and awareness of their aesthetic qualities has come about mostly from reclamation by a relatively small group of knowledgeable art enthusiasts.

The craftsman's concern for the proper visual presentation of religious concepts was all-important, and the spirit necessary to achieve this end eliminated the element of self-consciousness from the art object. Harmony with precepts laid down by religious canons and disciplined organization of form absorbed the craftsman's attention. A sense of rightness in the object evolved naturally. The authentic results are seen as refreshing and genuine.

The creation of these everyday artifacts originates with the Śūdra family craftsmen, artisans of Indo-Islamic orientation and isolated tribesmen who have maintained traditional forms prescribed by generations of practice and orthodoxy. After many centuries of prolific development, the production of these groups has today been reduced as a vigorous force because of changes in governmental powers, social structure and accompanying economic emphases. When the European traders

began to take political control around the eighteenth century, the economic stability enjoyed by the indigenous craftsmen began to decline. Gradually the loss of patronage forced many craftsmen to abandon the elegant and artistic production of artifacts, and they had to shift to more menial professions. Now, in the industrial age, the traditional craftsman is rapidly becoming a social anachronism. However, there still remains a large body of traditional Indian culture geared to the production and consumption of hand-produced objects for utilitarian and ritual use. Survival of present-day potters, weavers, metal workers and other craftsmen is aided by the continuance of age-old religious and cultural practices, as well as by government encouragement.

India's reawakened self-realization influenced the new independent government to initiate the *khādī*-weaving cottage industries and handicraft boards as a way to encourage the handcraft potential of the population. The restored dignity of the craftsman has temporarily put new life into the crafts, but it is foreseeable that eventually even this program will yield to mechanization. Most likely the more sophisticated "artist-craftsman" will ultimately produce sensitive "one-of-a-kind" hand-made objects or guide industry by creating artistic pilot designs. This is now the case to some degree.

The craftsman has continued to be essential to the economic life of the villages and population centers. The non-professional domestic crafts, principally carried on by women, are found extensively in rural areas. *Alpanas* (floor and wall pictographs) are painted for festivals and auspicious occasions. These are one of the many forms connected with the *bratas* (rites) for women. The craftsman has pursued his tasks with a relatively free hand. Execution and marketing of his products have usually been his prerogative. Obligation to religious dicta, cultural prescriptions and patrons' requirements are accepted as necessary disciplines, but the artisan has worked undisturbed within his understanding of craft processes. He usually has received little prestige and profit for work done; hence, the satisfaction of his sense of duty has given a higher purpose to his activities.

In Emperor Akbar's court, for example, the craftsman, always subordinated to his art, was honored for the high quality of his designs and was never rushed into "turning out" a fine piece of work. He was dedicated to his craft in a deep and all-inclusive sense. His professional dignity and sophistication, at least within his own domain, were rooted in generations of family craftsmen.

To the Brahmanical mind, the Śūdra craftsman remained a worker with his hands. His station was neither that of the enlightened priest and intellectual, that of the protector and defender of the empire, nor even that of the merchant. Very little, if anything, was done about changing his status. There were a few exceptions to such rigidity—for example, the social reforms of the Buddhists, Jains and Sikhs.

A. L. Basham, in his *The Wonder That Was India*,[1] mentions an early Jain potter who owned five hundred workshops and operated a fleet of boats which carried his products through the entire valley of the Ganges.

The craftsman whose position was hereditary accepted his lot. It was right to do what one was born to do. The ancient Hindu text known as *The Laws of Manu* states: "It is better to do one's own duty badly than another's well." This dictum sums up an attitude surviving today, although not always adhered to in practice. Zimmer writes:[2] "The Indian artist always works, therefore, within a very strictly delineated tradition. As we read in a craft manual: 'The artificer should understand the *Atharva-veda*, the thirty-two craft manuals (*śilpaśāstras*), and the Vedic mantras by which the deities are invoked. He should be one who wears the sacred thread [i.e., he should be a member of one of the upper, "twice-born" castes], a necklace of holy beads, and on his finger a ring of sacred kuśa-grass in the worship of god. He should be faithful to his wife, avoiding strange women, and should have acquired, piously, a knowledge of various sciences. Only such a one is truly a craftsman.'" (The high-born artificer referred to here is likely the master or overseer of subordinate Śūdras. Usually the upper castes were averse to using their hands, although it is possible this aversion did not apply to the forming of sacred images.)[3]

The Hindu craftsman did not view his humble status as an infliction but as his *karma*. Moreover, despite his low station, his exclusive position gave him a strategic influence on all the visual arts. Compensation most certainly stimulated the artisan's effort. Although rewards varied with circumstances, the artisans' ideals required a maximum effort in any case. An ornament for a palace or a pot for a neighbor expressed much the same qualities of aesthetic depth, religious feeling and ethical integrity. Religious profundity can be found equally present in the handsome, lovingly made earthen pot and the large, impressively refined stone sculpture of Shiva.

The craftsman was the creator of temple plans, sculpture, painting, pots, jars, metal vessels and all the visual arts. The requirements of the *śilpaśāstras* and other canons of form were laid down and written by the Brahmans, from around the fifth century A.D. on. They were passed on verbally to the craftsman for implementation. It is understandable that the "poetic license" of the craftsman was bound to shift the dictates of form to suit his own criteria of perfection. Improvisation was

[1] Grove Press, New York, 1959; Vol. I, p. 216.

[2] Heinrich Zimmer, *The Art of Indian Asia*, Pantheon Books, New York, 1955; Vol. I, p. 320.

[3] In his *The Arts and Crafts of India and Ceylon* (The Noonday Press, New York, 1964; p. 33), Ananda K. Coomaraswamy writes: "The higher Hindū and Sinhalese artificers trace their descent from Vishvakarmā: to this day they style themselves Vishvabrāhmans, employ priests of their own caste, and claim spiritual equality with Brāhmans. All craftsmen regard their art . . . as invested with sacred and scriptural authority. In connection with the consecration of images, the higher craftsmen themselves exercise sacerdotal functions."

not, however, conscious or pretentious, but only an inevitable result of the physical manipulation of the materials and the changing attitudes toward the function and symbolic meanings of the object.

Repetition is a prominent characteristic of Indian art and culture. Centuries of continuity have given the art of India extraordinary stature, but, in many cases, prolonged use of prescribed forms has caused the loss of vitality in the art. In the Hindu temple town of Bhubaneshwar early temple sculptures show richness, vigor and spirit. As quantities of structures were built and carved less artistic quality is evident. The craftsmen of the later temples lost the vision and spirit of their imaginative forefathers and worked on past momentum. Construction disintegrated into a ritual or mechanical process. However, this "burning out" is a seemingly less important characteristic of some of the more humble crafts. Comparison of the pot shapes of Mohenjo-Daro with those of numerous present-day village potters shows that much of the keen sense of full and freshly swelled clay still exists.

The heroic grandeur of the Ellora caves or the city of Fatehpur Sikri in all their splendor were created by ordinary but devoted craftsmen for what was ultimately everyman's everyday living. Medieval *rājas* and emperors, despite their great political and financial power, depended on the Śūdra to make the achievement of their plans possible. The spirit behind the construction of the temples of Khajuraho was much like that behind the great Gothic cathedrals of Europe. In both cases the compulsion to build grand religious monuments inspired men to express the glories of their religious faiths with selfless devotion and extraordinary efforts of skill. The results are fixed in the memory of all of civilization. It might be said that the universal language of art from every part of the world crosses all boundaries of time, race, creed and national loyalty.

The object, Indian or any other, stands on its own merit irrespective of the status of its creator, the materials from which it is made or its degree of complexity. All objects which are pure, basic and honest evoke refreshing newness. Regardless of their original purpose, such objects are tasteful and inspiring forms which have intrinsic value as artistic expressions. They reveal the sense of direct human contact with the nature of materials and the challenge that goes with the evolution of forms and ideas out of pure discovery.

From the everyday and common or even the primitive and naïve origins of these objects, one feels their warm and intimate vitality. Just as these facets of Indian art elicit appreciation and respect, many contemporary artists have been attracted by the lack of self-consciousness in the art of children and primitive peoples. Paul Klee absorbed the playful and fanciful experiments of children's art; Picasso assimilated the vigor and dignity of African art. The excitement of basic rhythms not clouded with tired, apathetic, perfunctory and rehashed stereotypes is always desirable.

Visual forms express a language all men can understand. Whether Indian artisans or any others consciously intend such results does not affect the potential impact inherent in all works of art; they announce to all men their quest for an ideal and a fuller interpretation of reality.

When one looks into the recent past of the Indian craftsman it is clear that his medieval attitude and resistance to change continues. He still works with religious, cultural and economic protection. It is predictable that this structure will eventually pass; hopefully the artistic idioms of Indian art will persist in a unique, though as yet undetermined, form.

Those who live surrounded by the mundane comforts created by technological advance can be inspired and aided by the vital presence of the objects of everyday Indian art, with their established universal and timeless attributes that counteract the dehumanizing tendencies of mass production, social regimentation and the depreciation of the dignity of individual human beings.

ROBERT F. BUSSABARGER
BETTY DASHEW ROBINS

CLAY

India has been a "clay culture" for millennia. Images, vessels, architecture, toys, boundary markers, walls, hookahs and well rings are among the diverse objects made in India of dried mud and terracotta. A plentiful supply of clay is found in the many river valleys, especially those of the Gangetic system, yielding raw materials both for necessities of daily life and for religious and cultural expression.

Clay has been essential to the people of India for survival. They respond to it as to a manifestation of "Mother Earth" which governs their livelihood and spiritual convictions. Therefore, clay and objects made from it innately suggest spiritual symbolism and the abstraction of nature. Implicitly patterned in clay vessels and images are nature's primordial energies and growth processes.

Moreover, the clay pot is a superior vessel for liquids and food. The function of containing and preserving such vital contents is organically reflected in the shapes, appendages and surface embellishments of the pottery. These designs are ideographic icons of formless gods, the mysterious powers believed to preserve life. Pottery shapes may also embody the concept of obedience to political authority or may represent, to the superstitious, a dwelling for magical forces. Sometimes anthropomorphic and theriomorphic appendages springing from the basic egg shape create direct associations with human and animal life. In other instances, completely developed animal or human forms replace the egg image.

Clay objects remain implicitly sacred regardless of their varied uses. The potter, conscious of the reverence required in his craft, makes every effort to create shapes that are not only the most utilitarian, but also worthy of his god. These deeply felt creations exalt the mundane pot to a place of respect. Nevertheless, a pot or clay image can also have a profane function. A clay toy may amuse a child as well as serve as a sacred image.

The glazing of pottery and tiles, at its height during the Moghul period, still exists with small but growing importance as a contemporary craft. However, glazed clay has never had wide cultural acceptance because of religious sanctions against the reuse of defiled earth.

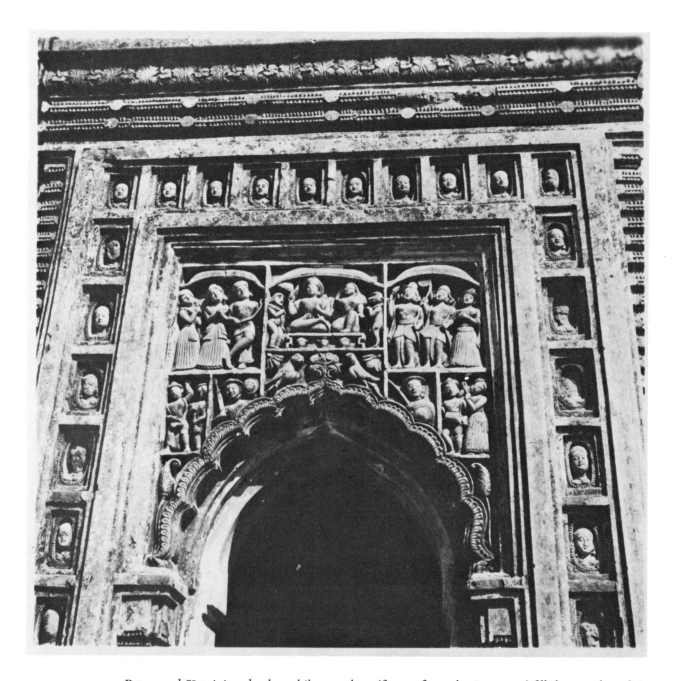

Rāma and Sītā sit in splendor while attendants (figures from the *Rāmāyaṇa*) fill the temple arch in formal balance within the border of female portraits. Surul brick temple at Shantiniketan, Birbhum District, West Bengal. The arch is 3 feet wide, the brick module 10 inches. Eighteenth century. *(Photograph by R. F. Bussabarger)*

Responsible for production, the potters and clay modelers of the traditional Kumbhakāra caste order the clay with their hands and produce forms based primarily on the plasticity and tactility of the material. Soft, spontaneous and intimate nuances of the hand (for all practical purposes the only tool used) give the resulting shapes their character.

Craftsmen innovate images with the pot as their basic shape, icons of dried mud and forms made from clay slabs and press molds which are all plastically handled. Large figures up to twenty feet high, elaborately painted and exquisitely dressed with *daksaj*, ornamental clothing made of *śolā* (pith) and paper, are reinforced with straw and bamboo frames. These figures are made for seasonal religious festivals or *pūjās* (worship), and are melted in rivers or tanks (ponds) at the end of the ceremonies.

The clay votive images of rural India take various forms: fertility figures; protective horses, elephants and tigers; gods and goddesses, such as Manasā, the snake goddess; and the symbolic water pot for religious rites and weddings.

The artisans of the Sūtradhāra caste also work with clay, but they shape it as carvers. Their tradition stems from carpentry, stone cutting and wood and ivory carving. The brick temples of Bengal were built and embellished with magnificent bas-relief facings by Sūtradhāra families.

After centuries of support from the traditional village social unit, artistic clay modeling and pot making continue as a basic Indian cultural expression.

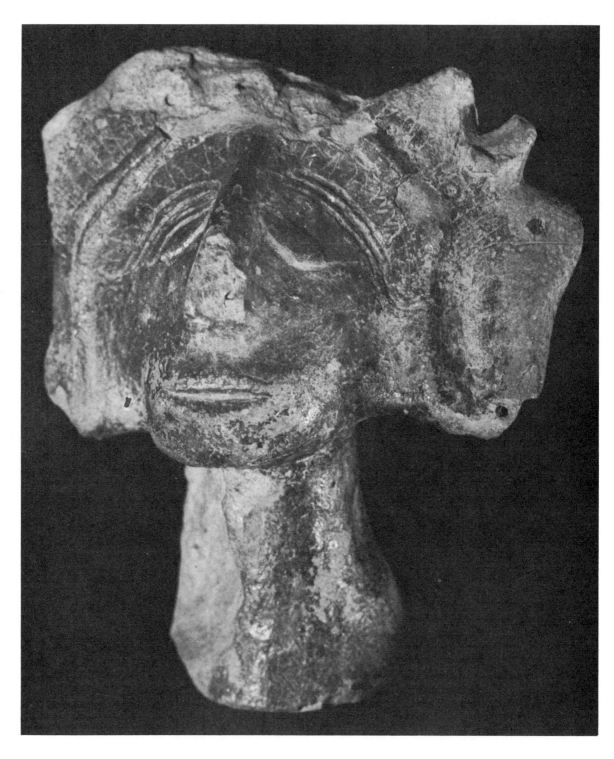

Early terracotta Buddha-like head with turban headdress and holes for ear ornaments suggesting the Śuṅga or Gupta period. From Raghunathhari, Tamluk, Midnapore, West Bengal. 10 inches high. (*Asutosh Museum photograph*)

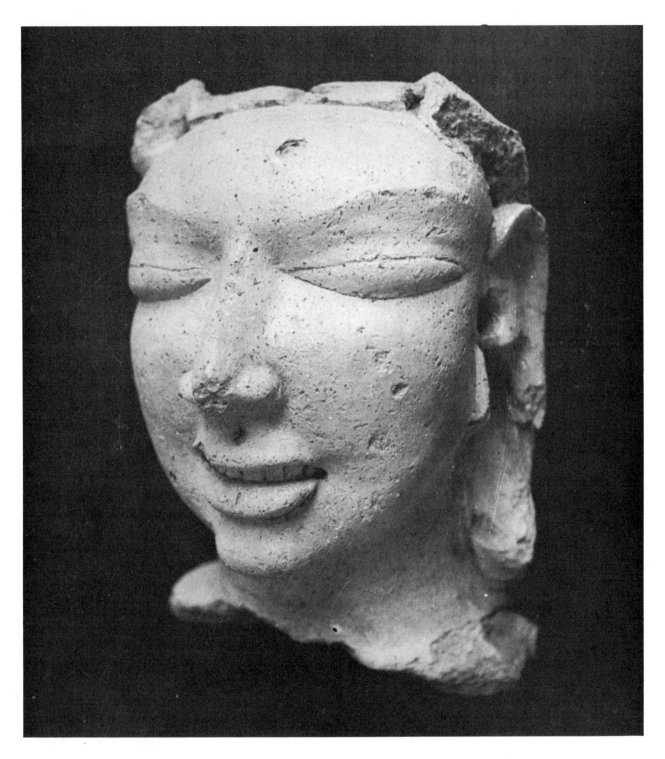

Life-size terracotta monumental female head found at Panna, Midnapore, West Bengal. Gupta period, fourth century A.D. (*Asutosh Museum photograph*)

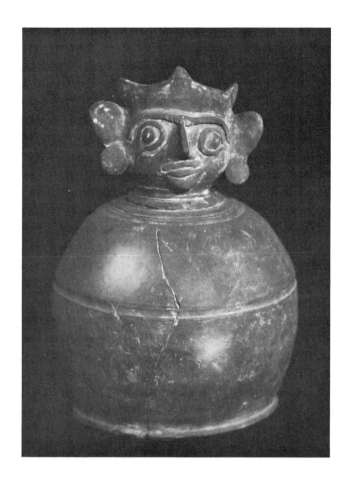

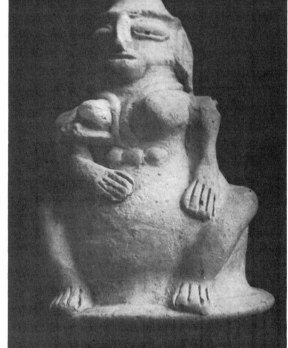

Medieval pots in the form of an anthropomorphic bottle, probably a deified ruler (ABOVE), and a mother goddess (RIGHT) with a child and a Vedic triadic necklace, probably symbolizing the trinity of the highest gods. Both shapes are crude but supple. Found at Tamluk, Midnapore, West Bengal. About 10 inches high.

(*Asutosh Museum photographs*)

12 CLAY

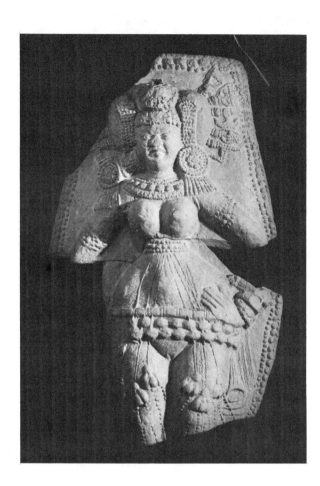

Molded terracotta plaques, parts of bas reliefs. These bejeweled female figures are Yakshīs, terrible—sometimes friendly, but impish—deities, slightly above humans in the celestial hierarchy, who grant fertility or demand human sacrifice. The Maurya and Śuṅga Buddhists who made these images had not long been converted from the worship of primitive Dravidian spirits. Excavated at Chandraketugarh, 24 Parganas, West Bengal. (*Asutosh Museum photographs*)

LEFT: Second century B.C. 5 inches high.

BELOW: First century B.C. 6 inches high.

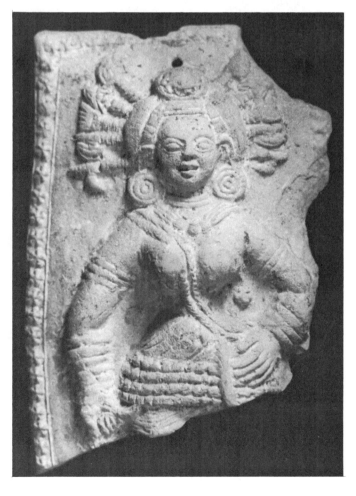

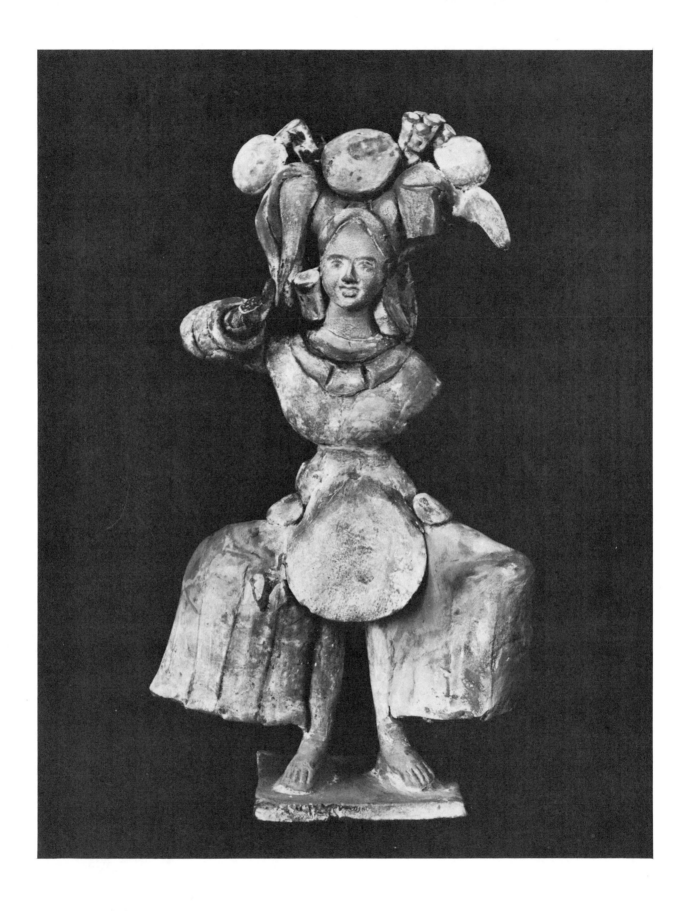

14 CLAY

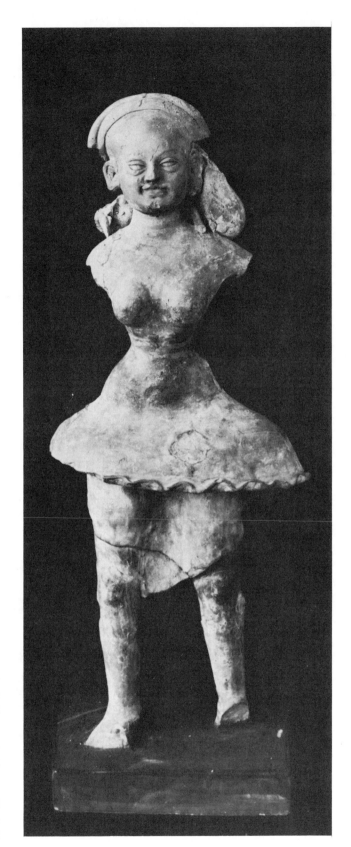

Two terracotta modeled slab female figures from the Buddhist Maurya period, third century B.C., excavated at Bulandi Bagh, Patna, Bihar, on the site of the Maurya capital Pataliputra.

LEFT: Figure with exaggerated accessories and extended skirt, possibly depicting a performer in a dance-drama. About 18 inches high.

RIGHT: Figure with an impish face and flowing skirt, suggesting the dance of a Yakshī-like damsel. About 13 inches high. (*Patna Museum photographs*)

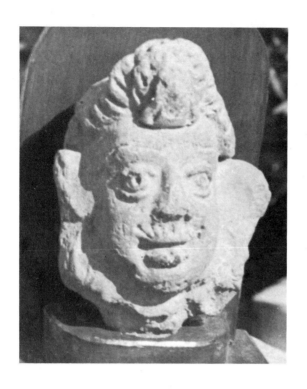

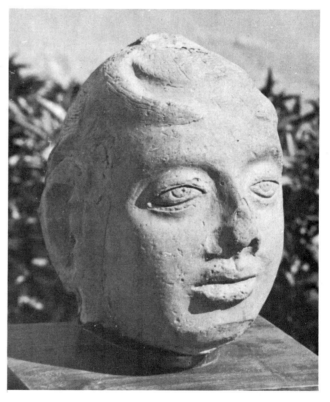

Two terracotta head fragments in the Museum of Allahabad, Uttar Pradesh. From Kaushambi, a flourishing city on the Jumna River during the Gupta period.

ABOVE: Third century A.D. 4 inches high.

RIGHT: Fourth century A.D. 6 inches high.

(*Photographs by R. F. Bussabarger*)

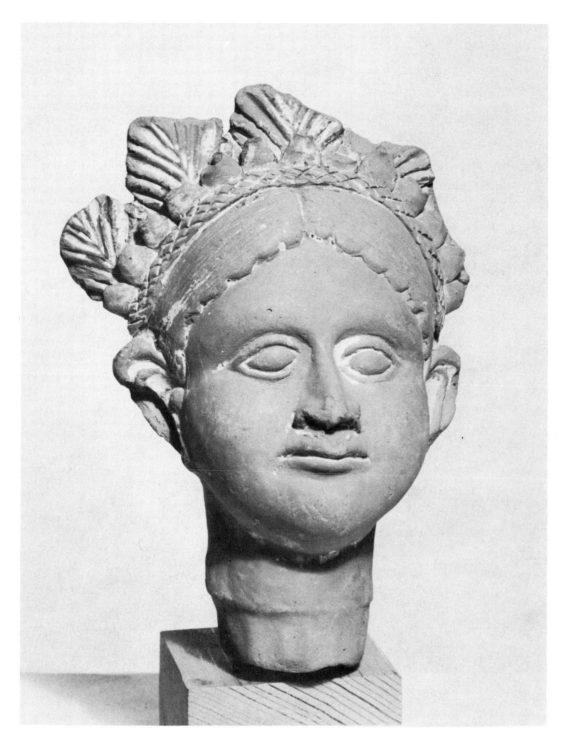

Old molded terracotta doll's head (actual size) from Mathura, Uttar Pradesh. The bright-eyed, leaf-crowned "bride" face reflects a strong Hellenistic-Gupta influence.

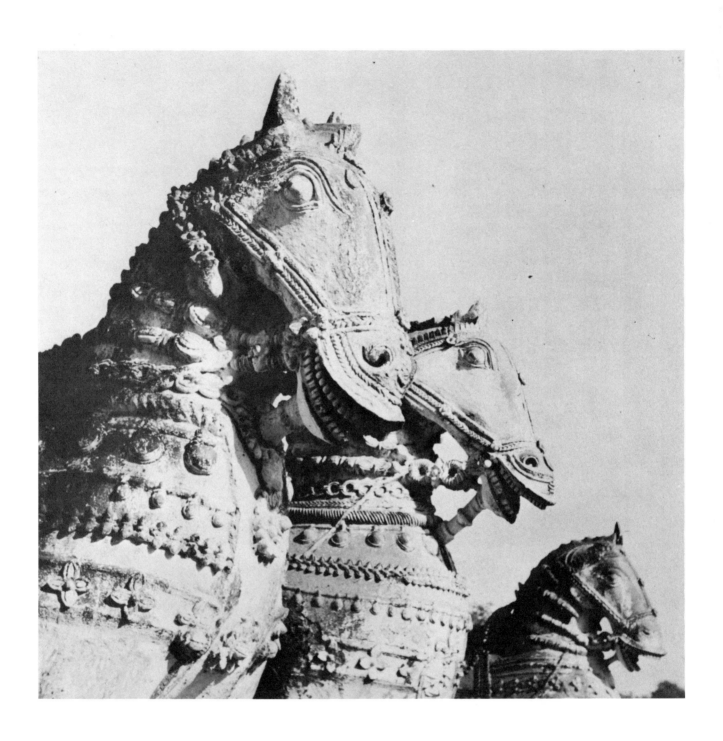

18 CLAY

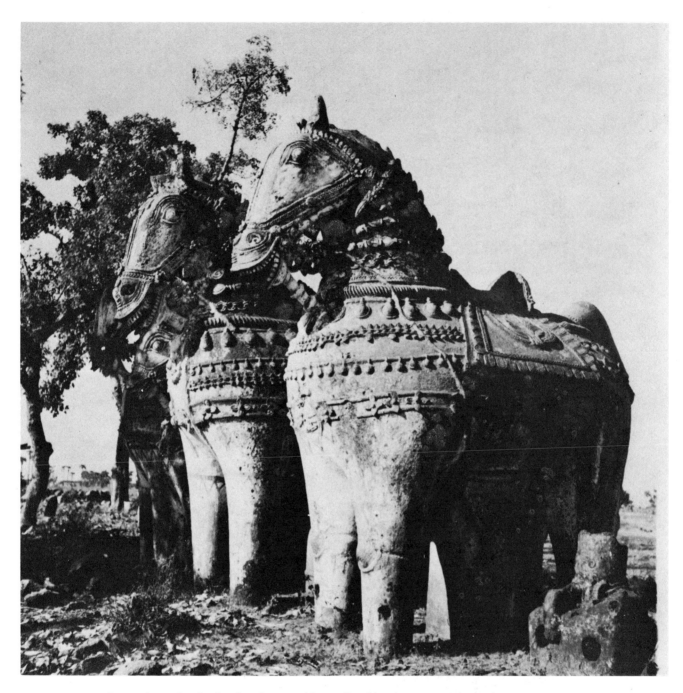

Giant terracotta horses (6–12 feet high, placed in rows) are offered by devotees to the god Aiyanar, benevolent protector of the Tamil rural village. These majestic caparisoned steeds are ridden by him nightly to keep away evil spirits. Aeration holes (possibly incense depositories) reveal the horses' hollow slab construction. These statues, executed at the shrine, are fired in temporary kiln enclosures. Those shown here are at Sirunathur near Tiruvannamalai, Madras, and date from the seventeenth and eighteenth centuries. (*Photographs by R. F. Bussabarger*)

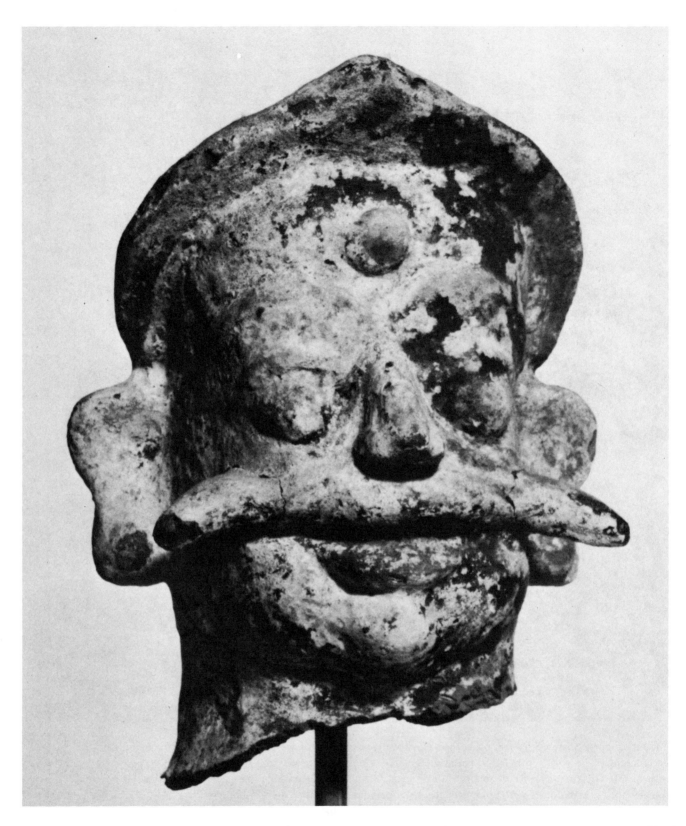

Heroic composure characterizes Aiyanar's head (actual size) with its Shivaite eye (a third eye, like that of the god Shiva). From a 3-foot-high terracotta shrine figure found seven miles south of Tanjore, Madras. Encrusted paint was applied for a sacrificial (non-meat-eating) festival during April and May.

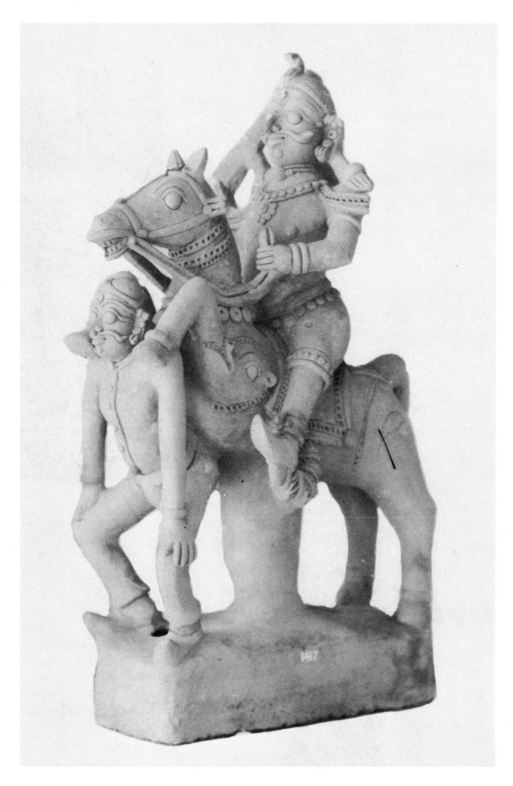

Madurai Vēēran (hero of Madurai), worshipped as a *grāma devatā* (village god), is shown mounted on a rearing horse over his companion Munadian. This somewhat disreputable pair attend Savaramma (Great Goddess) during animal sacrifices. The motif of this supple 18-inch terracotta slab figure is also used in stone pillars at the entrance to the *maṇḍapas* (worship halls) of the Śrīraṅgam temple and the Mīnākṣi temple in Madurai, Madras. (*Madras Museum photograph*)

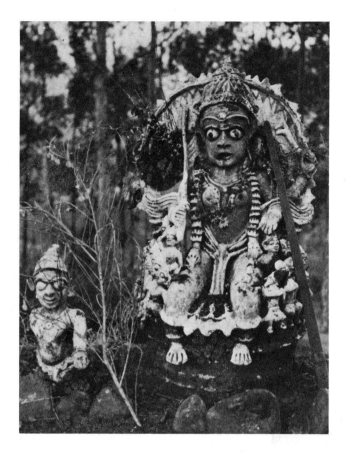

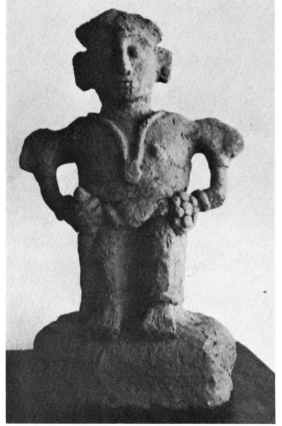

ABOVE: The great goddess called Maheśvaramma and Peddamma. Painted slab and potted terracotta mountain shrine figure, 30 inches high, located in the Nilgiri hills above Ootacamund, Madras. Stones, branches, garlands and a devotee image appear as offerings.

(*Photograph by R. F. Bussabarger*)

LEFT: European sailor effigy. Terracotta figure, 20 inches high, made by coastal villagers near Madras for protection from depredations of shore parties. Seen at the Madras School of Art.

(*Photograph by R. F. Bussabarger*)

OPPOSITE: Terracotta votive horse and rider, 15 inches high, primitively modeled but unusually shaped by the village potters of Buhari, Gujerat. Contemporary. (*Photograph by Haku Shah*)

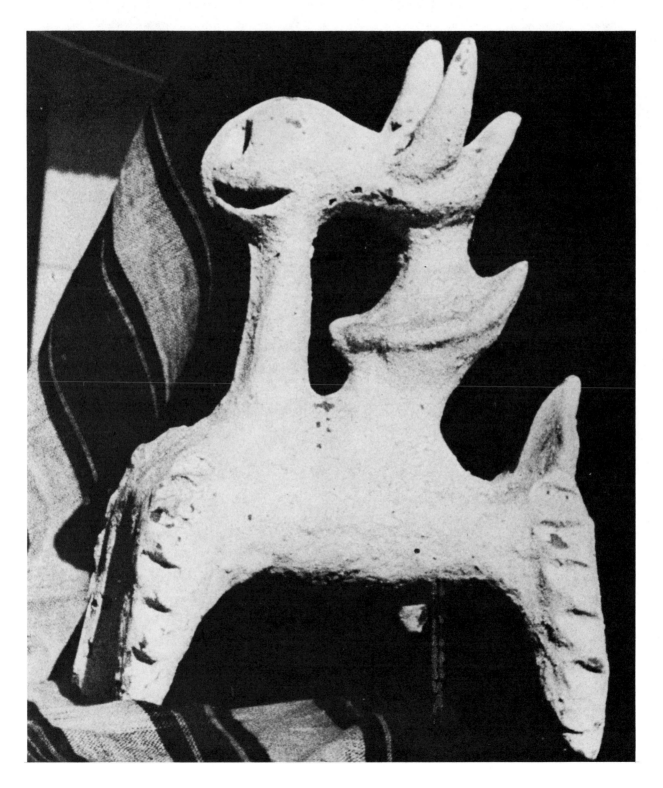

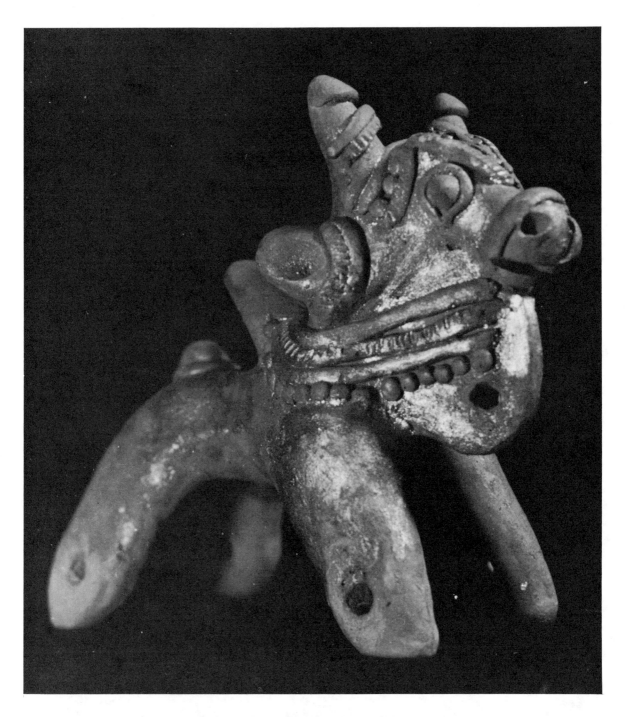

Nandi (Shiva's bull). Terracotta red-slip-coated toy without wheels, 6 inches high, made by the potters of remote Rajim, Raipur, Madhya Pradesh. Its spontaneous style is remarkably similar to that of ancient Mohenjo-Daro pieces, and demonstrates the cultural survivals from the earliest times to be observed in many villages. (*Asutosh Museum photograph*)

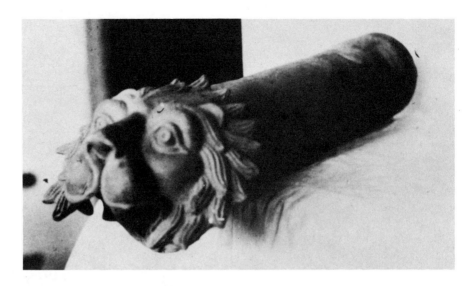

ABOVE: Drain finial with the humanized face of a lion. Contemporary terracotta, 20 inches long, from Bihar. The tiger-lion, the *vāhana* (vehicle) of Durgā, guards dwellings against demonic forces.
(*Photograph by R. F. Bussabarger*)

BELOW: Oil lamps for the annual *Diwālī* festival of lights made from pots and tubes and coated with silvery mica paint. 8–12 inches high. Patna, Bihar.
(*Photograph by R. F. Bussabarger*)

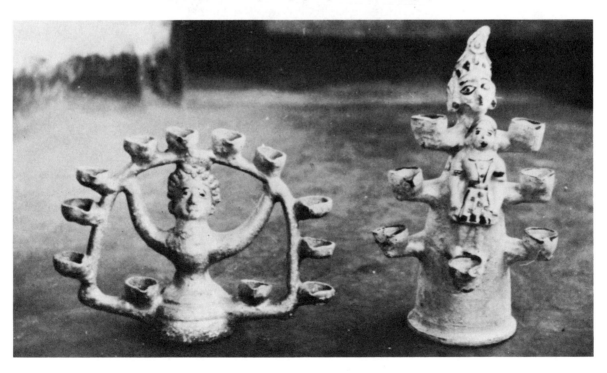

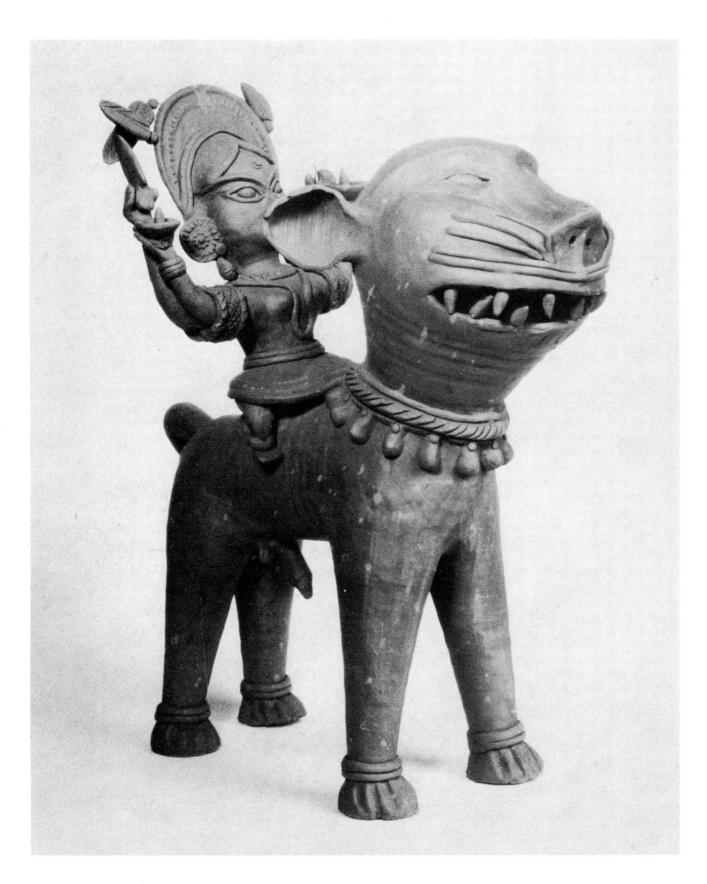

26 CLAY

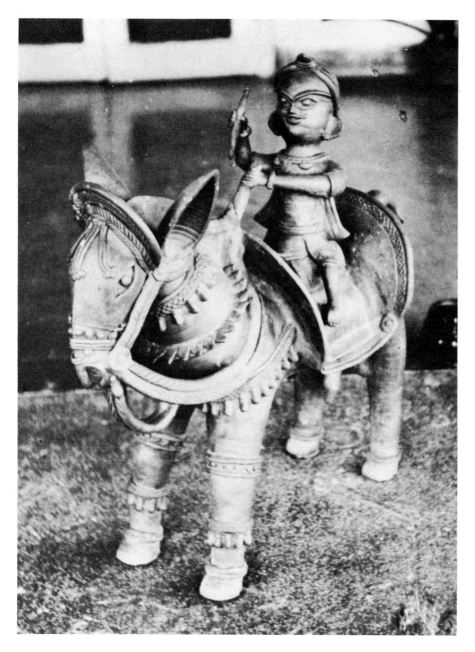

ABOVE: Equestrian figure (20 inches high) potted and modeled at Gorakhpur. The physical presence of the clay hero helps to satisfy the villagers' historically conditioned need for guidance and protection. (*Photograph by R. F. Bussabarger*)

OPPOSITE: Bānā Durgā rides her tiger-lion vehicle as a demon slayer of unsuspected ferocity. This 26-inch red-slip-coated figure was made by the potters residing at Naurangabad, Gorakhpur, Uttar Pradesh.

(*Calcutta Crafts Museum photograph*)

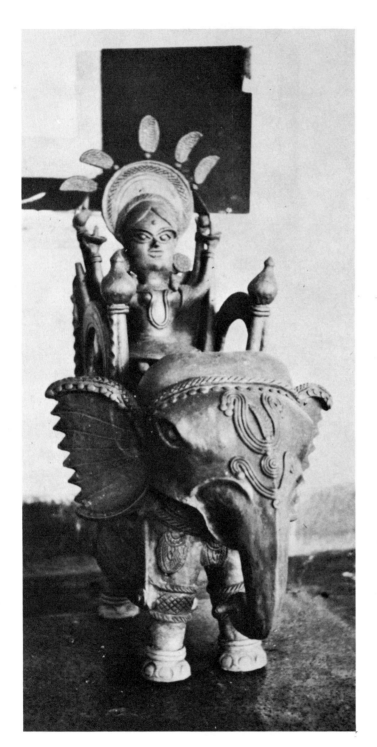

Śrī Devī rides authoritatively in her howdah on an elephant. Another of the many motifs produced by the Gorakhpur potters. 30 inches high.

(Photograph by R. F. Bussabarger)

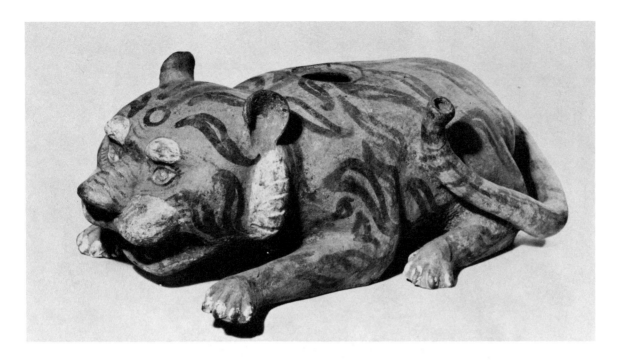

The 8-inch-high painted terracotta tiger above is a hookah (water pipe). The hollow tail serves as a pipe and the smoking bowl fits into the hole on the back. By the potters of Kumarpara, Puri, Orissa. Below is a slab-built guardian elephant with a reduction-fired gray finish by the resident potters of Puri.

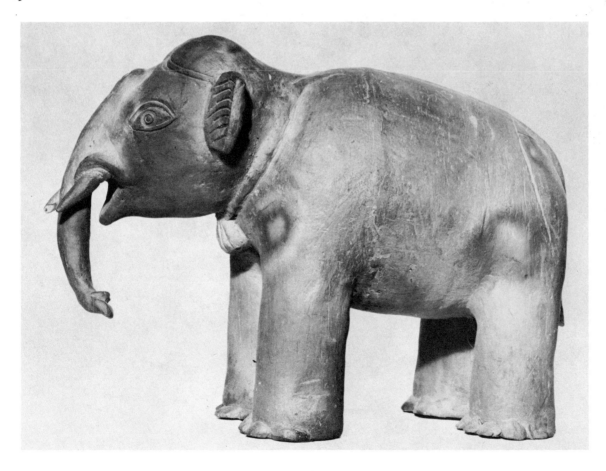

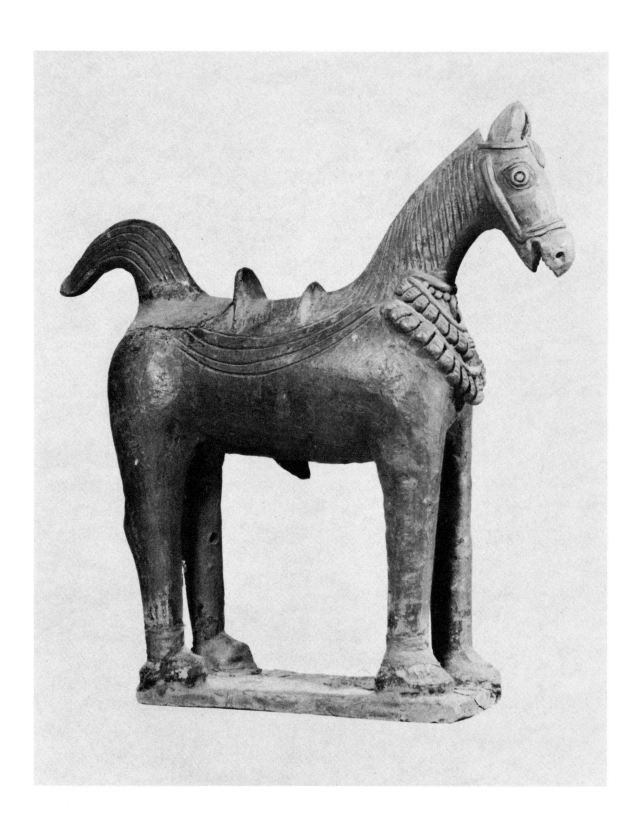

30 CLAY

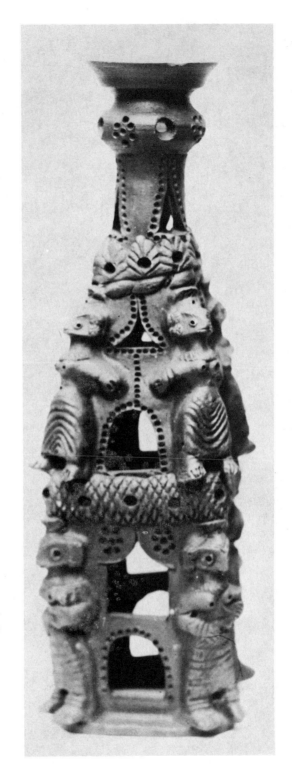

OPPOSITE: Whimsical steed without rider, 16 inches high, made by the Puri potters. This votive hero-horse theme is common to all India.

RIGHT: Terracotta lamp, standing 18 inches tall, potted and modeled at Goalpara, Assam. "Bird-mother" images, fretwork and holes for incense sticks are capped by the oil cup. Contemporary.

(*Asutosh Museum photograph*)

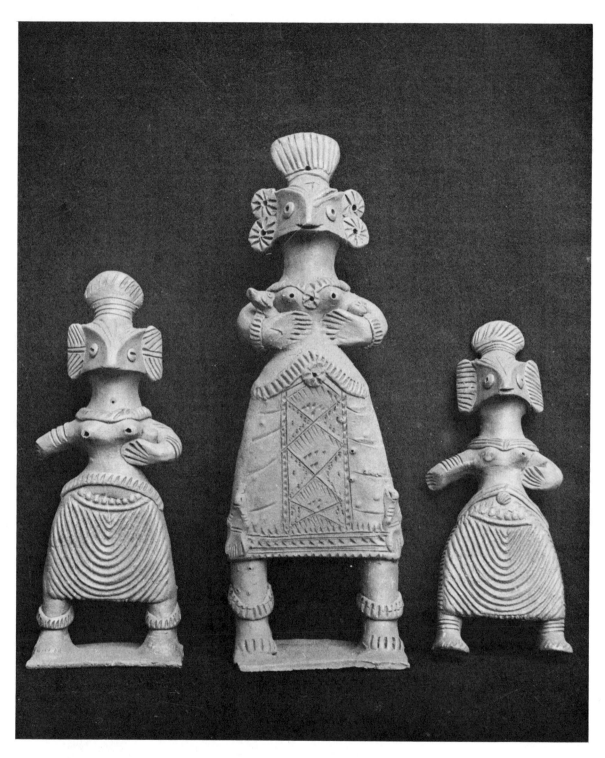

Terracotta theriomorphic "bird-mother" figures, 8–12 inches high, made by potters of Asadi-kandi village near Goalpara, Assam, who migrated there from what is now East Pakistan. These red-slip-coated figures are *brata* dolls of the ancestral totem mother Hātē-po-konkhē-po ("Baby at Her Arms"). (*Asutosh Museum photograph*)

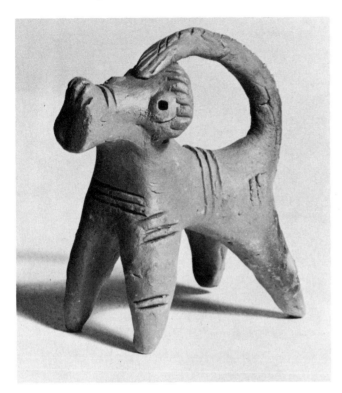

LEFT: (actual size) The dog toy is also made by the potters of Mymensingh District of northeastern Bengal (now Pakistan).

BELOW: "Bird-mothers," 3 and 5 inches high. These *brata* dolls are associated with Bengali bird ancestors, such as Subachani ("Duck Mother"), Chitra and Suparna (Garuda), kings of the bird clan.

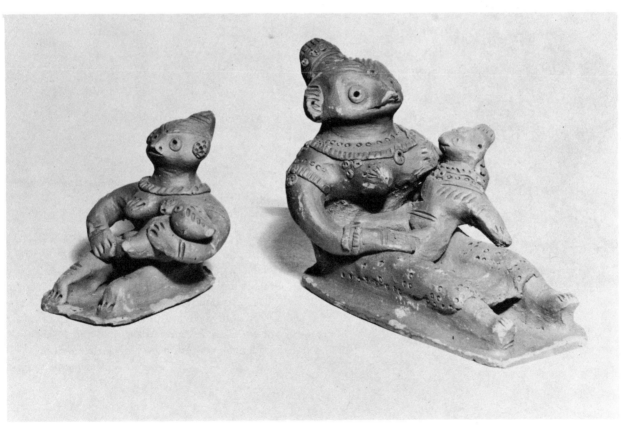

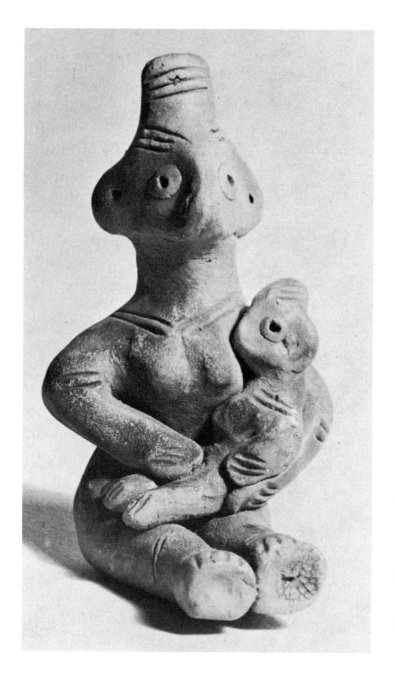

LEFT: Another "bird-mother" from Mymensingh, 3 inches high, made as a toy or a votive image for barren women.

OPPOSITE: Mahādeva ("Great God"), a form of Shiva, Lord-of-Snakes, made for the Shiva *pūjā* at Nabadwip, Nadia District, West Bengal. 10 inches high. The clay head, left unfired, is painted. The white face represents the ashes with which the ascetic Shiva covers his body, and the gold helmet of the military emperor is like the *linga*-shaped bridegroom's pith cap symbolizing union.

(*Asutosh Museum photograph*)

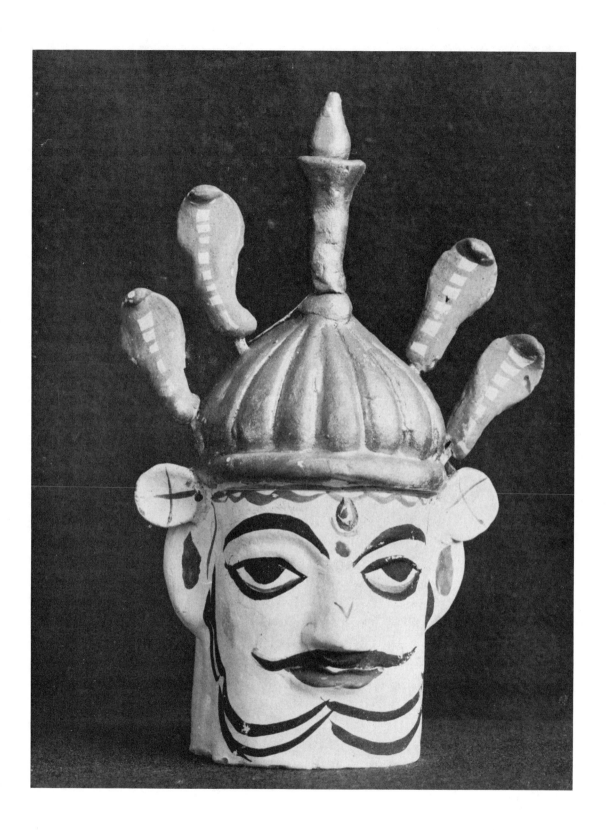

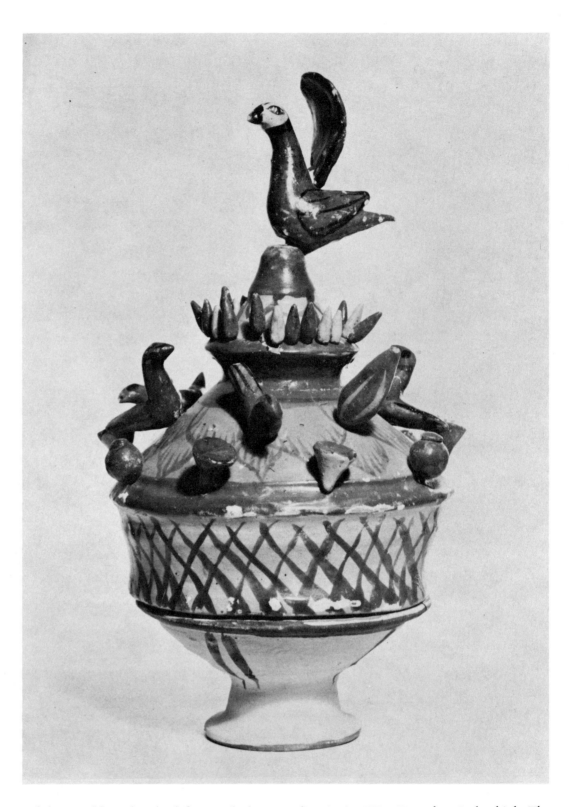

Lakshmī wedding *ghaṭa* (pot) from Nabadwip, Nadia District, West Bengal. 11 inches high. The auspicious painted terracotta *liṅga*-shaped top is gaily decorated with ancestral birds and flowers. Contemporary.

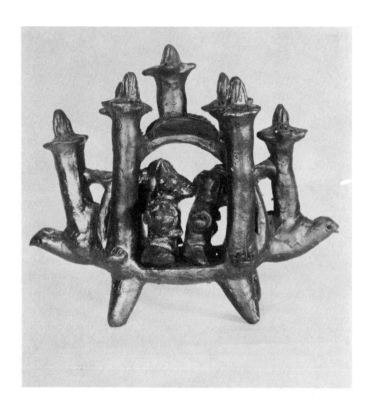

LEFT: Wedding palanquin 6 inches high with theriomorphic couple under canopy and *liṅga* finials. Bengali ancestral birds guard the ends.

(*Asutosh Museum photograph*)

BELOW: Among other playful images made by the potters at Panchmura, in the Bankura District of West Bengal, are this toy/votive slip-coated tiger (6 inches high) and this elephant. Contemporary.

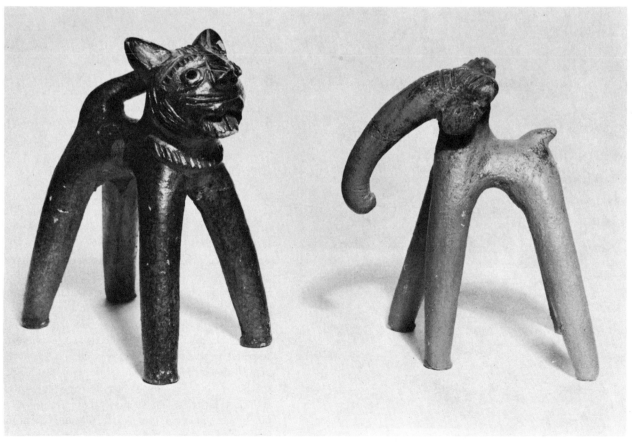

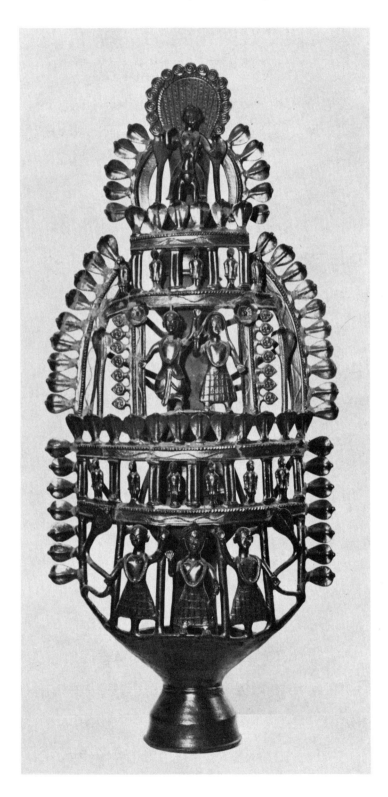

The realm of Manasā, a snake goddess who is represented as a human being, snake or abstract form, is illuminated in the *jhāḍs* (tree-shaped votive temples) by a complex mélange of Bengali folk-tale images.

LEFT: The boat-shaped bottom frontal of this votive piece shows the voyage of Manasā. The goddess (below, center) is flanked by two appearances of herself as a dancer and a dairymaid who appear to Cāndo (Shiva) in a seductive attempt to take possession of his power. The voyage is connected with the poisoning, resuscitation and winning over of Cāndo's six sons (who appear in the river directly above) by Manasā, who sails to Bengal to become the totem head of the snake clan. In the central tier, Jarātkāru ("Old Sage"; he has Vishnuite connections), prince of the snake clan, general and husband of Manasā, takes a Krishna-like dancing pose alongside Manasā, who appears as a dairymaid (like Rādhā). In the end he abandons her. The handsome Kārttikeya, son of Shiva (Cāndo), riding on his peacock, obediently tops the snake world, directly above the other five sons (in some versions, five girls), who were killed and resuscitated in a basket by Manasā. Terracotta with black slip. 60 inches high. Made at Panchmura, Bankura District, West Bengal.

OPPOSITE: The theme of the destructive and regenerative powers of female energy (with Shivaite orientation) in unresolved contrast with the preserving Vishnuite husband continues in this red votive piece. Manasā appears on this elephant-borne arch as a snake, as multiple Jāṅgulīs (old Buddhist form of Manasā) with *vīṇās* (in the plaques along the top of the arch) and as dairymaid and dancer (in the round, at the corners). A row of Cāndo and his six sons (under the arch, which is adorned with six lotuses) is topped by a Buddha in *padmāsana* (probably a representation of Jarātkāru). 30 inches high. Made at Rajagram, Bankura District. These masterly contemporary pieces are believed to ward off the demonic powers of snakes. (*Asutosh Museum photograph*)

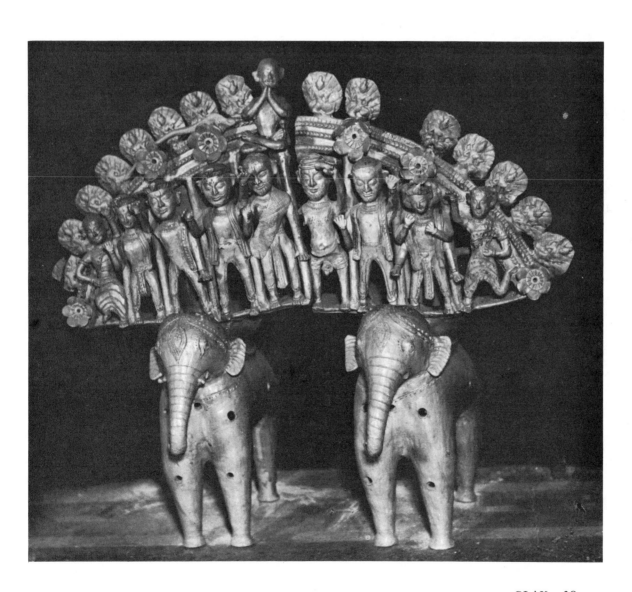

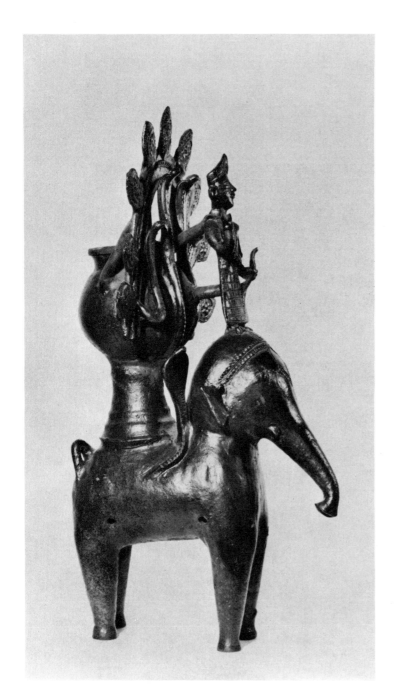

LEFT: Manasā, mother of earth and moisture, rides benevolent and malign on an elephant (signifying her importance and auspiciousness). She is also conceived as a pot (on the elephant's back) holding snakes (clan symbol). 25 inches high.

RIGHT: Two views of another piece. Jarātkāṛu, Manasā's husband, rides heroically on a horse (also holding the Manasā pot). 26 inches high. This type of black pot is given special attention during the July–August *Nāga-Panchamī* festival prior to the wet monsoon season at Panchmura and before snakes appear in profusion, sometimes coiling up inside these votive pieces.

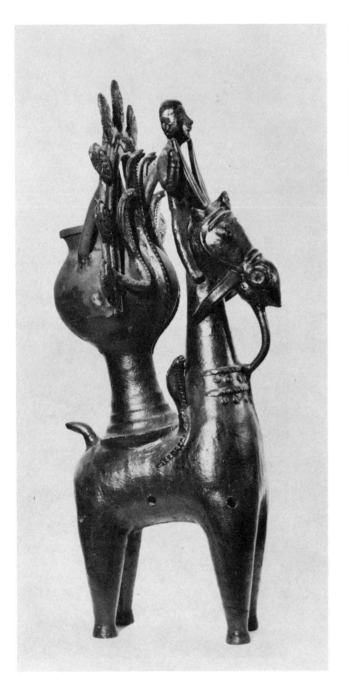 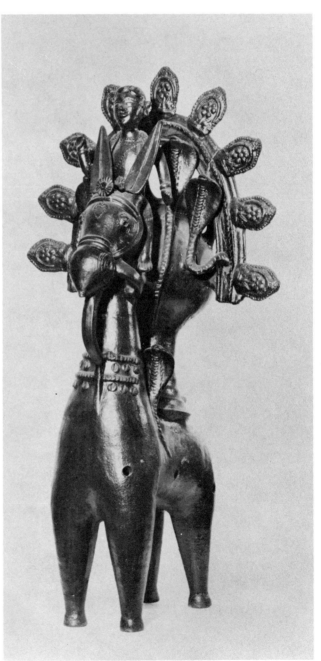

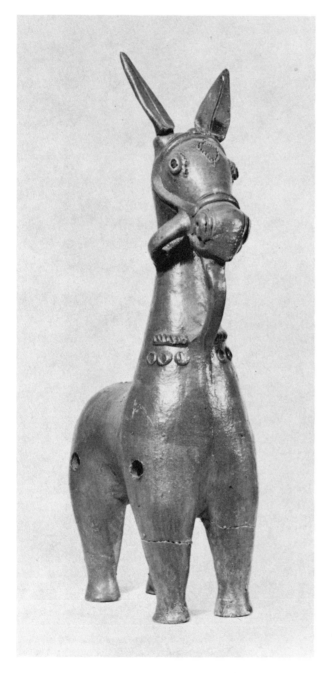

Horses and tiger. Red-coated terracotta guardian votive pieces. On the left is a 15-inch-high horse from Panchmura. This type of horse is frequently made up to 6 feet high; its aligned, bottle-like restraint is different from the fluid pot assemblage of the 25-inch-high horse opposite and the 15-inch-high tiger below, both made at Rajagram.

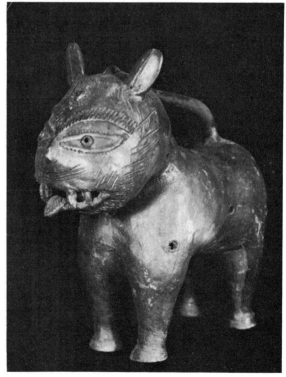

(*Asutosh Museum photograph*)

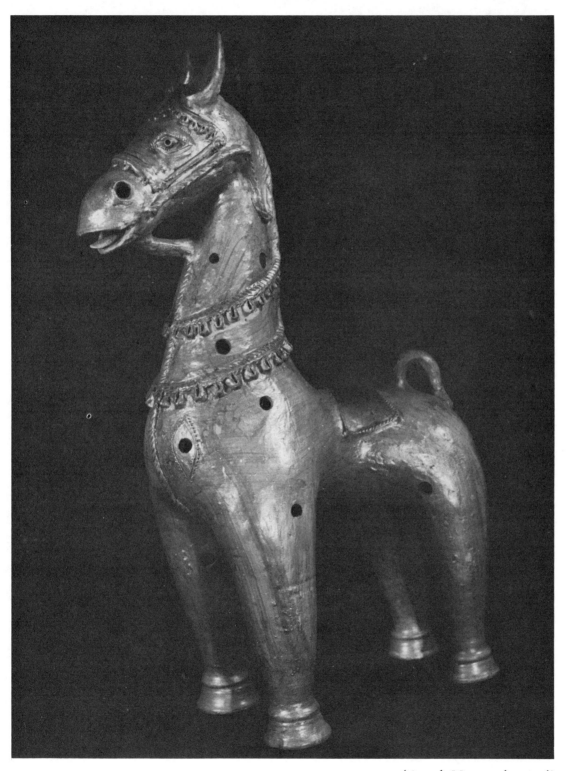

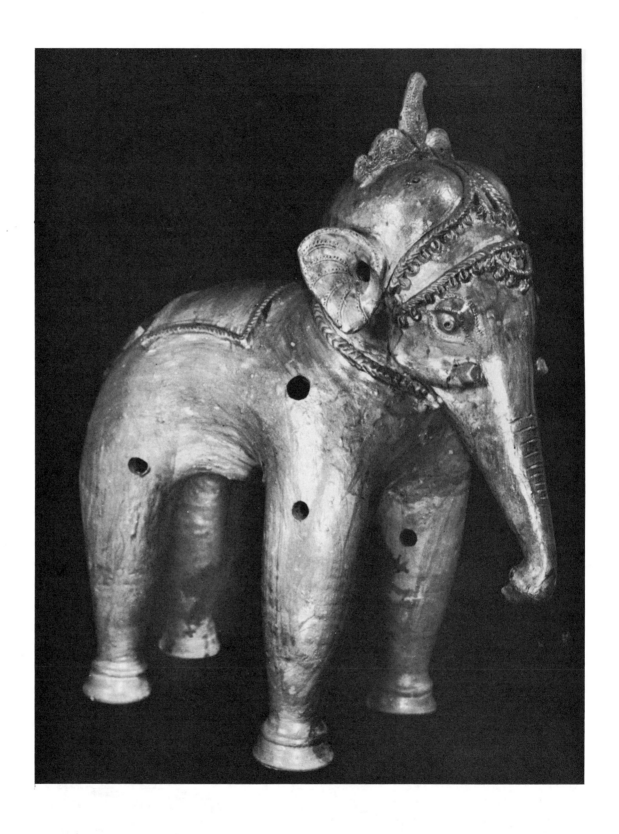

44 CLAY

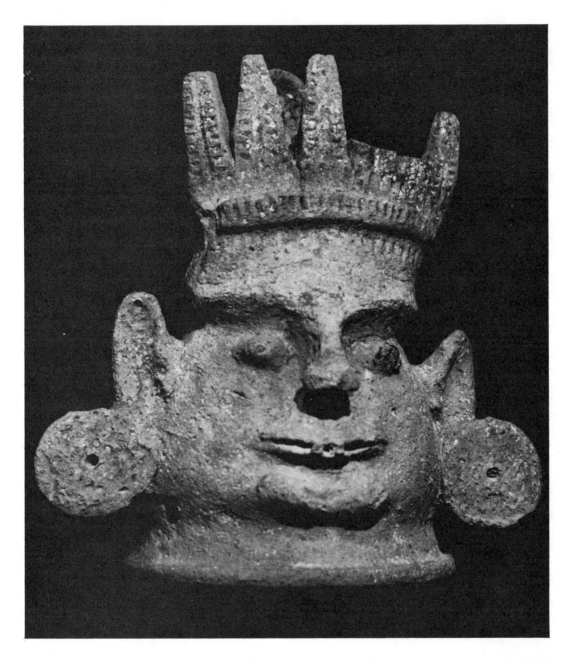

ABOVE: *Manasāghāṭ* (Manasā pot), 10 inches high. This contemporary terracotta pottery head of the snake goddess was modeled at Kheput, Midnapore District, West Bengal, with a commanding but whimsical and naive form. (*Asutosh Museum photograph*)

OPPOSITE: This red-coated potted elephant, 18 inches high, made at Rajagram, is the *vāhana* (vehicle) of Śrī Lakshmī. Such figures are used as auspicious offerings by village devotees.

(*Asutosh Museum photograph*)

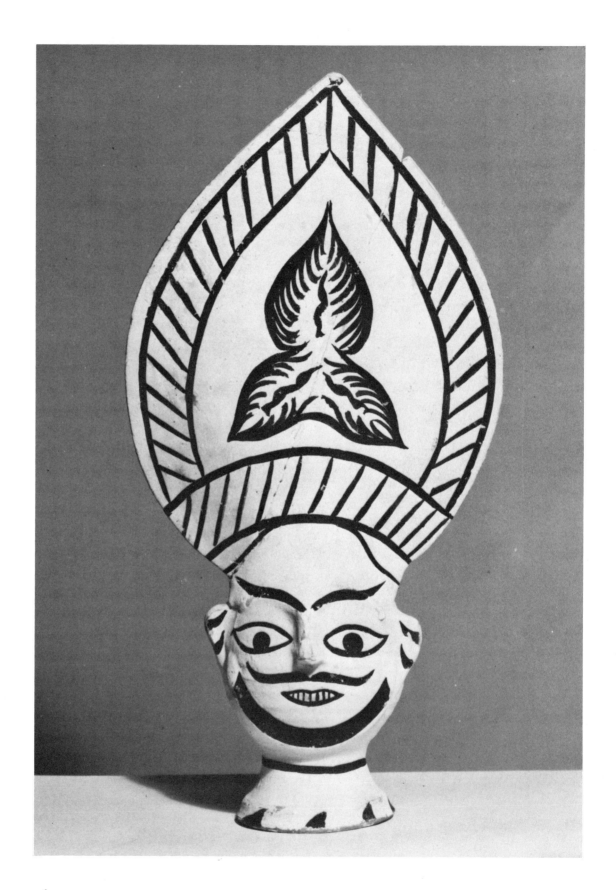

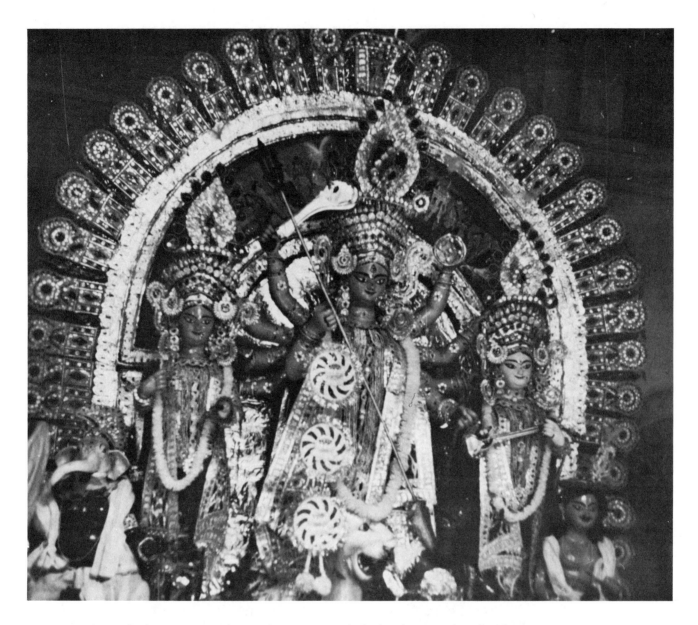

Durgā. An image for home *pūjā*, made in Calcutta, 1961. Clothed and crowned with pith, paper, wire and tinsel, the reinforced painted-clay goddess rides her lion *vāhana* and slays the buffalo demon Mahiṣāsura. Her attendants, from left to right, are Ganesh (with the elephant head), Lakshmī, Sarasvatī and Kārttikeya. After a few days the splendorous image is carried to the consuming Ganges waters. *(Photograph by R. F. Bussabarger)*

OPPOSITE: Dakṣiṇ-dar ("Door of the South"), a Shivaite quasi-god, is identified as the southern provincial governor of the ancient Bengali administration. The white-painted terracotta head, 15 inches high, is capped by a slab trident crown. A festival of respect is held in 24 Parganas, south of Calcutta, in the month Pauch (December–January) following the harvest. Afterward the image remains as a tiger-deterrent.

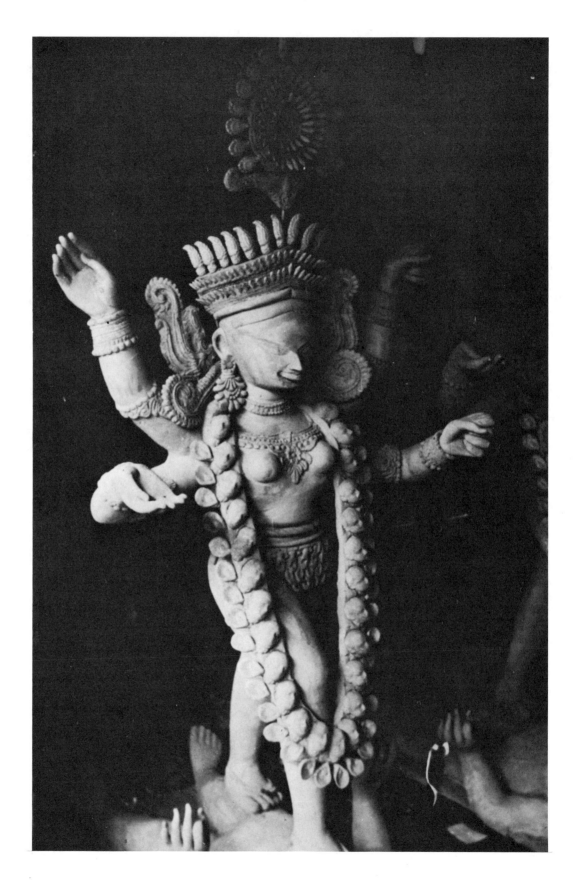

48 CLAY

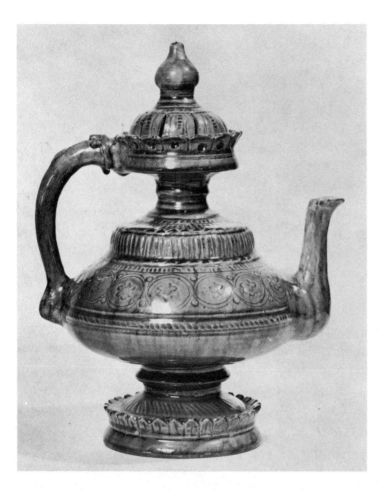

ABOVE: Magic pot, 7½ inches high, retaining a Moghul-Persian style established by the forefathers of the Hindu potters of Karigiri village near Vellore, Madras. Water poured through the base comes out the spout when the pot is held upright.

RIGHT: The village's white clay is being thrown on a typical stone pivot wheel by a hunkering family potter, who eventually assembles the fabricated sections, fires the pot and then applies green, blue and yellow lead glazes for the final firing.

(*Photograph by R. F. Bussabarger*)

OPPOSITE: Kālī, goddess of destruction and regeneration. An unpainted image from Kumartooly, Calcutta (home of the goddess), made in 1961. The figure, which stands on the dead Shiva (who eventually returns to life), is constructed from clay-coated straw and bamboo, with molded clay accessories. Kālī's *pūjā* ends by melting her form in the Ganges.

(*Photograph by R. F. Bussabarger*)

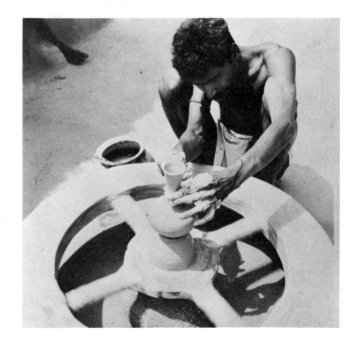

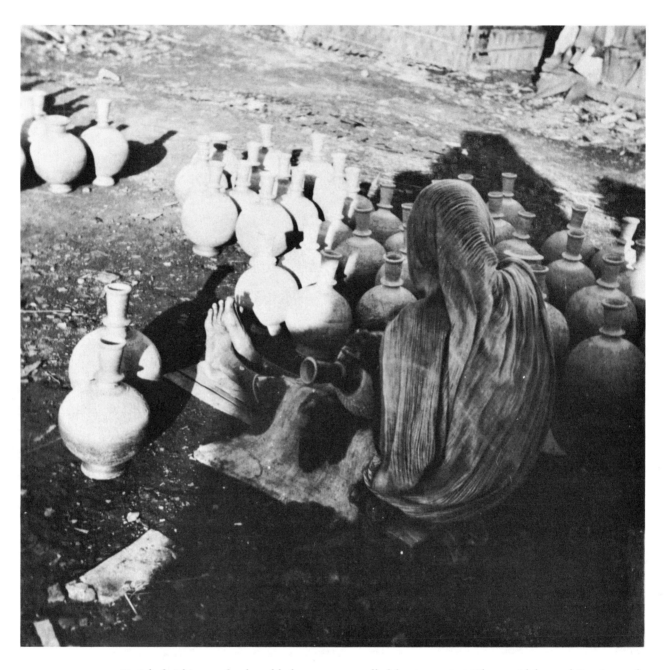

Pariah finishing unfired molded water pots called *kunjo* or *sārai*. These widely used Persian-style flasks will eventually be fired; then the porous terracotta will cool its contents by evaporation. Calcutta, 1961.
(*Photograph by R. F. Bussabarger*)

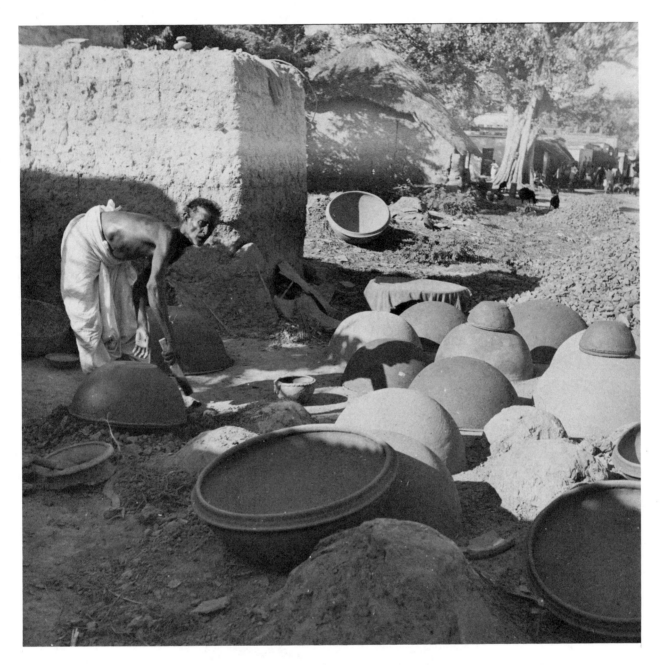

Cow-feeding vessels called *māzlā* or *chari*, near Nabadwip on the Hooghly River, West Bengal. Large clay bowls are being formed on earth humps; later they are turned and dried, then fired in a kiln. The repetitious process has not dulled the natural sureness of the form.

(*Photograph by R. F. Bussabarger*)

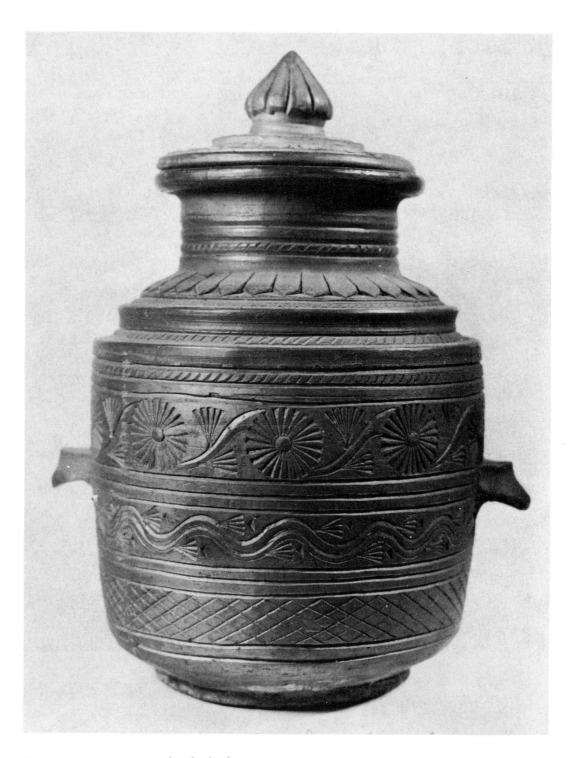

Contemporary jar, 11 inches high, from Kumarpara, Puri, Orissa. The gray-black terracotta reduction-fired form, with an incised surface pattern of lotus, tapers into a lotus-*liṅga* top. Its embellishment indicates ritual or wedding ceremony use. (*Asutosh Museum photograph*)

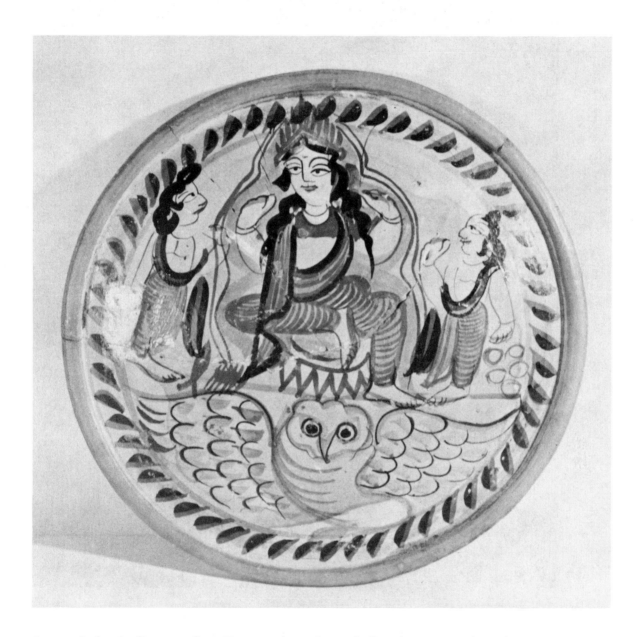

Sarā, 11 inches in diameter, from Kumartooly, Calcutta (before the partition these plates were traditionally made in Dacca, now in East Pakistan). Painted on the convex terracotta *pūjā* plate is Lakshmī, goddess of fortune, on a lotus, attended by two devotees offering an auspicious fish and five mystical stones. Below is the sacred owl, Lakshmī's earlier tutelary Bengali clan form. Feathery flames encircle the whole scene.

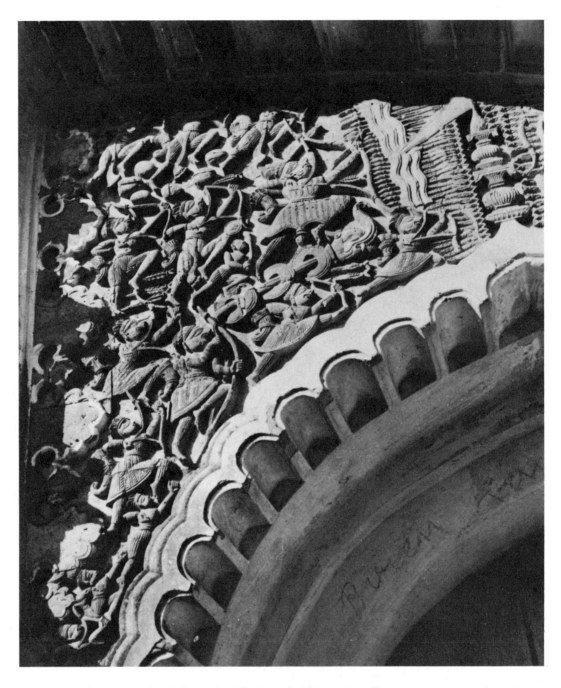

A seventeenth-century detail from the Charbangla ("Four Huts"), a terracotta temple at Bara-nagar, Murshidabad, West Bengal. In this brick illumination of the popular theme of the battle between good and evil, an army of boar-headed archers, led by a general mounted on a *makara,* attack a demon (not shown in photo). The turbulent motif accents the crenelated Moghul-style doorway for the entering worshipper. Brick module 10 inches.

(*Photograph by R. F. Bussabarger*)

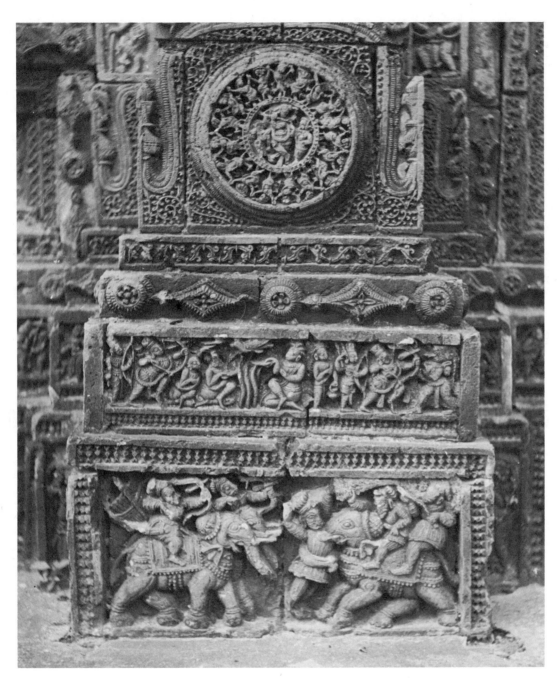

A seventeenth-century brick temple pillar at Banch Baria Town, Hooghly District, West Bengal, showing a circular *Krishna-Līlā*, with Krishna playing his traditional flute in revelry as he dances in a ring with *gopīs*. The middle frieze depicts *Rāmāyaṇa* forest episodes. At the bottom, warriors battle on elephants (traditionally at the plinth). Garlands frame the rich bas-relief motifs. Brick module 10 inches. (*Photograph by R. F. Bussabarger*)

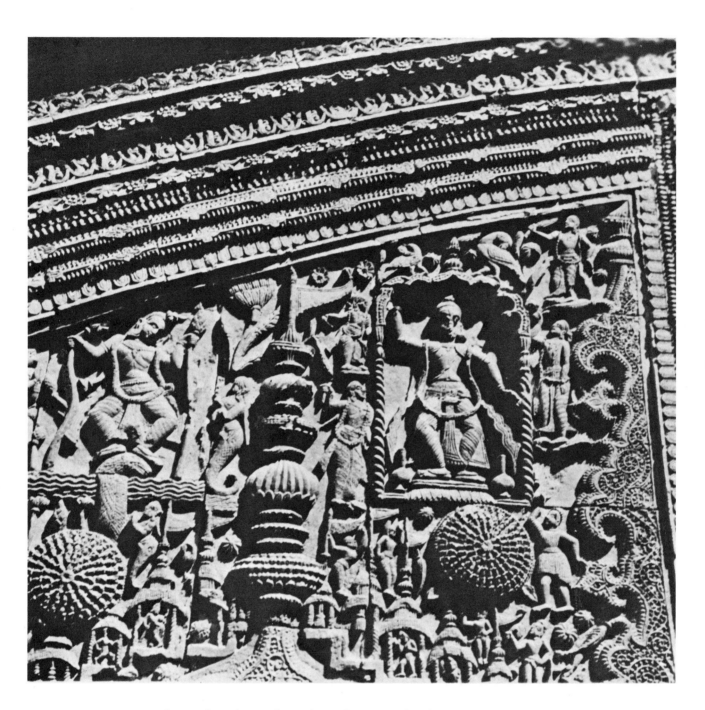

Archway frontals on the eighteenth-century brick temple at Suri, Birbhum District, West Bengal. At the left, Krishna stands triumphantly on Kāliya (a serpent king), who is in the river Jumna, accompanied by underwater maidens. In the next niche to the right is a dancing Krishna surrounded by attendants. Along the top of the right-hand photo, Ganesh sits on his rat *vāhana*; Vishnu rides Garuda, who is attacking a serpent; Vāyu, god of wind and air, rides a deer. Below,

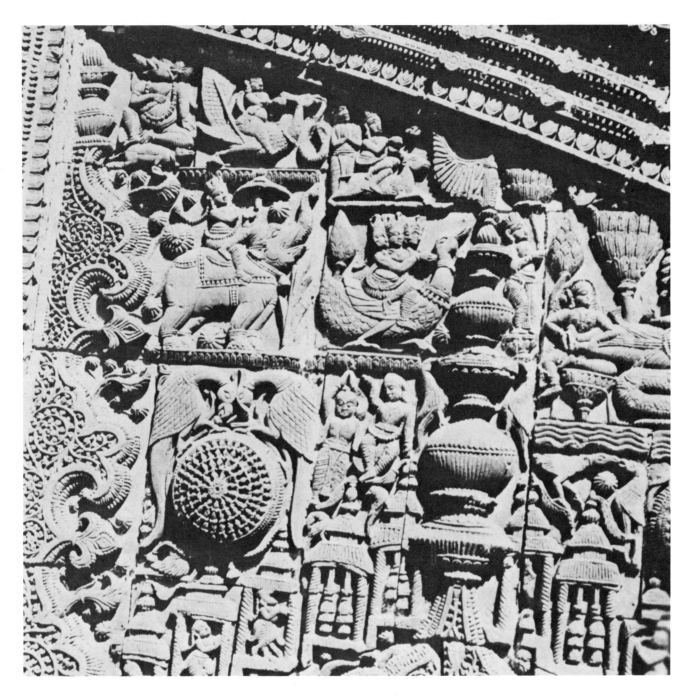

Indra rides an elephant; Brahmā, with four heads, rides a gander, preceded by Lakshmī, who is standing on one lotus and holding another. Continuing to the right, Lakshmī massages the feet of the reclining Vishnu. On top of the rosette is the double-*haṁsa* motif. The couple next to this appear to be Rādhā and Krishna. All these motifs embellish the devotees' worship. Brick module 10 inches. *(Photographs by R. F. Bussabarger)*

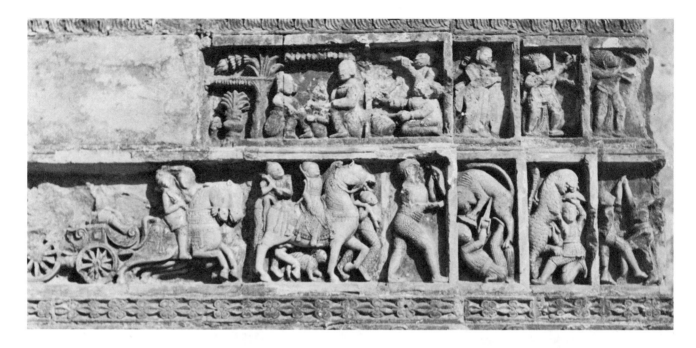

ABOVE: Wall detail from the seventeenth-century Charbangla brick temple at Baranagar, Murshidabad. The upper frieze shows characters from the *Rāmāyaṇa* shooting arrows and sitting in the forest. Underneath, a seventeenth-century family of means journeys in a carriage. Horsemen and tiger-hunters make the way safe. Direct modeling results in an exquisite ivory-like quality.

BELOW: A detail from the eighteenth-century brick temple at Atpur Town, Howrah District, West Bengal. From left to right, European and Indian "generals" confer, attended by soldiers, as women watch from the house; European horsemen and foot soldiers appear in procession. Secular themes usually adorn the lower temple friezes. Brick module 10 inches.

(Photographs by R. F. Bussabarger)

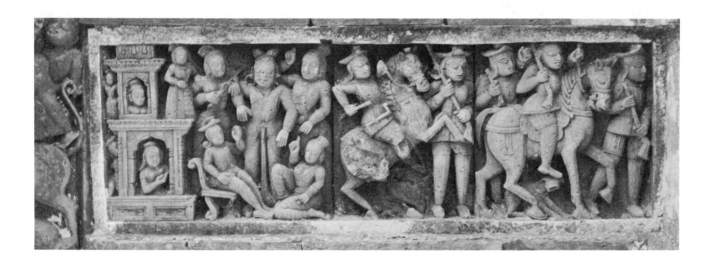

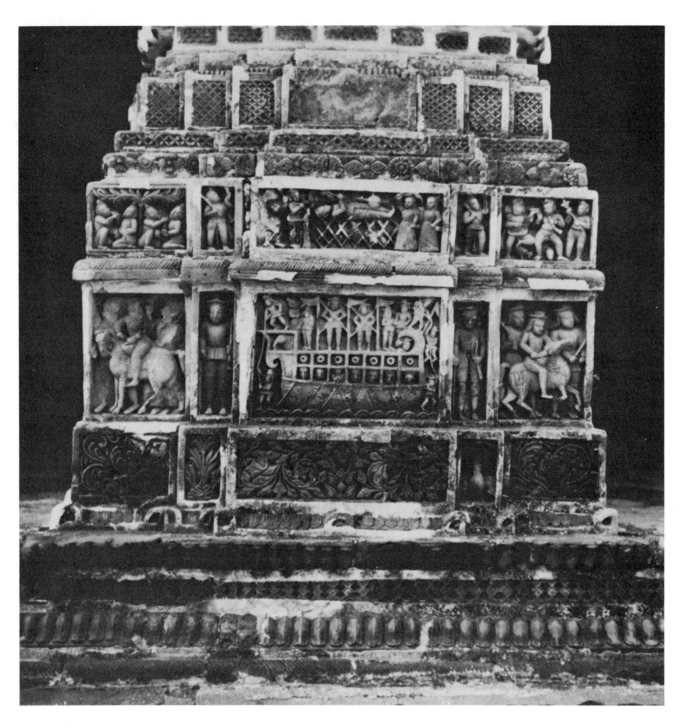

Porch pillar base from the eighteenth-century temple at Atpur. In the center is a moored European ship, flanked by European gentlemen and traders. In the top frieze, Krishna episodes appear. These brick structures exhibit the imaginative use of the most plentiful and durable material in the stoneless Ganges delta region. Brick module 10 inches. (*Photograph by R. F. Bussabarger*)

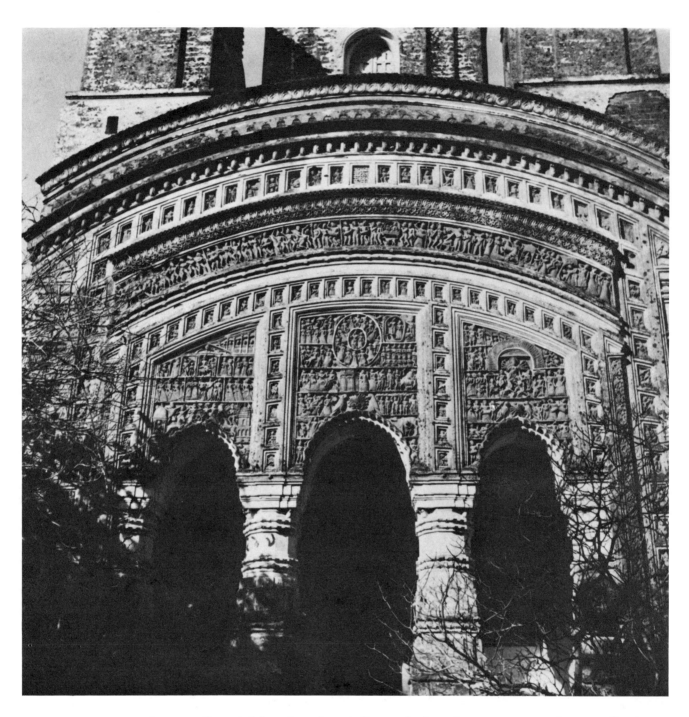

The magnificent Lakshmī-Janārdan triadic temple frontal in a private residence at Illambazar, southwest of Shantiniketan, Birbhum District, West Bengal, dated 1768. Its curvilinear *baṅglā* (hut) roof and skeletal carved pillars are authentically translated from a bamboo archetype into brick. *Rāmāyaṇa* figures (Rāma and Sītā and the battle of Hanuman and Rāvaṇa), as well as Durgā or Shakti, flank the central Krishna motif.

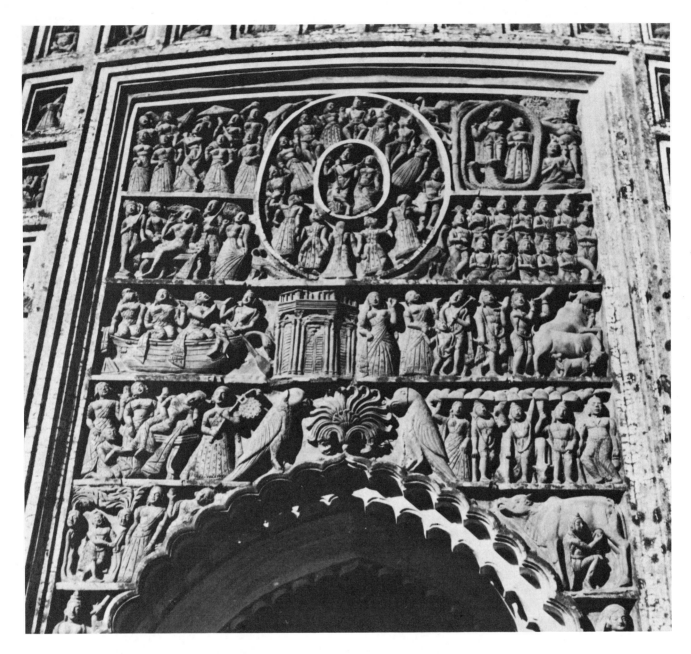

The life of Krishna detail, with direct modeling on molded shapes, is another classic of complex form and content interchange. Encircled in moon form, the multiple Krishna lovingly dances with the dairymaids. The top level also shows him doing a *Vasanta Rāgiṇī* dance while *gopīs* watch (left) and suppressing Kāliya, the serpent king (right). On the next level down (left), Devakī, Krishna's mother, hears an annunciation and prophecy of his peril at the hands of King Kaṁsa; on the right, Krishna appears with pastoral playmates. On the third level down is the boat of Krishna's escape and deliverance with Yashodā, his foster mother. From Yashodā's house the youth accompanies Balarāma, his elder brother, to work among the cowherds. The bottom level shows Krishna's birth and (right) his miracle of holding up the "umbrella" mountain to protect the cowherds from Indra's storm. The corners depict the retreat from Kaṁsa in the Vrindāvan forest, and the cow as a source of *soma* (nectar) from milk. Brick module 10 inches.

(Photographs by R. F. Bussabarger)

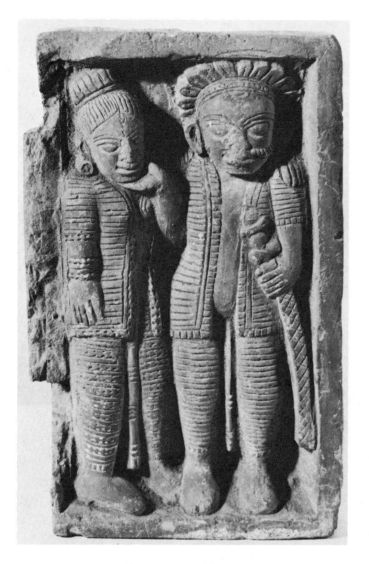

ABOVE: A brick showing an affectionate Kshat-riya *dāmpati* (donor couple) in Moghul dress, 9 inches high, from an eighteenth-century temple at Vishnupur, Bankura District.

RIGHT: A 5-inch brick depicts a temple dancer in a classical *bhārata nāṭya* pose, acting as an actual or symbolic preliminary sacrificial offering to the deity of the temple. From Panchthupi, Murshi-dabad District, West Bengal.

METAL

The use of metal has been known almost from the beginning of Indian civilization; bronze and copper implements and images have been excavated in the Indus valley that date from the Harappa culture, circa 3000 to 1500 B.C. The quantity of implements which have been found indicates that they were in common use. Despite the Aryan destruction of the Harappan civilization, the hymns of the *Rig Veda* give evidence of the continued use of metal. Mentioned in them are the Ribhus, celestial artificers who worked in metal. A prayer from the *Rig Veda Saṁhitā* describes the chariot of the gods Mitra and Varuna: "The substance is gold; its pillars are of iron. . . ." Another prayer states: "Intelligent Maruts [wind gods], you are armed with swords, with lances. . . ."[1]

The early excellence of Indian metal work is illustrated by both the small bronze dancing girl excavated at Mohenjo-Daro, an Harappan site, and by the twenty-three-foot-high iron Pillar of Menarauli in Delhi. The pillar, believed to have been erected about the fourth century A.D., has never shown any evidence of rust.

Metal is an important material for both religious and household objects. Metal religious images appear not only in the great temples and in the homes of the wealthy, but also in simple shrines and humble homes. Metal talismans are worn to ward off evil and disease.

Indians have long valued jewelry not only for its beauty but also for its economic worth. The wealthy and high-born place their savings in gold; the lower castes, in heavily decorated silver jewelry. The *śilpaśāstras* detail the attributes of all images, and prescribe the ideal proportions of tools, utensils and jewelry, as well as the metals to be used. On beginning a project, an artisan prays for guidance to Tvastram (one of the five sons of Viśvakarmā), who worked in metal.

In the past, most figures were made either entirely of copper, or a copper-base alloy, or of brass. Copper was considered next to gold in purity, and therefore the most desirable metal for the major deities. There were combinations of metals which

[1] *Rig-Veda-Sanhita*, translated by H. H. Wilson, Ashtekar & Co., Poona, 1920; Vol. III, pp. 260 and 251.

were believed to be auspicious. *Aṣṭadhatu*, an alloy of zinc, gold, silver, iron, tin, lead, mercury and copper, was used in the north; *panch loha* ("five irons"), an alloy of copper, silver, gold, zinc and lead, in the south. Bronze, as usually defined, is a combination of copper and tin. However, the designation is used loosely in describing Indian images and artifacts. For example, the dark southern Indian bronzes, according to some authors, are pure or almost pure copper; many of the light "bronzes" are brass (copper and zinc).

In addition to its use for religious iconography, metal is frequently used for common household utensils because the prohibition against the reuse of "defiled earth" inhibited the indigenous development of china or porcelain production.

The shapes, decorations and type of metal reflect the function of the utensils, the geographical area in which they were produced and the people for whom they were made. Many artifacts show the influence of cultural groups which have invaded India. The impact of the Greek conception of the human figure and beauty is evident in many images from northwestern India. The introduction of animals into the floral and calligraphic designs of some Muslim utensils, and the floral and crenelated archways to be seen on a number of Hindu artifacts, are other examples of cultural interplay. For cooking utensils, the Hindus use only brass, bell metal and copper being forbidden by their religion; Muslims use tinned copper.

The malleability and tensile strength of metal allows it to be shaped into thin sheets, wire and extended shapes where clay, stone and plaster fail. The unlimited possibility of forms led the craftsmen to produce every type of shape within the Indian idiom. Metalworking techniques represented in India include casting, raising on the anvil, brazing and soldering, as well as such surface embellishments as repoussé, piercing, chasing, engraving and damascening.

The Indian metalworker fashions his images, utensils, weapons and jewelry with much the same attitude as the potter shows in his work. Frequently the products are similar to creations in clay, reflecting the priority of clay manufacture in the history of the civilization. The aesthetic appeal of these metal artifacts is due to the skill of the individual artisan and his sensitive approach to his craft.

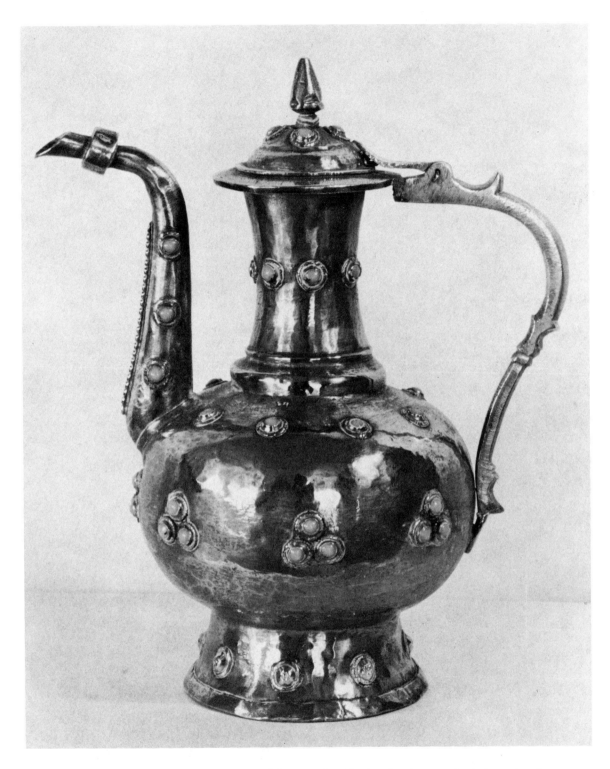

An *āftābā*, an Iranian-influenced copper vessel decorated with simulated turquoise in brass bezels. Eighteenth century. 14 inches high. Incised Persian script on the bottom gives the owner's name as Abdullah Khan. Similar contemporary works are found in Lahore, West Pakistan.

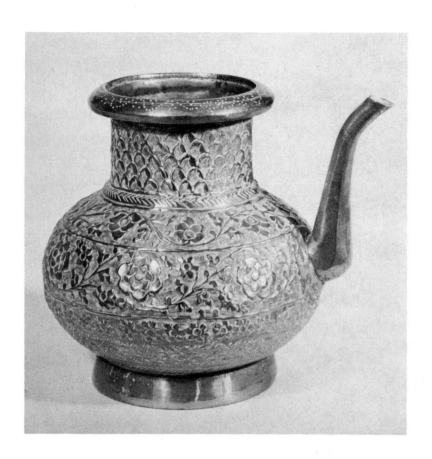

ABOVE: Another *āftābā* or *ṭoṅṭi-wālā-loṭā*. This Muslim contemporary *ṭoṅṭi* (spout) vessel (8 inches high) for daily ablutions incorporates a raised and punched Kashmiri design of poppies and leaves. Because the Koran prescribes the use of running water for lustrations, such pots require a *ṭoṅṭi*. Pouring from a spout symbolizes running water.

RIGHT: A small hair-oil *loṭā* with similar copper strips and incised leaf designs, 3 inches high.

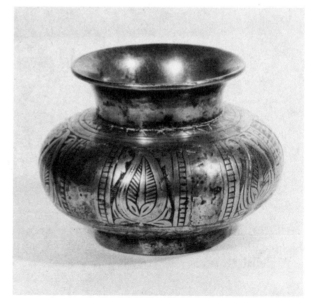

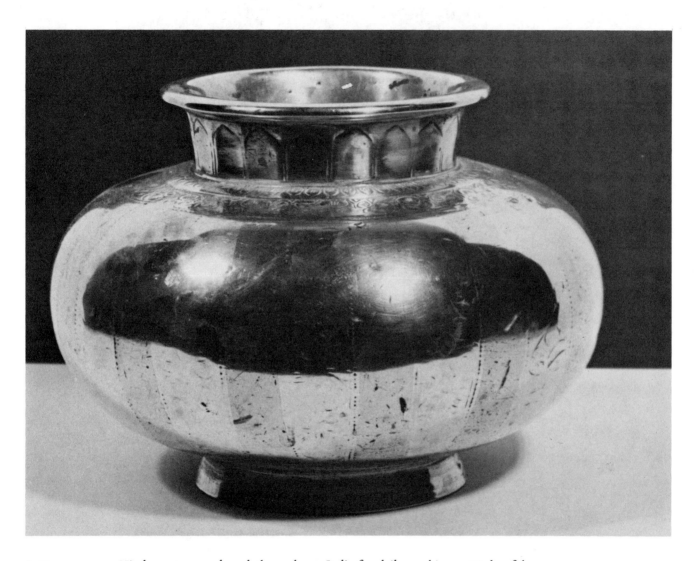

Loṭā, a common Hindu water vessel used throughout India for daily washings. Made of brass, it is decorated with inlaid strips of copper and incised outlines of copper lotus-leaf motifs. This *loṭā* is from north central India, eighteenth century, 6 inches high.

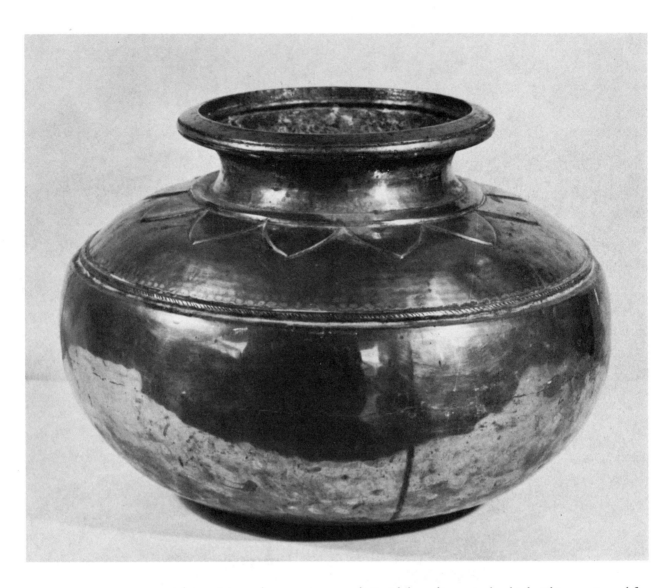

ABOVE: A large nineteenth-century copper *loṭā* with brass lip, 11 inches high. This type is used for carrying water from the village well and for water storage in the home.

OPPOSITE: Measuring vessels from southern India, nineteenth century, $3\frac{1}{2}$ to $4\frac{1}{2}$ inches in diameter, made of brass with copper encrustations. The bottoms are beautifully decorated (as seen opposite, above, in actual size) by inlaying copper petals within an incised lotus. Otherwise, plain copper bands and incising appear. Such vessels are used like the Western measuring cup.

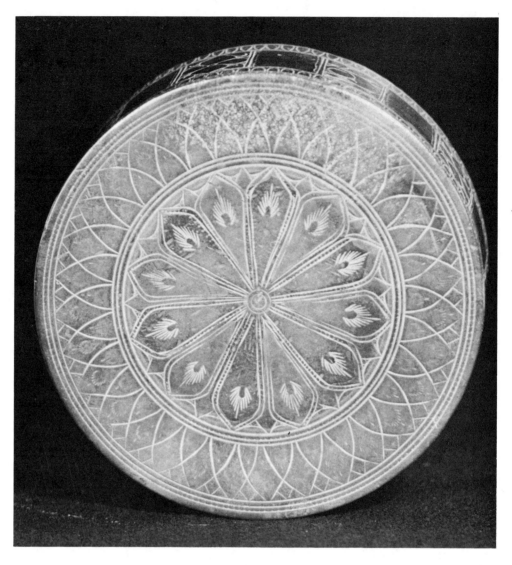

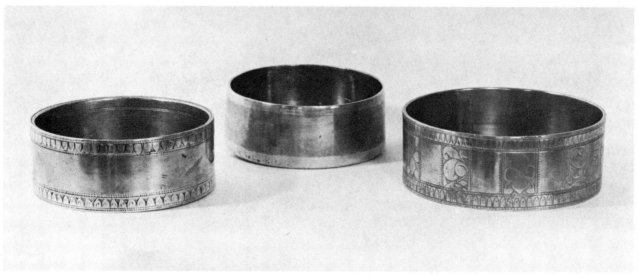

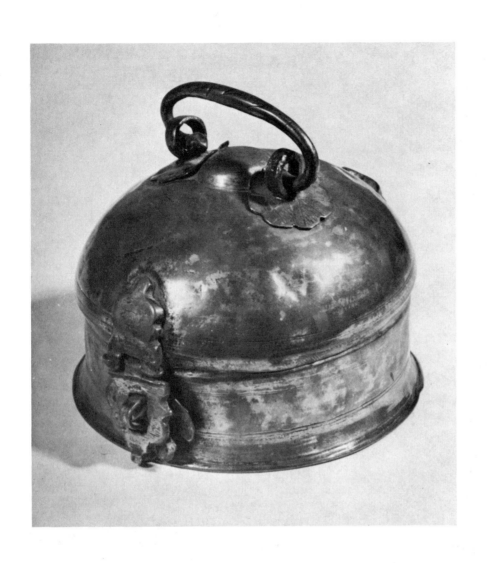

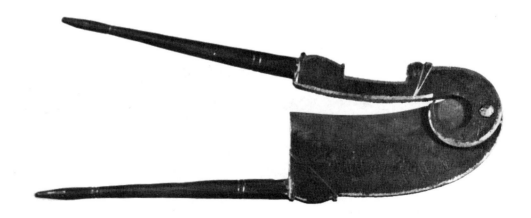

70 METAL

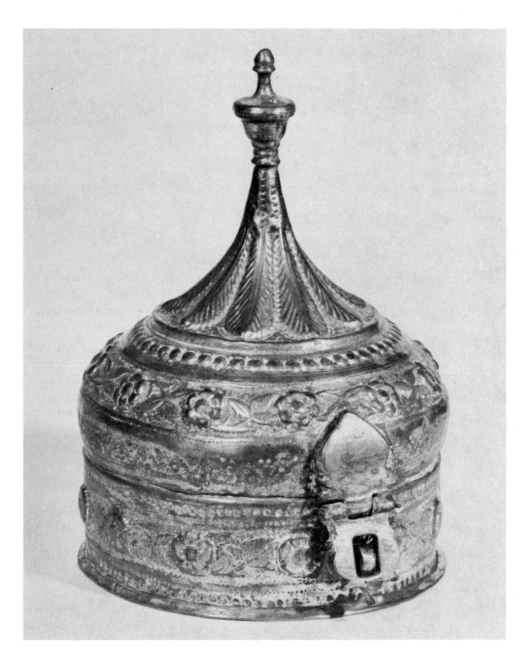

OPPOSITE ABOVE: *Pan dān*. A late nineteenth-century tinned copper spice and betel leaf container (base 4 inches in diameter) from north central India. Such containers (sometimes made of brass) may be plain, or highly decorated like the eighteenth-century 10-inch-high *pan dān* (ABOVE) with a gross Kashmiri punched and raised flower design and a minaret-shaped lid.

OPPOSITE BELOW: Betel nut cutter from contemporary Bengal, 10 inches long, made of steel. There is a suggestion of a parrot head at the hinge.

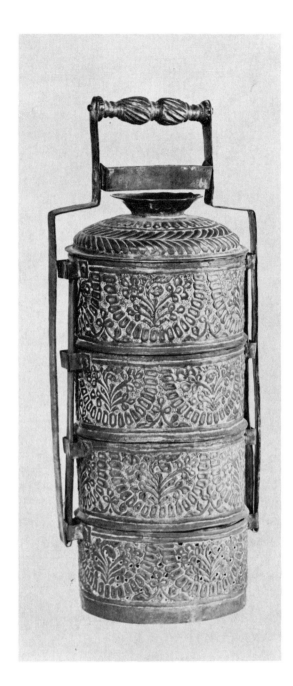

Tiffin box. This nineteenth-century tinned copper lunch box of Kashmiri design (17 inches high) has four stacked compartments. The top three hold food; the perforated bottom section, hot charcoal.

BELOW: This seventeenth-century plate ($7\frac{1}{4}$ inches in diameter) is an example of very fine work from Bidar, Andhra Pradesh, where *bidrī* ware originated. Silver-wire poppy designs are deeply imbedded in a heavy black metal alloy. This form is called *teh nashān* (deeply engraved).

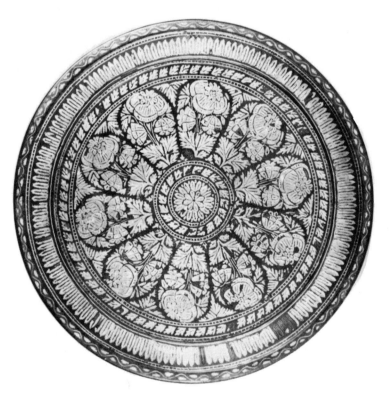

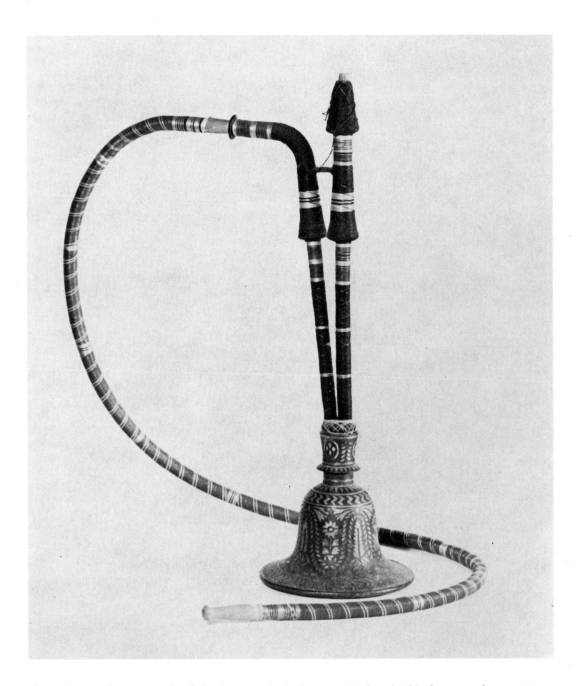

This nineteenth-century hookah (water pipe) (base 12 inches high) from Lucknow, Uttar Pradesh, is an example of a cheaper, less intricate *bidrī* form in which silver leaf has been applied to a shallow engraved design.

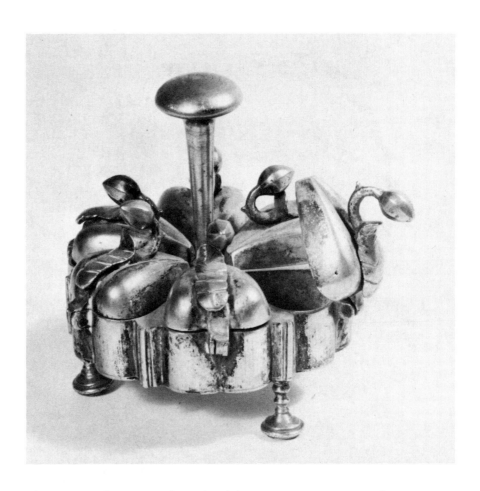

This nineteenth-century silver-plated brass cosmetic container from Mysore, standing on four legs, has six compartments, each with hinged lotus-blossom and leaf lids which resemble swans. Actual size.

OPPOSITE BELOW: Eighteenth-century brass lidded cosmetic container (actual size) in the form of a tortoise, possibly symbolizing Kaśyapa (old tortoise man, lord and progenitor of all creatures) or Akūpārā (the turtle upon which the world rests). Within are five compartments (which may indicate that this is a man's ceremonial cosmetic box) where sandalwood paste, vermilion, curds, honey and ghee (the five sacred ingredients) are kept.

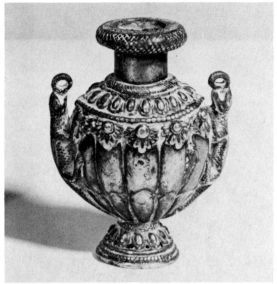

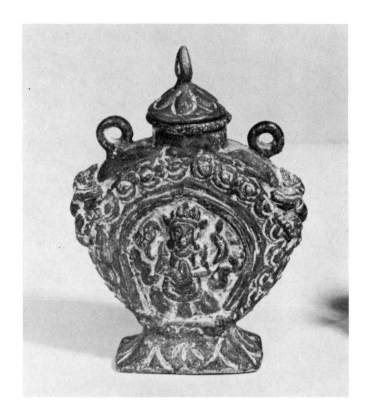

Nepalese *attar dāns* (perfume containers) or *dawāts* (ink wells), circa seventeenth to eighteenth centuries.

ABOVE: 3-inch-high brass container decorated on each side with a chameleon holding a ring for chains that are now missing but are ordinarily connected to what may be a long, narrow pen box or censer.

LEFT: Gold gilt bronze container, 4 inches high, with Hanuman in relief.

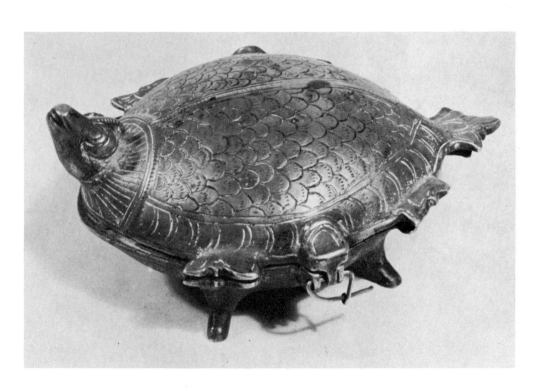

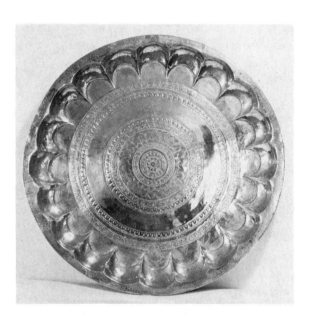

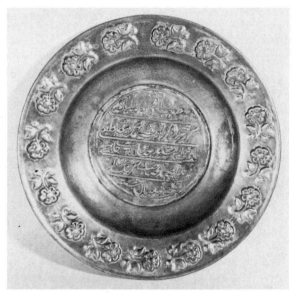

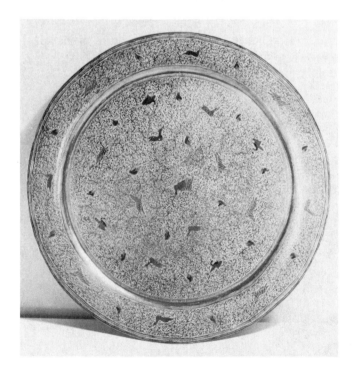

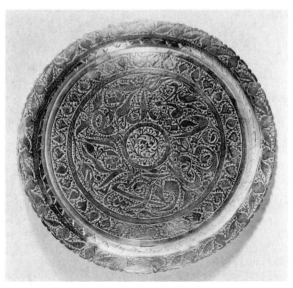

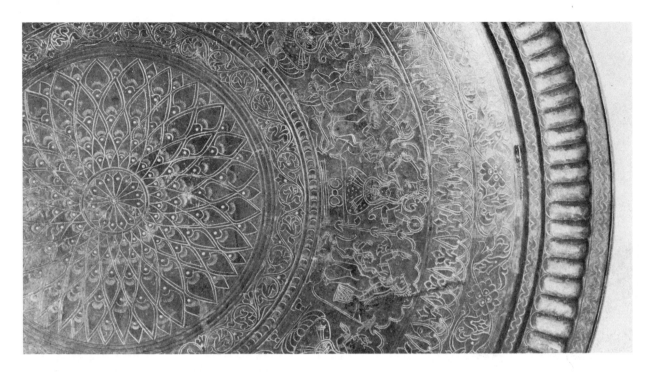

OPPOSITE UPPER LEFT: Nineteenth-century brass temple-offering _ṭabāq_ (round tray or plate), $22\frac{1}{2}$ inches in diameter, with engraved lotus medallion and peripheral pattern of elephant feet. Made in north-western India.

OPPOSITE UPPER RIGHT: Nineteenth- or twentieth-century commemorative tinned copper Muslim marriage plate, 7 inches in diameter, with a poppy rim design encircling the names of the groom and his father and the date. From north-western India.

OPPOSITE MIDDLE LEFT: Northwestern Indian Muslim chased silver tray, 12 inches in diameter, with variously colored animals and birds executed in champlevé enamel, interlaced with a floral motif.

OPPOSITE LOWER RIGHT: Eighteenth-century tray from the Deccan, inlaid tin on brass ($11\frac{1}{2}$ inches in diameter), with an incised floral and calligraphic design.

ABOVE: Detail of a nineteenth-century Bengali copper temple tray ($23\frac{1}{2}$ inches in diameter) with lotus center surrounded by engraved Shaktis (goddesses symbolizing female energy of a deity).

RIGHT: Nineteenth-century tinned copper tray with incised tree-of-life design. From north-western India. 12 inches in diameter.

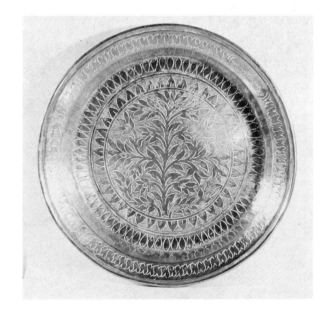

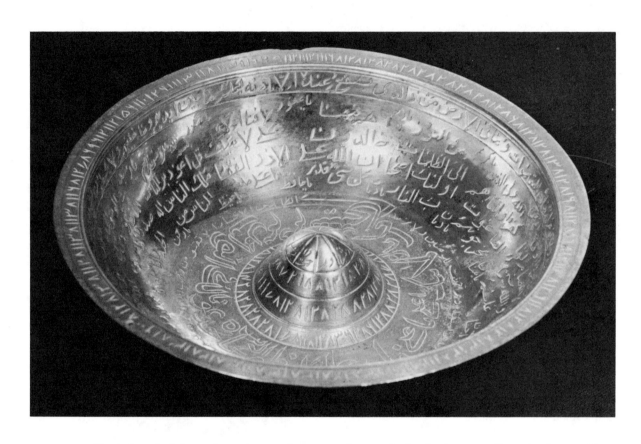

Tawiz bowl, eighteenth or nineteenth century, brass, 7 inches in diameter, from Lucknow, Uttar Pradesh. Incised are Allah's 101 names and prayers on the qualities of God, for protection from evil and for physical wellbeing. The underside, with its incised animals and numbers, shows the influence of Persian astrology and numerology. Water from the bowl is believed to have curative powers.

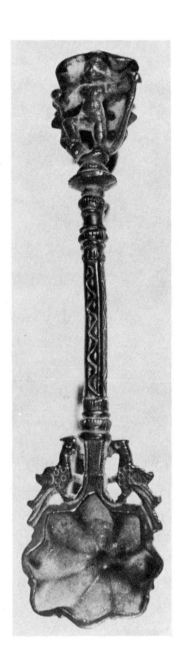

Panch pātra (holy cup) and *sruva* (spoon) for offering water to the idols. The nineteenth-century brass cup with inlaid copper (actual size) from north central India has punched and incised diamond shapes and flowers on its sides. On the bottom, outside (not seen in photo), is a lotus flower encircled by petals. The eighteenth-century southern Indian copper spoon (5½ inches long) has a lotus bowl and a Hanuman image at the end of the handle.

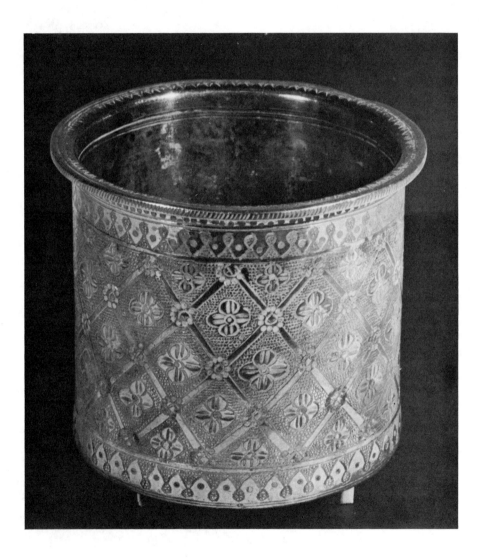

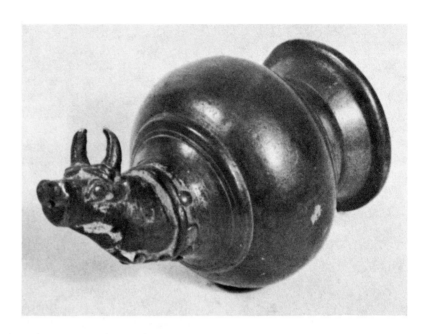

Holy water sprinklers, with *loṭā* bowls and cow-head spouts (probably symbolizing Surabhi, the cow of plenty), used for anointing the images of the gods.

ABOVE: Brass, eighteenth century, 4 inches long, from western India.

BELOW: Bronze, seventeenth century, 5 inches long, from southern India.

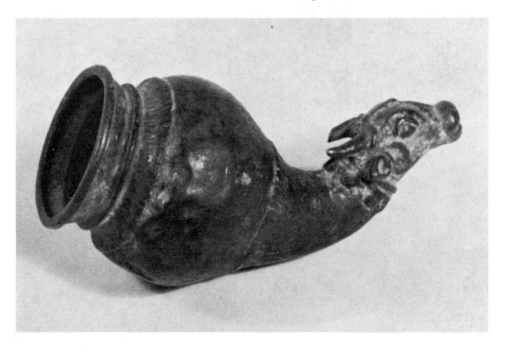

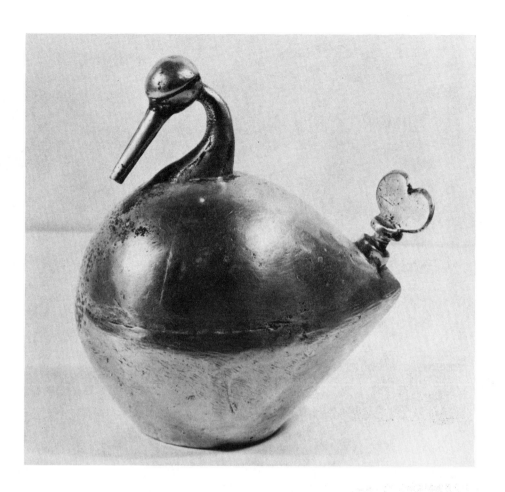

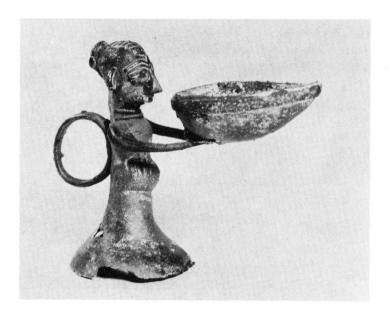

ABOVE: Holy water container. Eighteenth-century brass duck, 6¾ inches high, from north central India, used for carrying water from sacred rivers. The tail is a screw stopper for filling.

LEFT: *Dīpa-Lakshmī*, a simple contemporary village oil lamp (*dīpa*) in the form of a woman. Made by the *cire perdue* (lost wax) process by Dhokra casters, Bankura, West Bengal. This is an *arati* lamp, which is waved before the idol. Actual size.

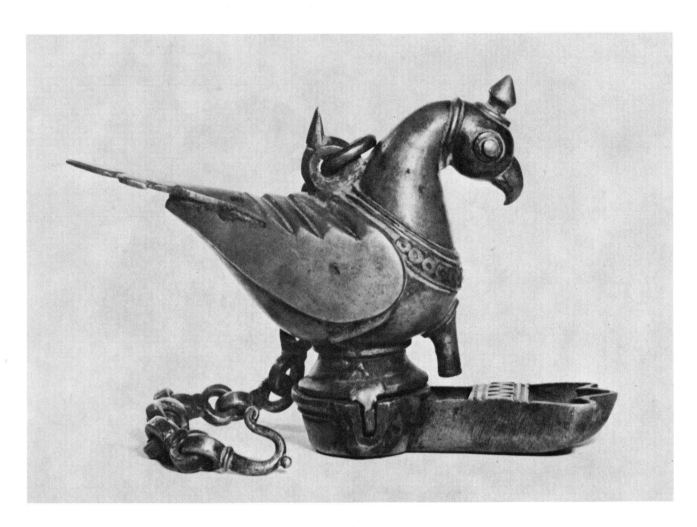

ABOVE: Hanging *dīpa* in the form of a peacock, brass, 5 inches high. Oil contained in the body drips through the spigot into the well that forms the base. The flat, trident-shaped tail is typical of many *haṁsa* (gander) lamps indigenous to southern India. Combinations of peacocks, ganders and paddy birds are used.

RIGHT: *Sandhyā pradīpa*, a nineteenth-century Dhokra brass elephant lamp (actual size) of a type commonly seen in Bengali households. The figure of Lakshmī, supporting an auspicious *loṭā*, screws into the top of the elephant. The relationship between the potter and the Dhokra artisan is seen in the decoration and molding here.

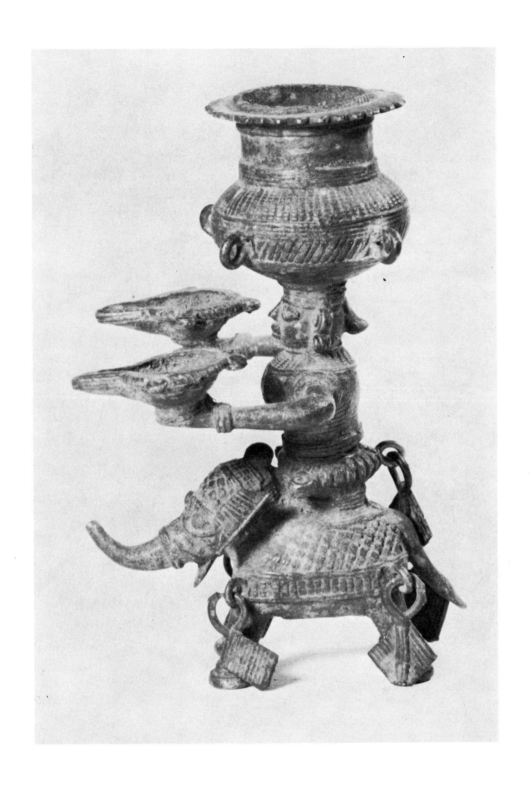

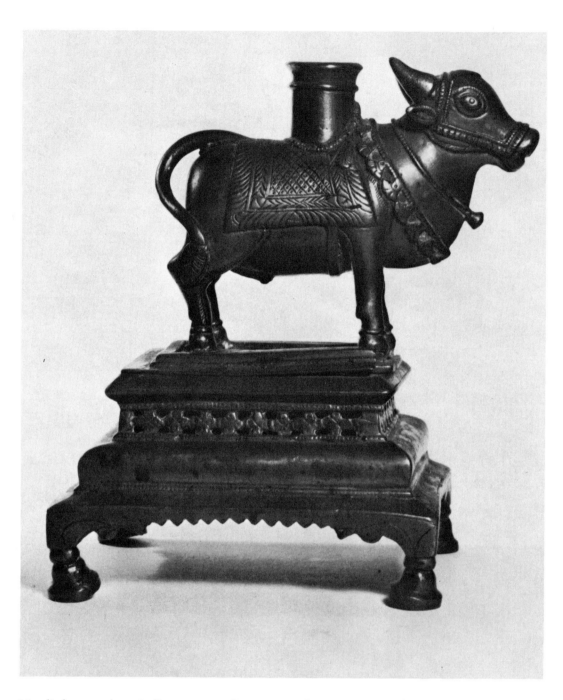

Nandi *dīpa*, southern Indian, copper gilt, seventeenth century, 11 inches high. The bull Nandi (Shiva's vehicle) slides into the grooved base. The lamp (now missing) held by the cylinder at the top was possibly cobra-headed (like the one seen opposite) or *liṅga*-shaped.

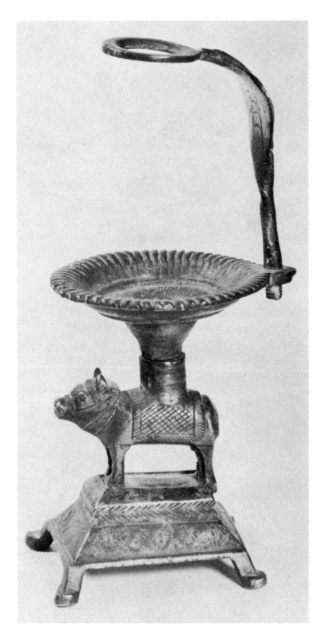

LEFT: Nandi *dīpa*, nineteenth-century north central Indian brass oil lamp or incense burner with a cobra-and-ring holder attached to the oil reservoir which fits into the cylinder on top of Nandi. The execution of the lamp, characteristic of Moradabad work, is much cruder than that of the *dīpa* on the opposite page.

BELOW: Lakshmī *arati*, an eighteenth-century brass votive lamp from the Deccan with *panch arati* (five oil lamps) held by the elephant's trunk. (*University of Missouri Museum*)

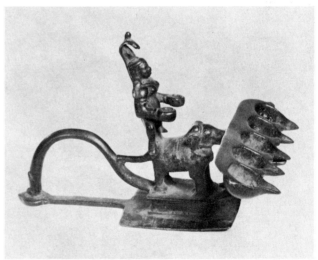

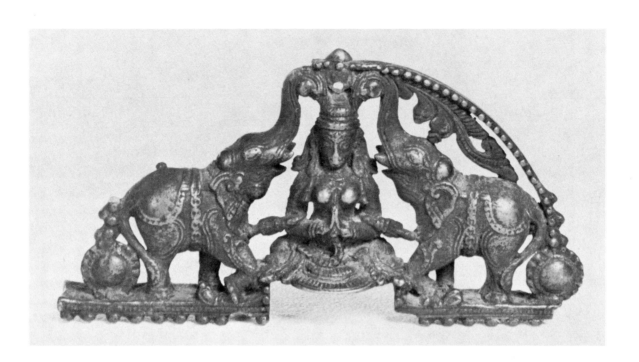

Gaja–Lakshmī *dīpa*, a nineteenth-century brass lamp fragment, shows Lakshmī, with her hands held reverently in the *anjalī hasta* position, attended by elephants.

(*University of Missouri Museum*)

 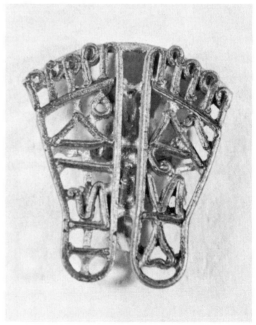

Brass printing seals for printing (reversed) designs in red on saffron cotton prayer cloths (example seen above), and sometimes on the bodies of devotees; displayed at the Kālī Temple bazaar, Calcutta. Beginning far left: heart shape; feet of Vishnu with name of Rādhā; and conch shell.

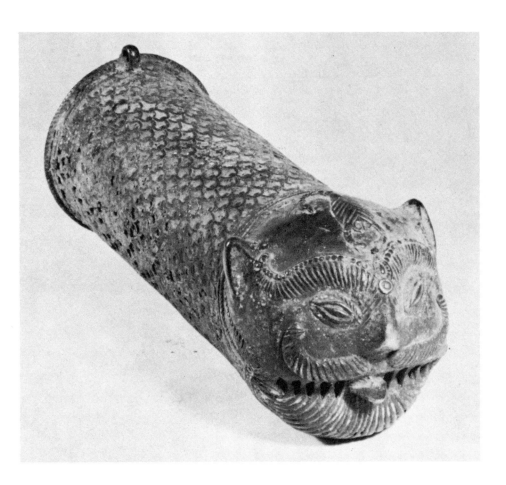

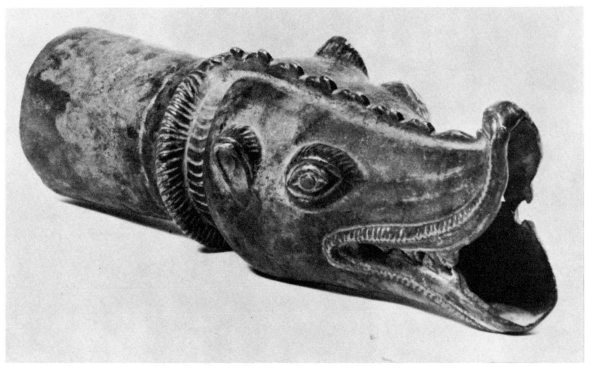

88 METAL

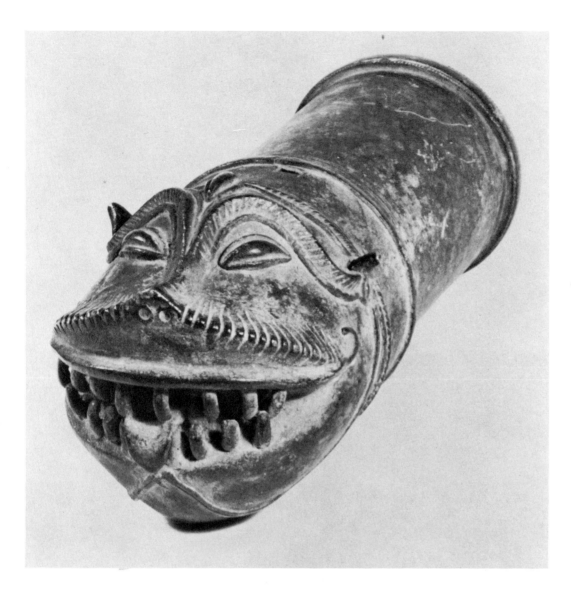

UPPER LEFT & ABOVE: Eighteenth-century brass monster finials used as protective images. Note the flame-shaped eyes, bared teeth, ravenous tongue and the all-seeing Shivaite eye. The one above, 11¾ inches long, is from Bihar. The one at the upper left, from central India (12 inches long) displays benevolent ferocity. On its head is the scorpion which symbolizes suffering. The scale-like design on the cylinder reflects the strength of chain armor or the vigor of a serpent.

LOWER LEFT: Nepalese bronze spout, representing a *makara* (vehicle of Gaṅgā). Seventeenth or eighteenth century. 8 inches long. This type of *makara* with open mouth, curled-up snout and sharp teeth, which was developed about 150 B.C., also appears on bracelets given to Bengali brides. (*University of Missouri Museum*)

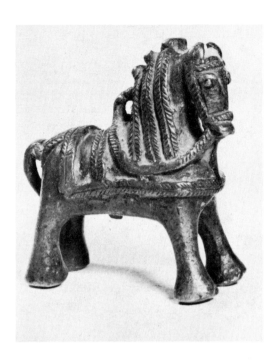

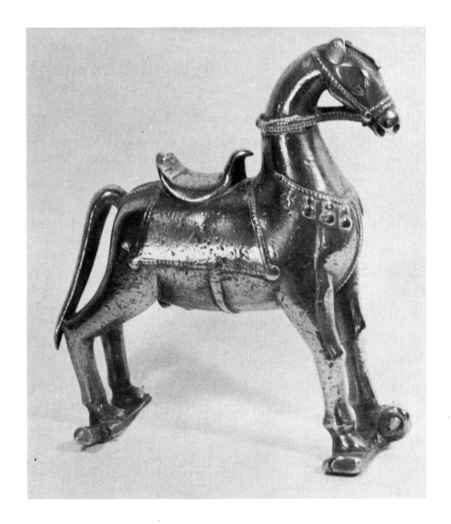

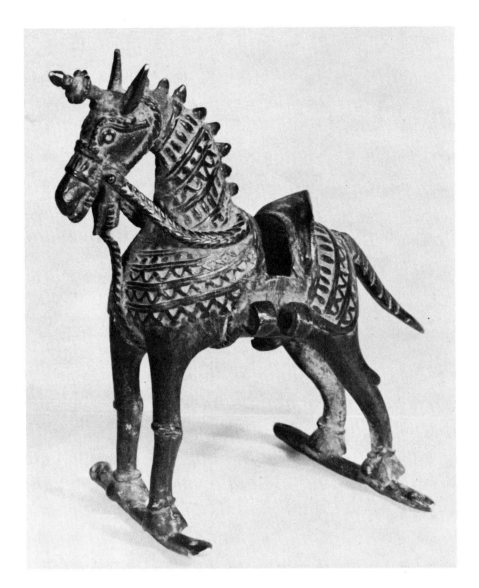

Horses frequently appear in Hindu mythology. A horse is the vehicle of Kandeh Rao (an avatar of Shiva); the divine horse Dadhikrā is mentioned in the *Rig Veda*; Indra's white horse Ucchaihśravas appeared when the ocean was churned; the horse sacrifice *aśvamedha* is prominent in the *Rāmāyaṇa* and elsewhere. The significance of the horse in early times rivaled that of the cow.

ABOVE: Brass toy horse, originally with wheels, made by the Bengali Dhokra casters in the seventeenth or eighteenth century. Actual size.
(University of Missouri Museum)

OPPOSITE ABOVE: Nineteenth-century central Indian brass (actual size).

OPPOSITE BELOW: Northwestern Indian brass, showing Persian influence, seventeenth or eighteenth century, 6½ inches high.

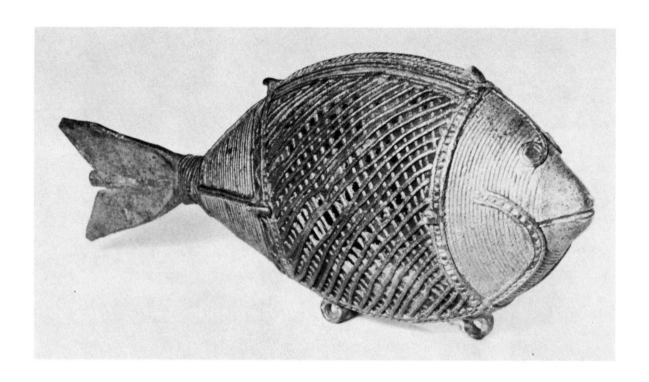

ABOVE: Old brass fish-shaped casket (actual size), a coin container made by the Dhokra craftsmen in Bengal. The *jāli* (crisscross construction) is similar to basketry. Brides take such auspicious caskets to their new homes.

RIGHT: Wall lizard or "chipkillie," sixteenth- or seventeenth-century bronze (actual size) from Jaipur, Rajasthan. The *Gowli Śāstra*, the scientific manual of wall lizards, describes the meaning of their movements and sounds. They are very common in India and are considered to be prophetic.

RIGHT: Owl. Nineteenth- or twentieth-century Bengali Dhokra brass (actual size) worshipped at festivals of Kārttikeya, Brahmā and Lakshmī (with whom the owl is most frequently associated in Bengal).

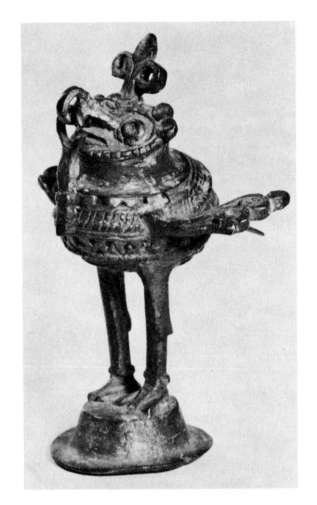

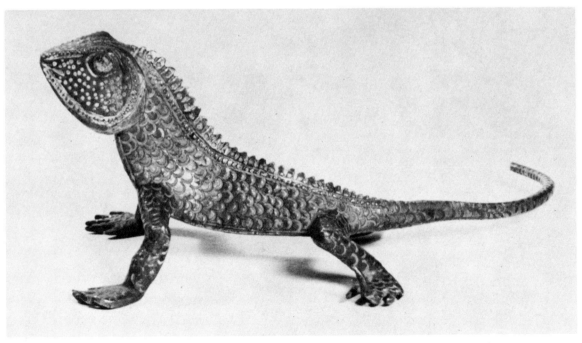

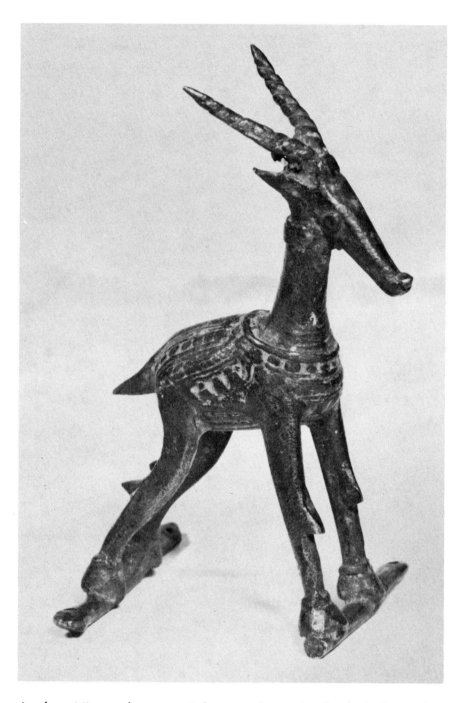

Antelope. Nineteenth- or twentieth-century brass, 4¾ inches high, from Bihar. The antelope is the vehicle of the Vedic gods Chandra (the Moon), Soma and Vāyu. On this toy and object of worship are traces of vermilion (used in rituals). (*Mr. and Mrs. J. W. Singer, Jr.*)

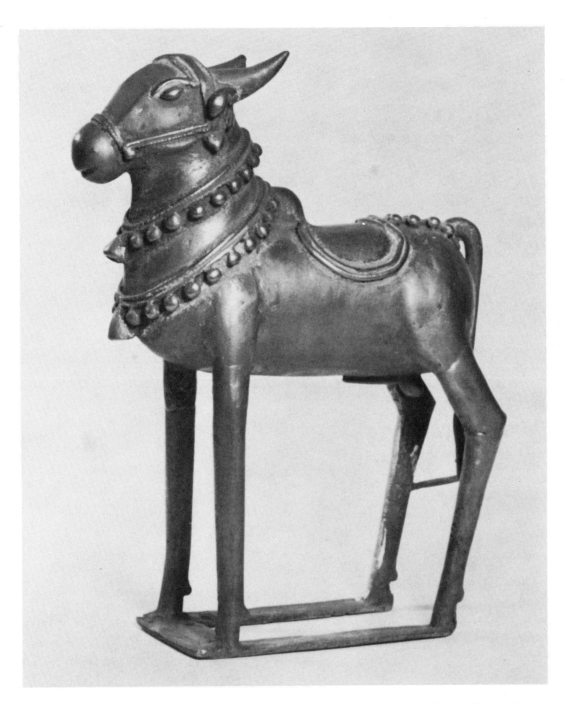

Nandi (bull of Shiva). Old brass *cire perdue* cast (actual size) from northern India, made for a household shrine or local temple. The proportions are exaggerated (especially the legs) to suggest Nandi's potential power.

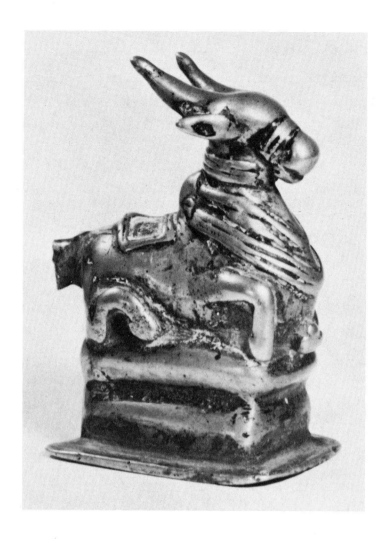

Nandi *liṅgas* are used in the worship of Shiva. The *liṅga* is in front of each bull.

ABOVE: Eighteenth- or nineteenth-century brass (actual size) from Hyderabad.

RIGHT: Eighteenth-century bronze, 4 inches high, from Mysore, probably a fragment of a processional piece.

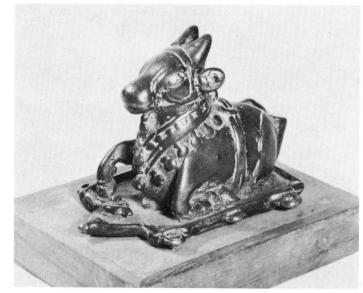

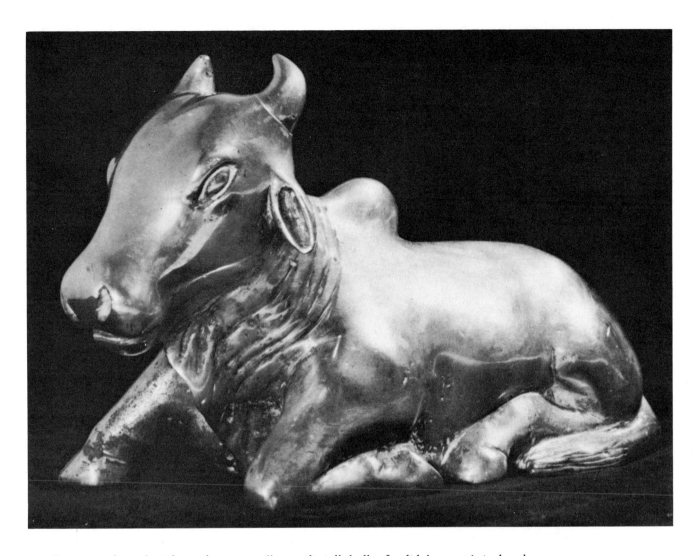

Nandi, an unadorned eighteenth-century "naturalistic" bull of solid brass, 8½ inches long, weighing 14 pounds, from north central India, probably designed for use in the temple.

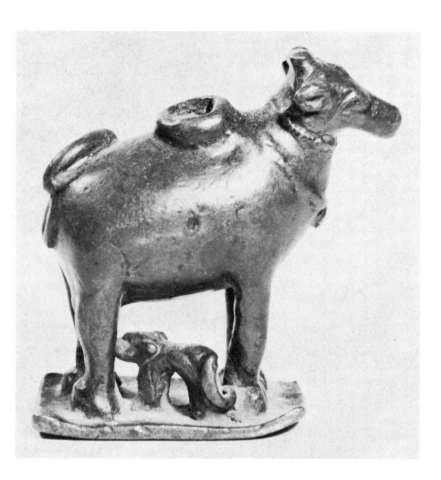

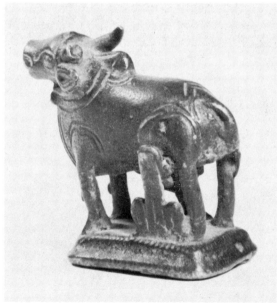

ABOVE: Cow and calf, nineteenth-century brass, 2 inches high, from north central India, a crude but expressive village household image.

LEFT: Cow and milker, with calf on opposite side, eighteenth- or nineteenth-century bronze, 1¼ inches high, from southern India, with flat, stylized features. Both pieces, kept in the household, assure a good calving season and evoke Surabhi, the cow of plenty.

OPPOSITE: Processional plaque representing Vīra Bhadra, a fierce emanation of Shiva. Seventeenth- or eighteenth-century copper repoussé (actual size) from western India. Vīra Bhadra is enraged by the Vishnuite sacrifice made by Daksha (with goat's head, left). Vīra Bhadra's consort Umā (right) encourages him in the conflict. Other prescribed motifs appear within the expressively rendered scheme.

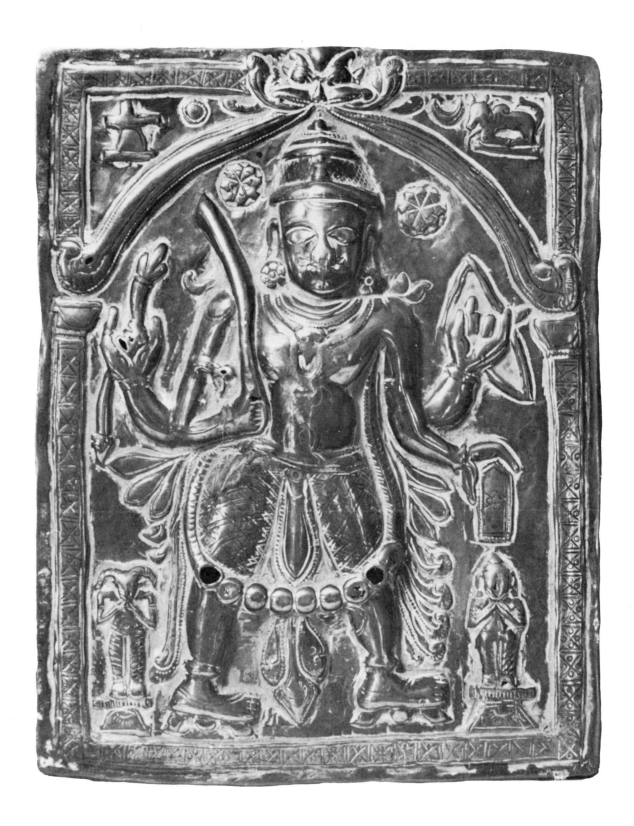

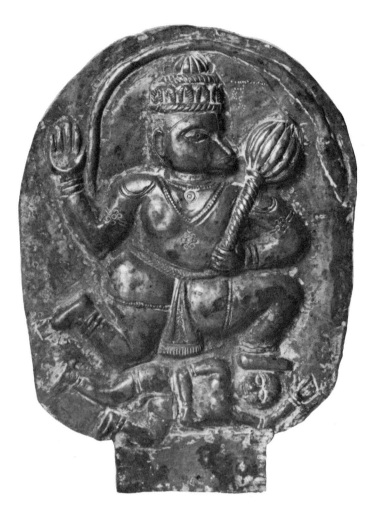

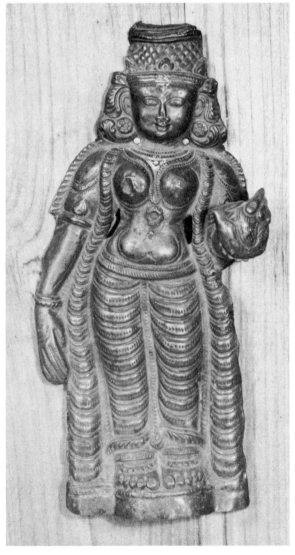

ABOVE: Repoussé plaque, nineteenth century, 7½ inches high, from north central India, which represents simply but forcefully Hanuman, the monkey god, killing a demon. Hanuman is the god of strength, an ideal friend and servant and a *Rāmāyaṇa* hero.

RIGHT: Another repoussé image of a goddess, possibly Lakshmī or Padmāvatī (lotus goddess). Eighteenth or nineteenth century, 12 inches high, from southern India. The left hand is in *kaṭaka hasta* position (holding flower); the body is in *ābhaṅga* pose (upper half inclined to the left).

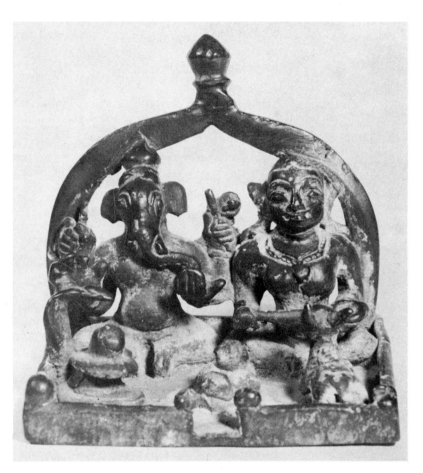

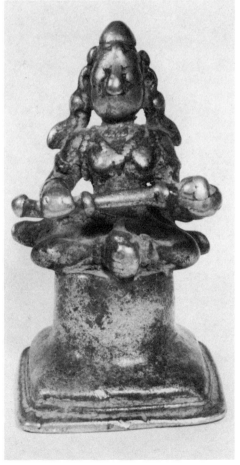

ABOVE: Annapūrṇā and Ganesh, early nineteenth-century bronze, 2¾ inches high, from central India, a household image for worship. With Ganesh (remover of obstacles and lord of harvest) and Annapūrṇā (a benevolent form of Pārvatī, Ganesh's mother and bestower of food) are the *liṅga*, Nandi, and the *panch-piṇḍa* (five piled stones) representing Vishnu, Sūrya, Pārvatī, Ganesh and—on top—Shiva. (*Mr. and Mrs. J. W. Singer, Jr.*)

RIGHT: Annapūrṇā. Nineteenth-century brass, 3 inches high, from north central India. Annapūrṇā is always portrayed holding a ladle, signifying her bountiful attributes. (*Mr. and Mrs. J. W. Singer, Jr.*)

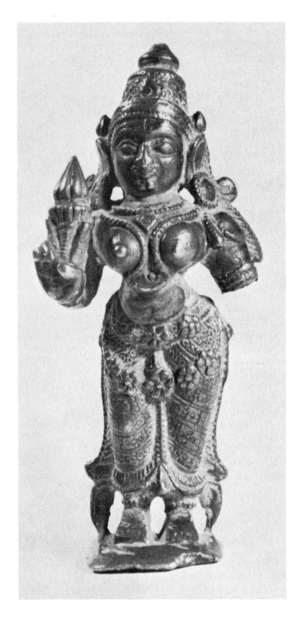

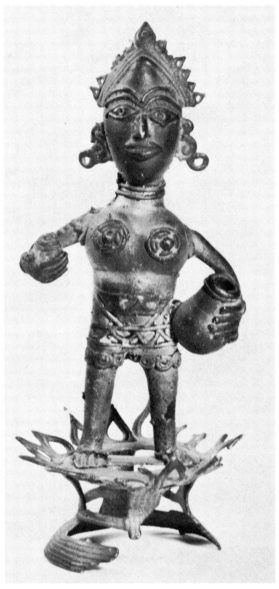

Pārvatī. Seventeenth-century southern Indian bronze. The consort of Shiva holds a lotus in her right hand and takes the *ābhaṅga* body position.

Lakshmī, or possibly Bhū Devī. Contemporary brass *cire perdue* image cast at Bankura, West Bengal, with a simple, primitive execution.

LEFT: Vishnu and Lakshmī on Śeṣa. Eighteenth- or nineteenth-century brass from western India (actual size). A common portrayal of Vishnu reclining on a serpent (Śeṣa, Nāga or Ananta) and attended by Lakshmī, who is rubbing his leg.

BELOW: Shivaite figures, *grāma devatās* (village gods). Eighteenth-century bronze, 4 inches high, from Karnatak (the Carnatic). Attributes of Shiva, such as the *liṅga*, crescent moon and sun, Nandi and the *panch-piṇḍa*, are incorporated into the primitively styled image.

(*Mr. and Mrs. J. W. Singer, Jr.*)

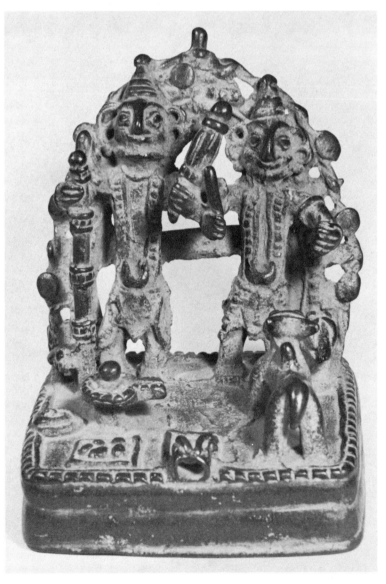

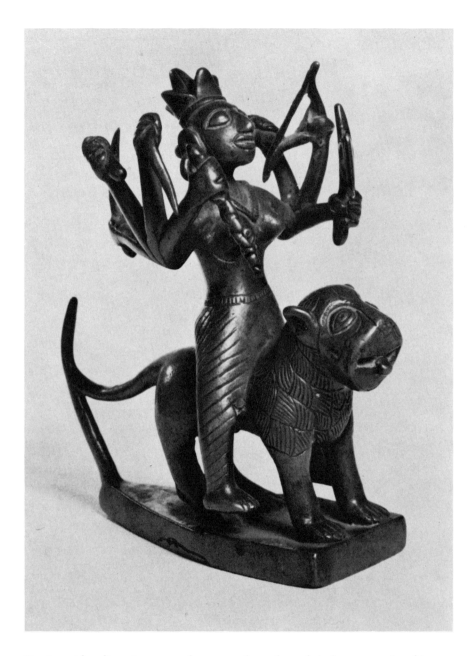

Devī astride a lion. Seventeenth-century brass (actual size), a processional image with tail-handle. As Shiva's consort in her destructive form, Devī holds weapons in eight arms. The lion's lolling tongue symbolizes Devī's ravenous nature. The simple, stylized treatment of the figure is characteristic of Kulu Valley images.
(*University of Missouri Museum*)

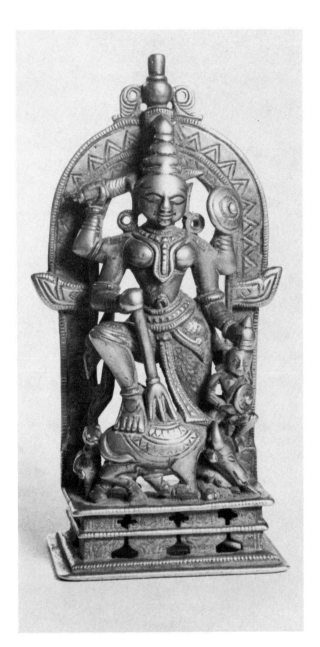

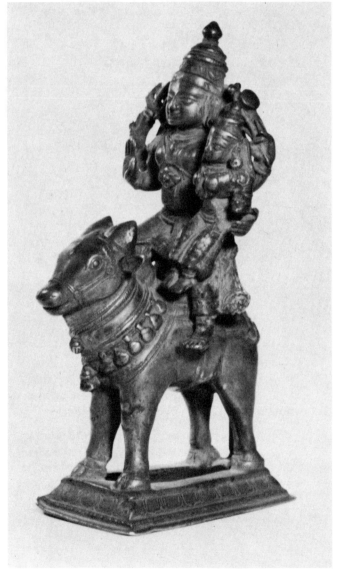

ABOVE: Mahiṣa-asura-Mardinī ("Buffalo-Demon-Killer"). Seventeenth-century bronze from central India (actual size). This is a form of Durgā (fierce aspect of Pārvatī) who kills the *asura* (demon) Mahiṣa (Mahiṣāsura), who is in the form of a water buffalo. (*University of Missouri Museum*)

RIGHT: Shiva and Pārvatī on Nandi. Seventeenth-century bronze, 7½ inches high, from southern India. The two figures slide into the grooved top of the stylized bull.

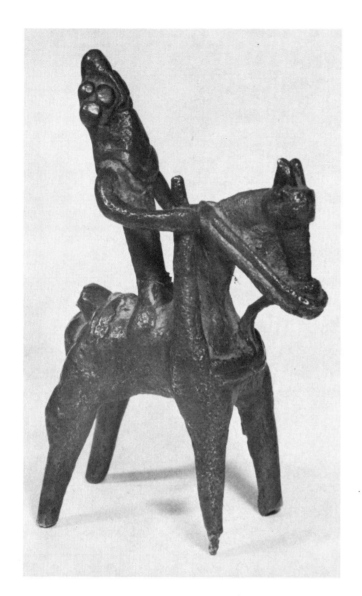

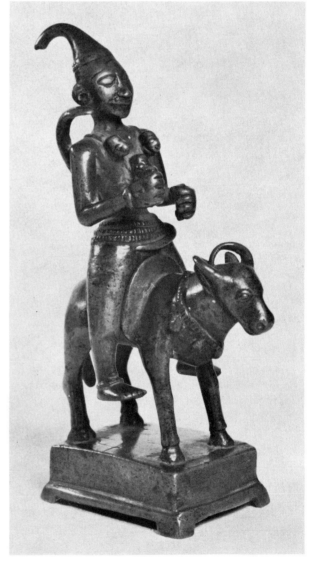

ABOVE: Man on horse. Nineteenth-century brass, 3½ inches high, from western India. Possibly Kandeh Rao (Shiva avatar and popular hero in this region). The attenuated and commanding rider serves as a spontaneous contrast within the massive primitive motif. (*Mr. and Mrs. J. W. Singer, Jr.*)

RIGHT: Shiva on Nandi. Eighteenth-century brass, 5 inches high. Characteristically, this Kulu Valley image has little surface embellishment. Shiva in demonic form is wearing a *muṇḍ-mālā* (necklace of human skulls). (*University of Missouri Museum*)

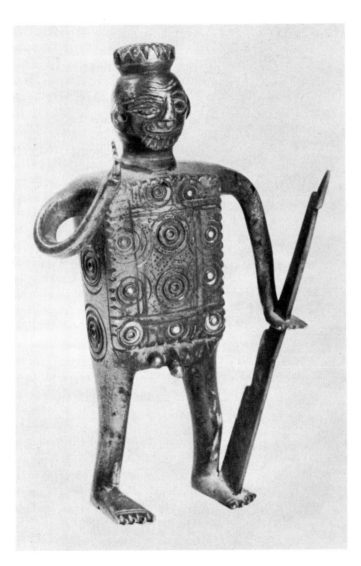

ABOVE: Warrior. This simply executed late eighteenth-century brass image from Vizagapatam (on central eastern coast of India), is seen as a whimsical martial figure. 4 inches high.

RIGHT: Brahmā. Seventeenth-century brass from the Kulu Valley. The four-headed Brahmā is unusually portrayed here with a book in each of his four hands, symbolizing his tutelary aspects and wisdom. He also wears a conical crown with triangular flaps. 5 inches high.

(*University of Missouri Museum*)

Hanuman, shown here in two forms (both actual size), is a character in the *Rāmāyaṇa*, in which he helps to rescue Sītā (Rāma's consort) from Rāvaṇa, king of the Rākshasas (enemies of the gods).

BELOW: Early twentieth-century Moradabad brass. Hanuman is stepping on an *asura* he has subdued.

RIGHT: Seventeenth-century Kulu Valley brass. Hanuman holds a banner and club, leading his division of monkeys in the fight against Rāvaṇa. (*University of Missouri Museum*)

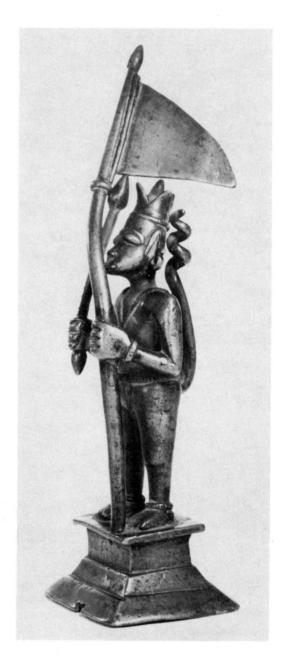

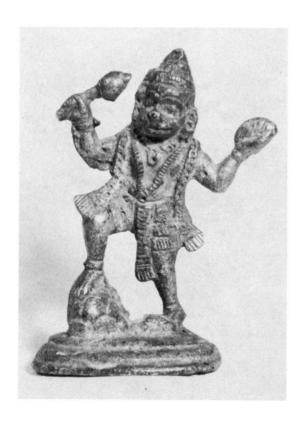

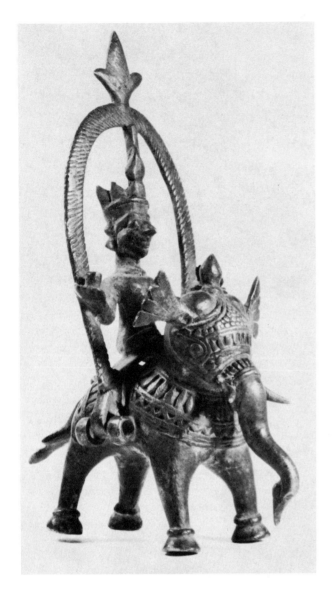

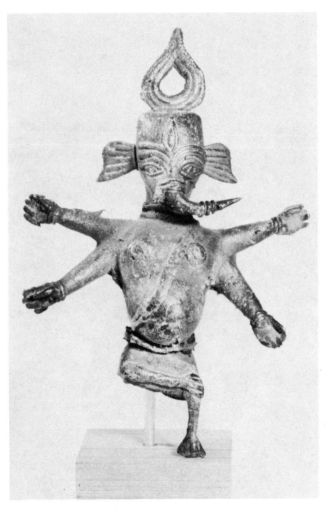

ABOVE: Indra on his elephant Airāvata, with a halo (rainbow) which is hinged to the elephant. This casket is a Bengali Dhokra cast brass, circa nineteenth century. 6½ inches high.

RIGHT: Ganesh, the elephant-headed god, son of Shiva and Pārvatī, portrayed in a primitive, light-hearted style by the resident Dhokra brass casters of Bankura, West Bengal. 5½ inches high.

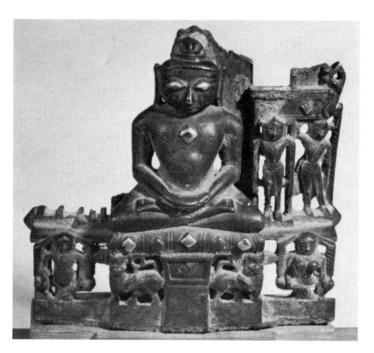

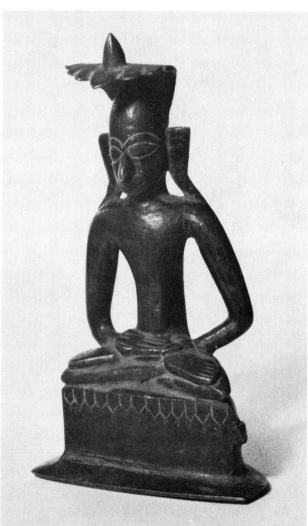

Tīrthaṅkaras, Jain saints or prophets, of whom there are twenty-four. Both shown here are in *padmāsana* position with hands in *yoga hasta* position, denoting meditation.

ABOVE: Fragment, possibly representing Neminātha. Seventeenth-century bronze with diamond-shaped silver relief (*śrīvatsa*), from East Khandesh, Madhya Pradesh.

LEFT: Pārśvanātha, the twenty-third *tīrthaṅkara*, is always distinguished by a snake canopy. Seventeenth or eighteenth century.
(*University of Missouri Museum*)

Krishna, Vishnu's eighth avatar, is seen here in three Bāla-Krishna forms, a young boy holding a spherical object which is either a butter ball or the world.

OPPOSITE TOP: As a mischievous child Bāla-Krishna is conventionally presented crawling. Nineteenth-century brass from northwestern India. (*Mr. and Mrs. J. W. Singer, Jr.*)

OPPOSITE LOWER LEFT: This eighteenth- or nineteenth-century bronze "jungli" (*jaṅglī* = "jungle-like, barbarous") piece is an unusual portrayal of the crawling Bāla-Krishna. The primitive execution of the figure gives it a whimsical charm.

OPPOSITE LOWER RIGHT: Navanīta-Krishna, in this humorously modeled seventeenth-century bronze from southern India, is gaily dancing.

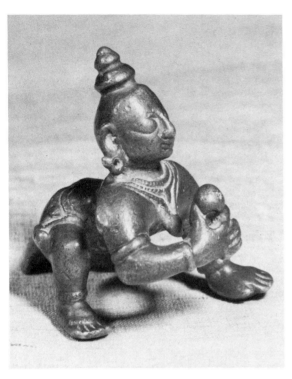

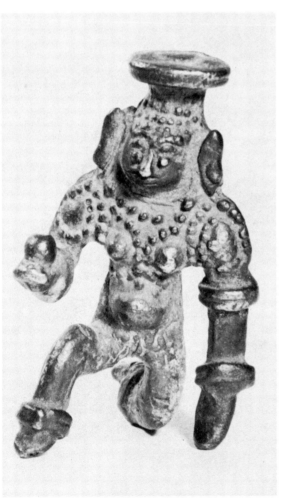

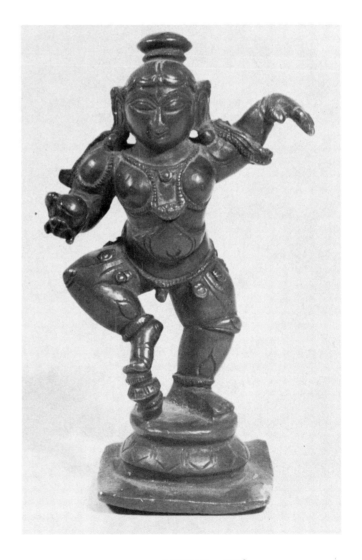

METAL III

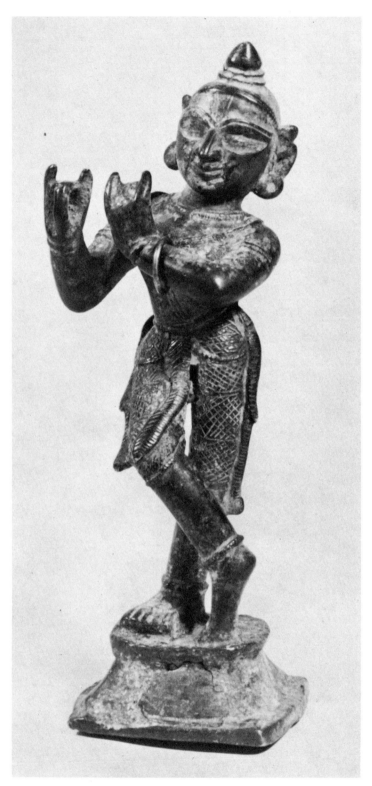

LEFT: Veṇugopāla. This seventeenth-century brass from Bengal is a solid casting of Krishna playing a flute. (*University of Missouri Museum*)

BELOW: Rādhā-Krishna. This eighteenth-century *cire perdue* brass is an almost childlike ornamented cylinder. Rādhā, Krishna's beloved *gopī*, is commonly worshipped along with him.

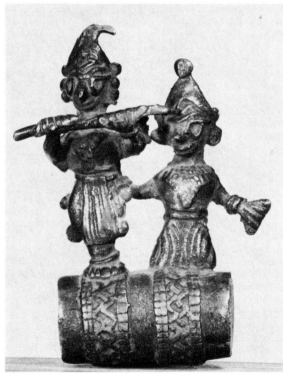

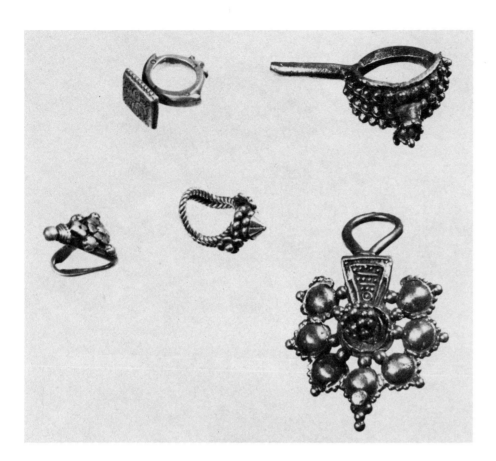

ABOVE: Toe rings, contemporary silver and silver-plated brass castings. The plated rings at the upper and lower left are from north central India; the braided type in the center is from northern India; and the heavy silver ones at the upper and lower right are from Ceylon.

RIGHT: *Pāhzeb*. Nineteenth or twentieth century, silver, from Ceylon. An anklet made of chains and pendants that clink together.

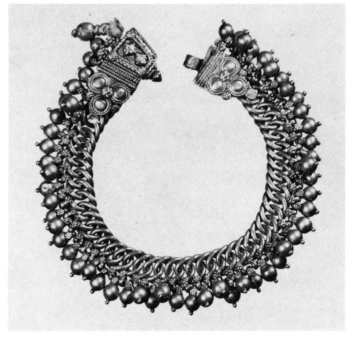

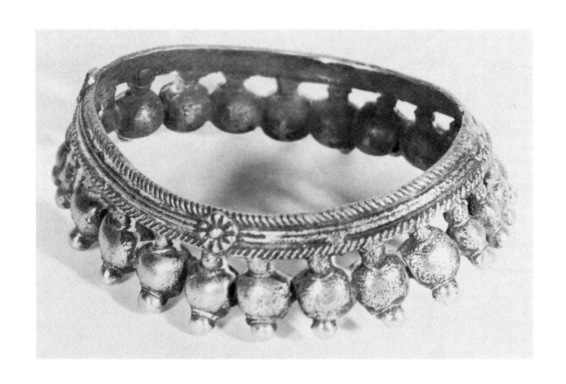

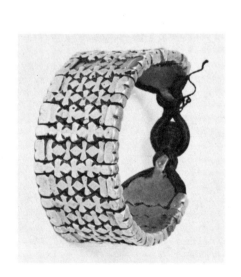

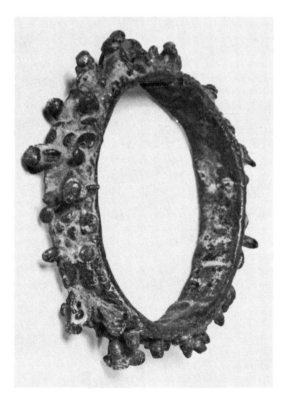

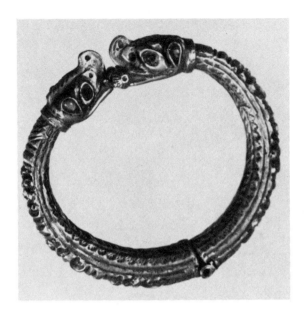 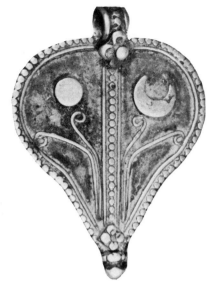

ABOVE LEFT: Bangle. Contemporary Nepalese hollow-cast silver, 3 inches in diameter, with ruby eyes on the *makara* finials.

ABOVE RIGHT: Silver talisman, nineteenth or twentieth century, from Ceylon, with sun and moon Shiva symbols, worn hanging from the waist between the legs of young boys to assure their manhood.

OPPOSITE ABOVE: Anklet. Nineteenth or twentieth century. Hollow-cast, silver-plated brass from north central India. Inside are metal pieces that jingle when the wearer walks.
(*Mr. and Mrs. E. L. Goldberg*)

OPPOSITE LOWER LEFT: Armlet, called *bāzū*, nineteenth century, silver, from north central India. The silver sections are held together by twisted threads.

OPPOSITE LOWER RIGHT: Bronze bracelet, seventeenth or eighteenth century, from central India, decorated with raised mythological figures and animals in a primitive style.

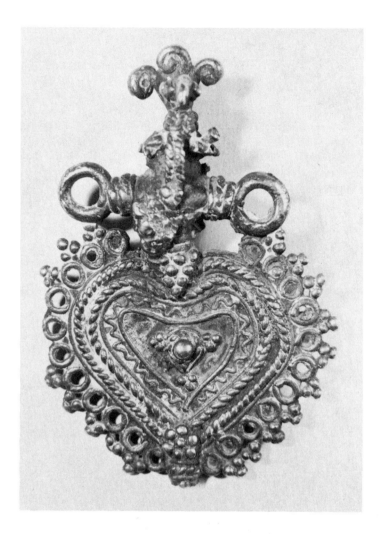

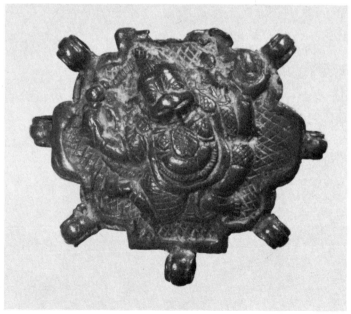

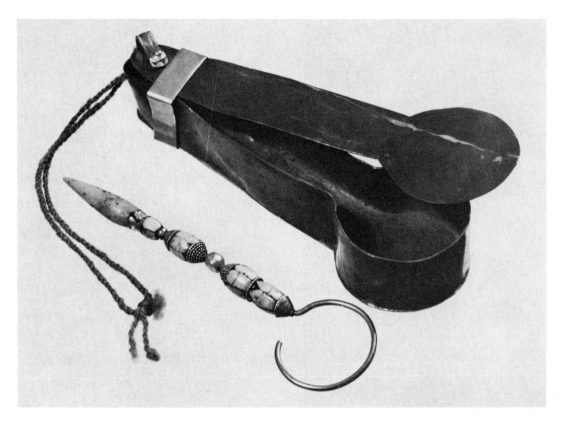

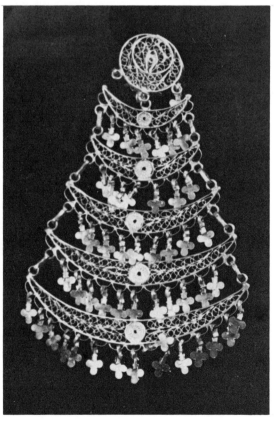

ABOVE: Eighteenth-century Tibetan earring and container. This earpiece of turquoise with gold decoration, pearl and brass loop is worn by important men; brass facsimiles are worn by servants. The copper box ($6\frac{1}{2}$ inches long) has a silver handle and slide.

RIGHT: *Kuṇḍala* (earring), contemporary, silver filigree, from Cuttack, Orissa (known for the outstanding quality of its products in this technique).

OPPOSITE ABOVE: Shivaite talisman, nineteenth century, heavy-cast, 5 inches high, with ornate surface embellishment, from western India. The goat's head at the top represents Daksha. The bull's head (Nandi) in the center and the bells in trident form are associated with Shiva.

OPPOSITE BELOW: This Hanuman talisman, nineteenth-century cast copper (actual size) from southern India, shows the monkey god carrying Rāma and Sītā and leaping to demonstrate his prodigious strength.

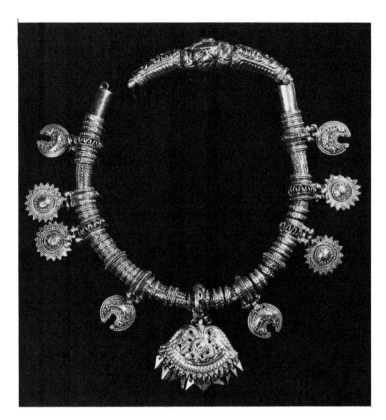

LEFT: Gold gilt necklace, eighteenth or nineteenth century, from Kandy, Ceylon, made of repoussé lotus and crescent-shaped medallions decorated with clustered gold balls added to the surface. These sections are held together by a thickly twisted gold thread.

BELOW: *Bāzū* armlet, eighteenth or nineteenth century, from the Punjab. A combination of brass and copper with each pair of links individually pinned together. The outer section is copper and the inner, brass.

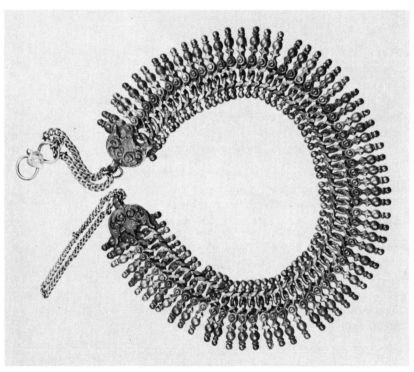

WOOD

Centuries ago India was stripped of its vast forests through agricultural encroachment, but wood, until the recent past, has been sufficiently abundant for carpenters to build and carve. Many fine and exquisite artifacts of wood, dating from the sixteenth century on, have been preserved in public and private collections or form an integral part of historic structures. Nevertheless, decay due to moisture and insects has considerably reduced the existing number. Some artistic production continues.

Sculptural and structural productions in wood have influenced those executed in stucco, brick, stone and metal. The Sanchi stupa stone railings are a direct translation from earlier wood railings; the terracotta temples of Bengal are similar to bent bamboo and carved supporting pillars; we can observe how the remaining wooden temples of southern India were transposed into the large stone and stucco Dravidian temples; even elements in the caves of Ajanta and Ellora have wood derivations.

All of the earth's organic and inorganic materials are involved in the Hindu concepts of existence and religion. Natural phenomena evoked spiritual interpretations. Tree worship was common and continues in varied forms in Hindu and tribal practices. As Bosch explains,[1] the *padmamūla*, the earthly germ, produced the lotus and terrestrial trees, eventually evolving into animal life and human beings. The *brahmamūla*, the celestial germ, produced celestial trees and the gods. *Amrita* (elixir of life) in the form of *soma* juice or sap sustains life. Therefore, the natural tree trunk or carved form embodies *amrita* and signifies sustenance to devotees. The carver's embellished forms are carefully made to meet religious requirements.

Hewing the image or utensil from the trunk or block is the task of the Sūtradhāra, the carpenter caste whose eponymous mythical ancestor is the carpenter son of Viśvakarmā. Temples, houses, palaces, gates, shrines, chariots and domestic accessories of wood provide numerous surfaces and volumes to embellish with sculptured and painted patterns or images.

[1] F. D. K. Bosch, *The Golden Germ*, Mouton & Co., 's Gravenhage, 1960; pp. 39–46, 73–81, 106–127, 140–150, 210–213 and *passim*.

In present-day India the professional wood carvers in village industries (such as those found in Mysore and Kashmir) produce an abundance of work. These objects, usually turning out as curios, are executed with significant skill but lack the profundity, authenticity and command found in older works. There are, however, some craftsmen remaining who have maintained a more indigenous or less debased approach.

Older objects, as well as some of the new ones that have been treated in harmony with the genuine evolution of religious and cultural ideas, illustrate the sustained authenticity of handling wood.

These meaningful wood forms, therefore, may be placed among the artisan's more artistic endeavors.

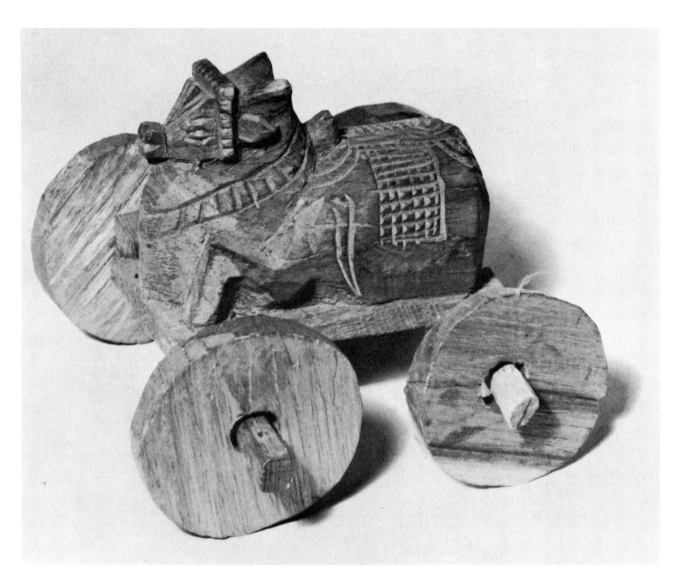

Nandi toy (actual size). The roughly carved wood image, on sale in the Mysore City Market, is a likeness of the monumental seventeen-foot-high stone Nandi at a nearby mountain shrine (Chamundi Hill).

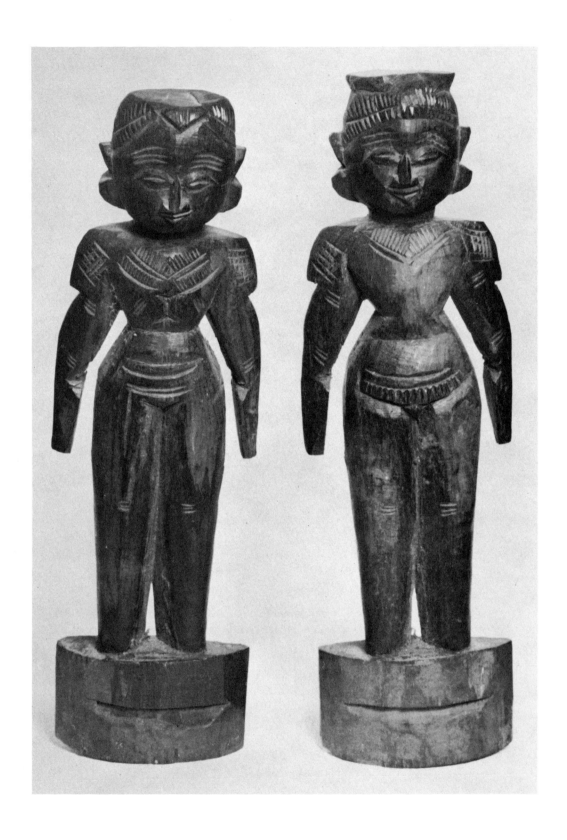

122 WOOD

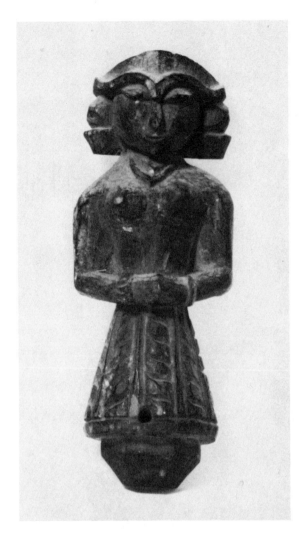

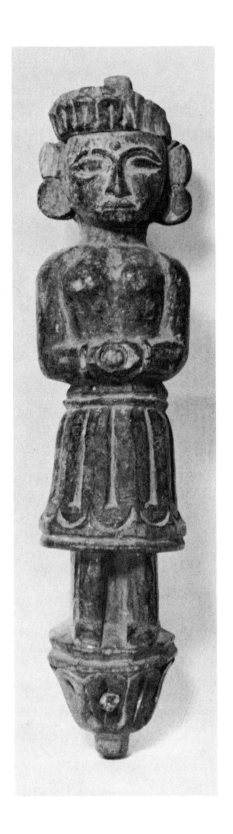

Brackets (for houses, temples, chariots) from western India, circa seventeenth to eighteenth centuries.

ABOVE: Idealized female devotee. 6 inches high.

RIGHT: Goddess, probably Lakshmī. Crown, skirt and base are all in lotus form. 12 inches high.

OPPOSITE: Husband and wife *dāmpati* (donor couple), 9 inches high, made in Tirupati, Andhra Pradesh. Couples with modest means buy these idealized effigies to emulate wealthy donors like those represented in the Buddhist stone caves of the Deccan, and to obtain spiritual and material benefits from the deities of their chosen shrine.

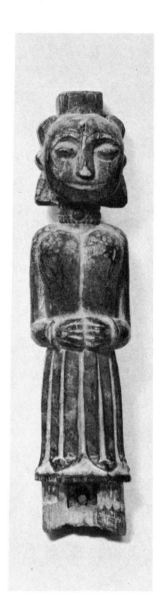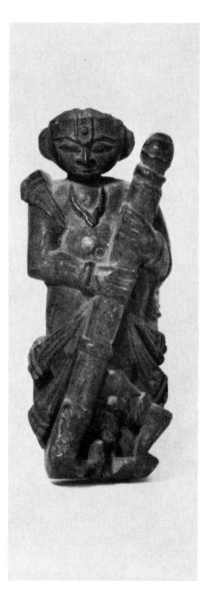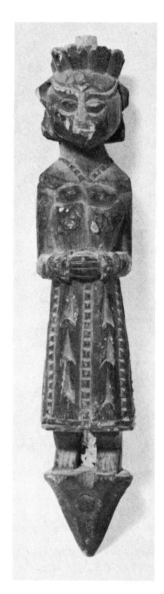

Brackets from western India, circa seventeenth to eighteenth centuries, from 6 to 12 inches high. From left to right: A devotee; a Vishnuite *dvārapāla* (doorkeeper) with *gadā* (club of Vishnu); and a Lakshmī-like goddess.

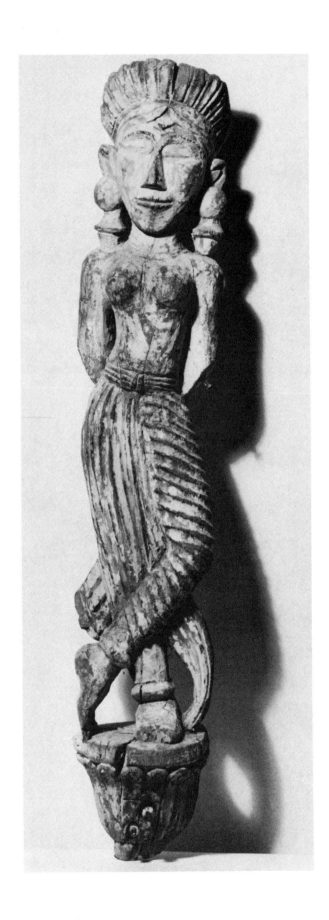

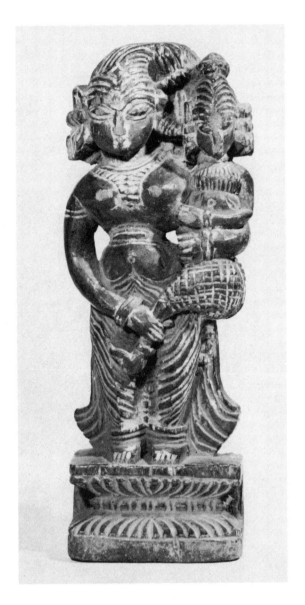

ABOVE: Yashodā or Devakī "Madonna" holds Bāla-Krishna. A household image, 9 inches high, from the same area and period.

LEFT: A goddess bracket, 28 inches high, from a processional chariot or temple in western India, circa seventeenth to eighteenth centuries. Encrusted paint forms a mellow patina.

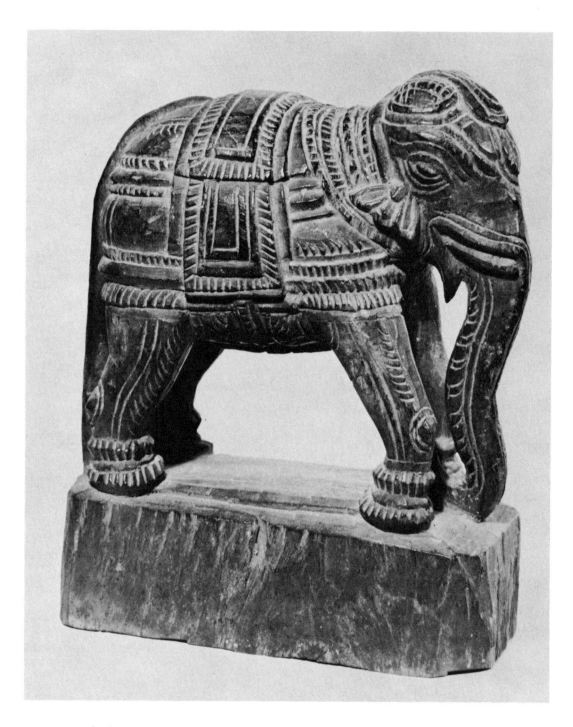

Auspicious elephant, 9½ inches high, from Gujerat, circa seventeenth to eighteenth centuries. The elephant often appears as Indra's *vāhana* (Airāvata), Lakshmī's companion or the vehicle of important and powerful personages.

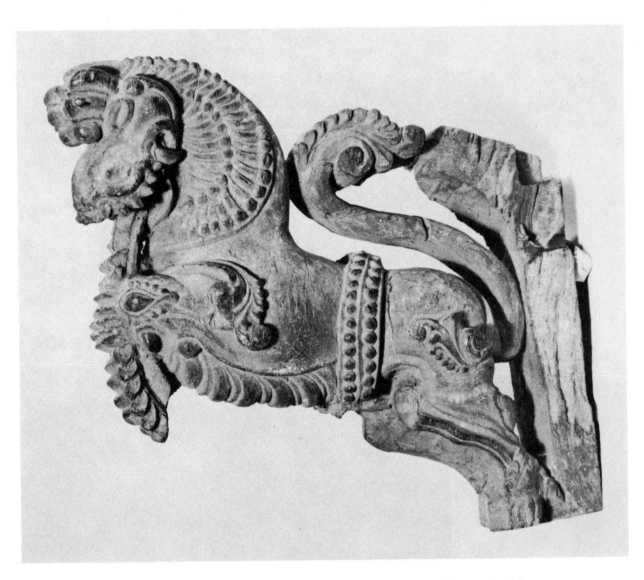

Lion bracket, 7 inches long, from southern India, circa seventeenth century. The energized form, with florescent leafy flames, guards against demons and is closely related to the Shivaite *kīrtti-mukha* ("face of glory").

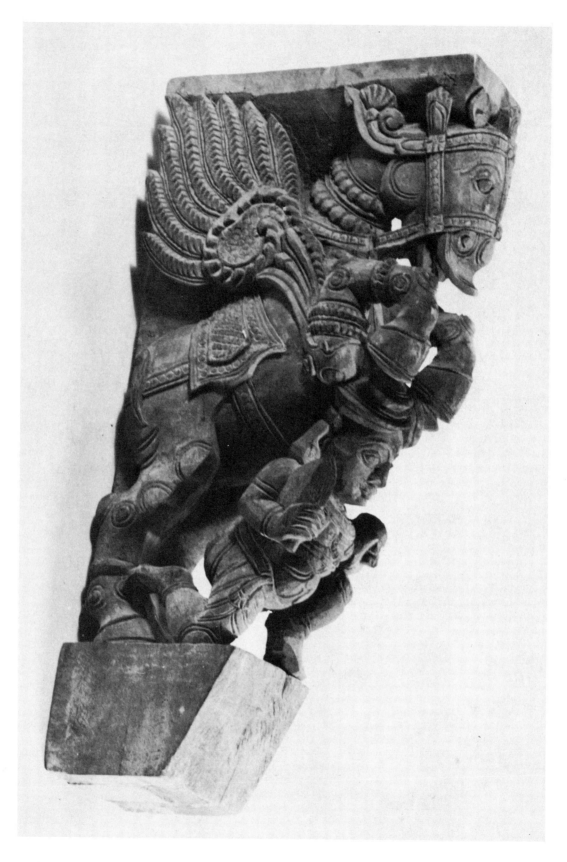

128 WOOD

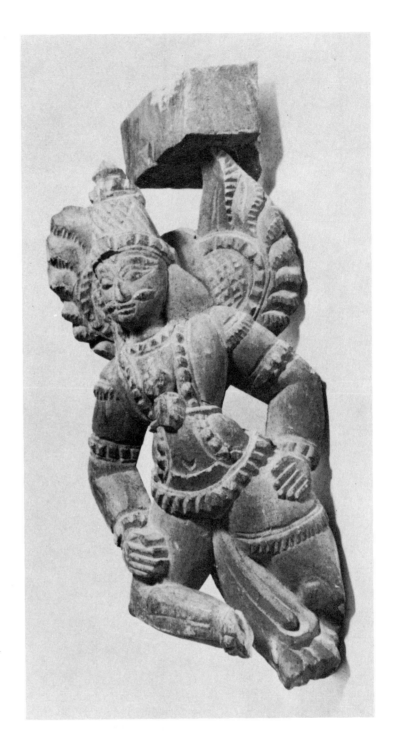

RIGHT: Bracket, 8 inches high, representing Garuda (celestial bird king, Vishnu's *vāhana*) as a winged human being. From western India, seventeenth or eighteenth century. This image has been conceived with celestial vigor in form and pose.

OPPOSITE: Celestial horse bracket, 12½ inches high, from southern India, circa eighteenth century. The horse is poised on an armed attendant. Such motifs are associated with the flaming chariot of the sun god Sūrya and the horse sacrifice *aśvamedha*, an ancient rite of kings.

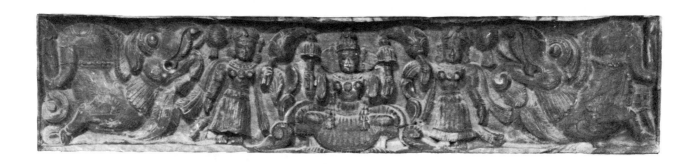

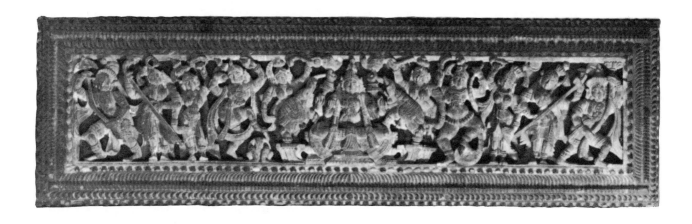

TOP: Door lintel from southern India, seventeenth century, 25 × 8 inches. Lotus goddess (Lakshmī or Gangā), majestically flanked by attendants and *makara*-headed quadrupeds, insuring the wellbeing of the dwelling and occupants.

BELOW: Panel of the same size. Lakshmī with elephants, and Krishna dancing with *gopīs*.

OPPOSITE: Lion bracket, 15 inches high, from southern India, circa seventeenth to eighteenth centuries. The power and prowess of the protector's form wards off impious creatures.

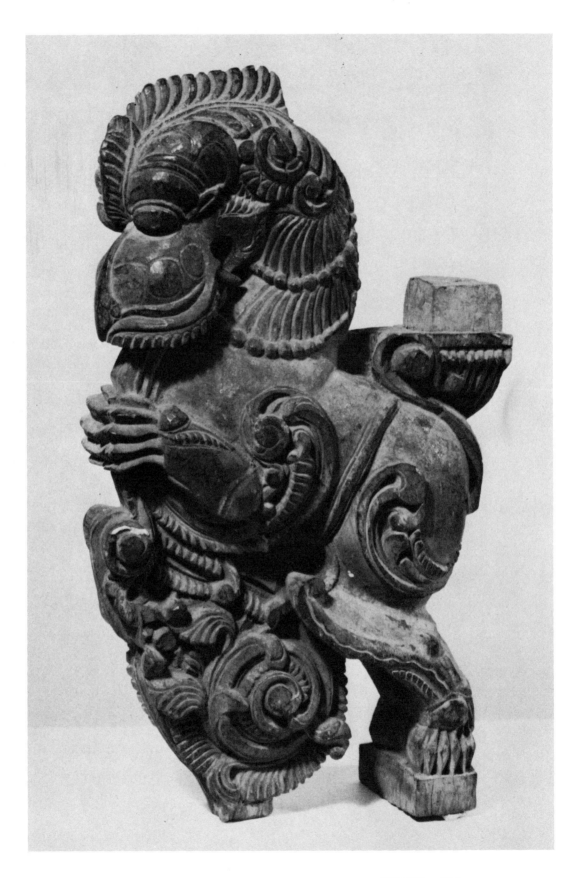

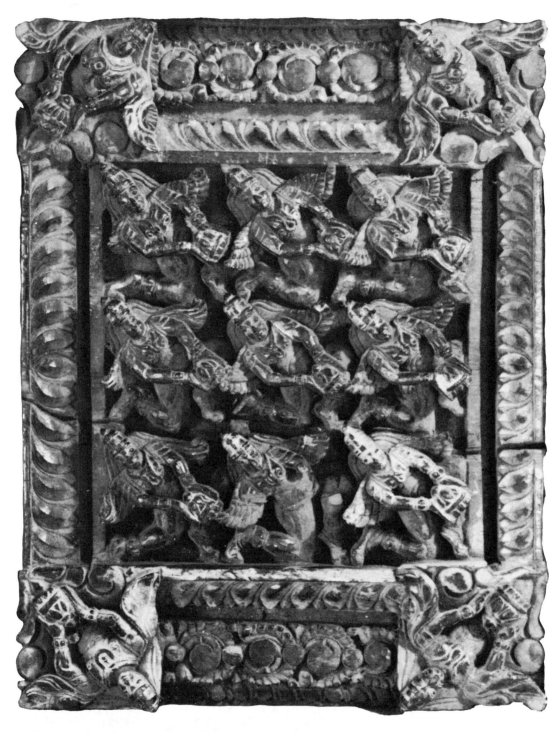

Ceiling panel with *apsaras* (heavenly maidens) bearing caskets of good fortune. 11 × 16 inches. From Gujerat, seventeenth or eighteenth century.

LEFT: Sweetmeat molds shaped like fish, leaves, conch shell and swastika, 1 to 2 inches long, from Bengal.

BELOW: Fish toy, jointed, 10½ inches long. Contemporary.

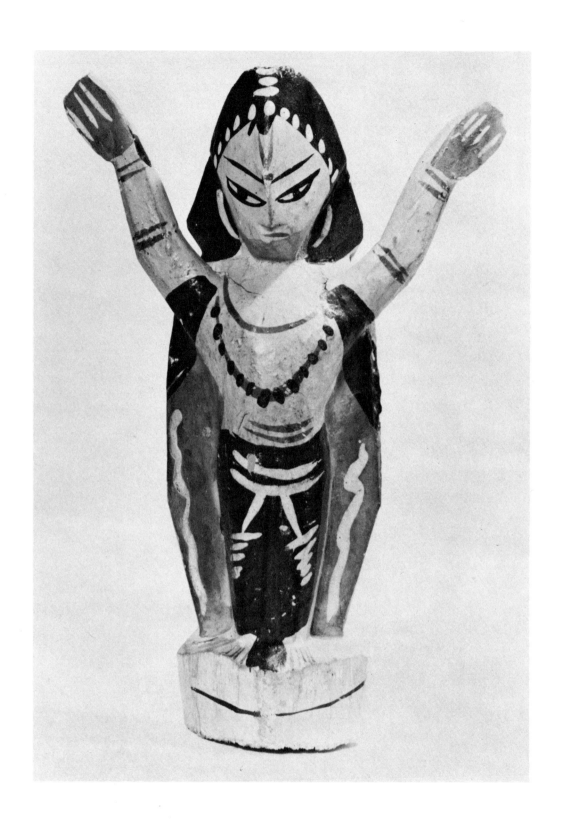

134 WOOD

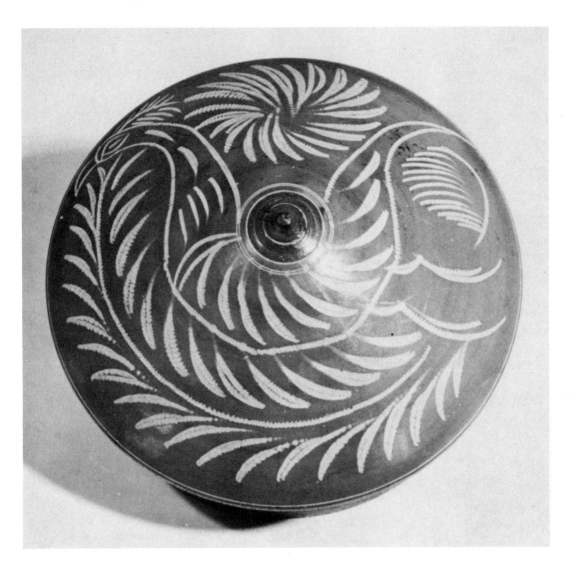

ABOVE: Lakshmī casket (looking down on lathe-turned lid), actual size, from Calcutta market. The red lacquer finish is incised with a florescent bird motif, including a swastika-lotus.

OPPOSITE: Doll representing Gaṅgā, the Ganges mother goddess with arms in *abhaya mudrā* (gesture of assurance). Gaṅgā descended from the moon, alighting on the head of Shiva. Made for the *mela* (festival) season at Nabadwip, West Bengal. Actual size.

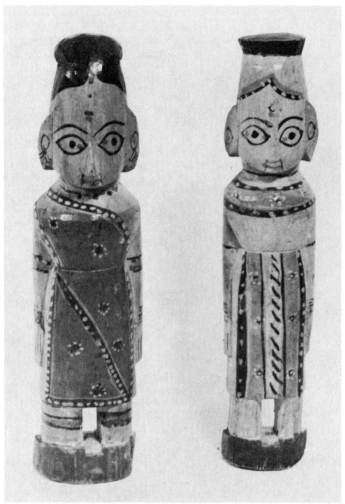

ABOVE: Painted *dāmpati* (patron) dolls from Ranchi, Bihar, 5 inches high. Contemporary.

LEFT: Idealized painted female doll in a *sārī*, 7 inches high, from Burdwan, West Bengal.

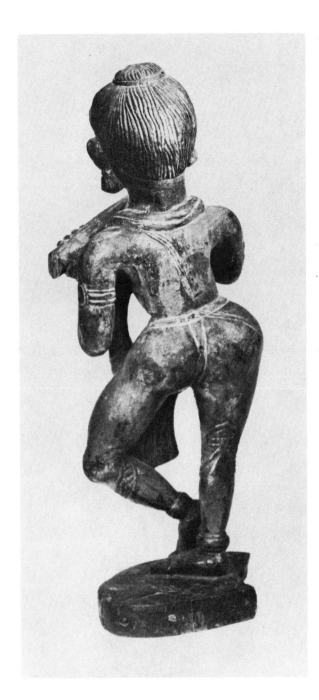

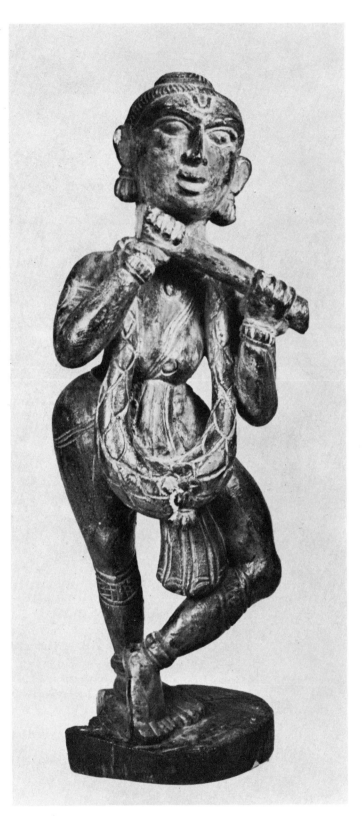

Back and front views of Krishna, vigorously carved as Veṇugopāla, 15½ inches high, eighteenth century, from Gujerat. The exaggeration of the carving helps to depict the dancing flutist handsomely. (*Mr. and Mrs. E. L. Goldberg*)

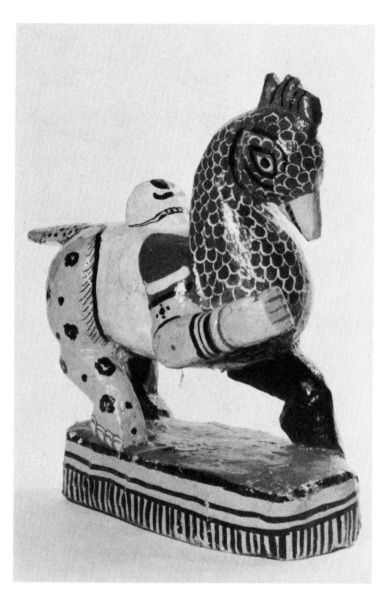

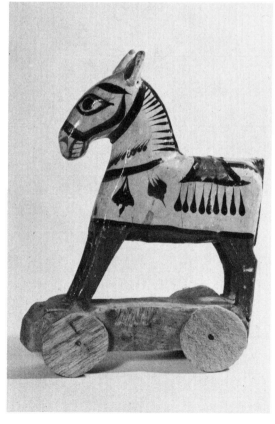

ABOVE: Navagunjar, also called Virāṭarūpa and Sharava (universal monarch form), a mythological animal with a peacock's head, a human hand holding Vishnu's *gadā*, a horse's front leg, hind legs of a tiger and an elephant, a snake's tail and a bull's body. Made and painted at Puri, Orissa. Contemporary.

RIGHT: Toy horse on wheels. This spirited painted steed, 10½ inches high, was made at Tippera, East Pakistan. Contemporary.

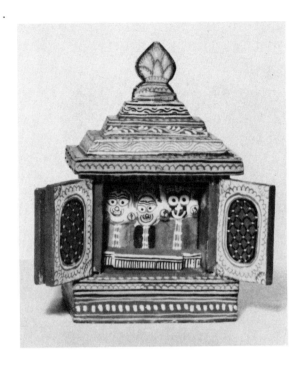

Miniature Jagannāth temple, 8 inches high (LEFT) and Jagannāth ("God of the World") figure, 15 inches high (BELOW). Painted images made at Puri, Orissa.

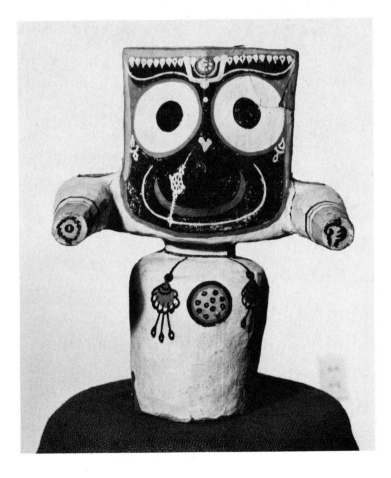

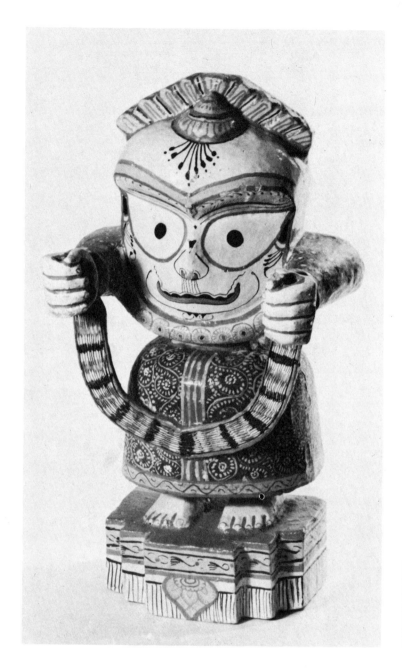
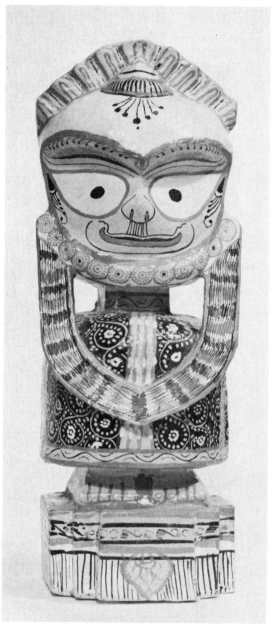

140 WOOD

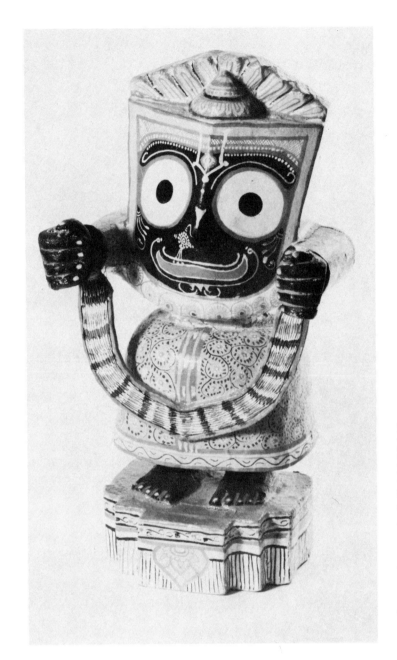

From left to right: Balarāma, elder brother of Krishna (12½ inches high); Subhadrā, sister of Krishna (10 inches high); Jagannāth (Vishnu-Krishna; 12½ inches high). These images signify the unfinished form of Vishnu, carved from a tree trunk. Viśvakarmā, the carpenter god, was angered when the king who ordered the carving stole a glance at the figure before it was finished. Nevertheless, Prince Indra-Mehna, who rediscovered Puruṣottama (Puri, Orissa), built a great temple there and continued to worship the image as Jagannāth, Lord of the Universe. This theme, expanded to include the Krishna family trinity, is seen here brightly painted and refined.

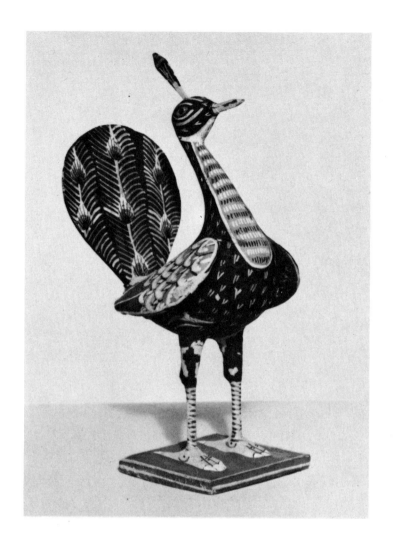

LEFT: Peacock. Painted wood, 9½ inches high, from Kondapalli, Andhra Pradesh. Contemporary.

BELOW & OPPOSITE BELOW: People of India. Painted dolls for domestic shrines, 4 inches high, from Kondapalli near Vijayawada. Thirty families of toy makers who have inherited the skills of several centuries work on these figures at the present time. Families divide their efforts, the women doing the painting. The figures are made of light, white, soft wood.

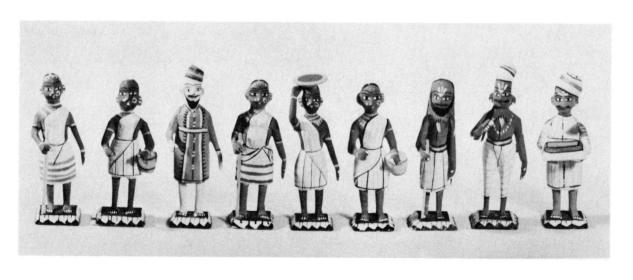

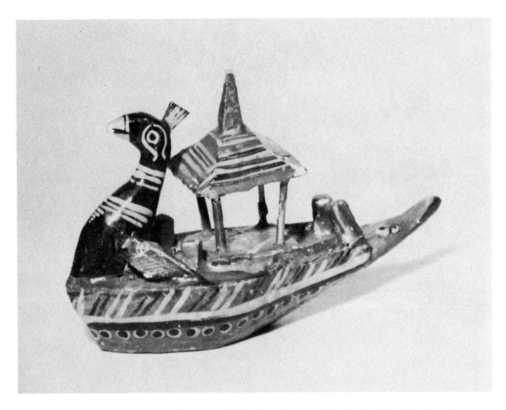

Mythical monarch barge with peacock head and crocodile (*makara*) tail. Painted, 3 × 5 inches, from Banaras (Benares), Uttar Pradesh. Contemporary.

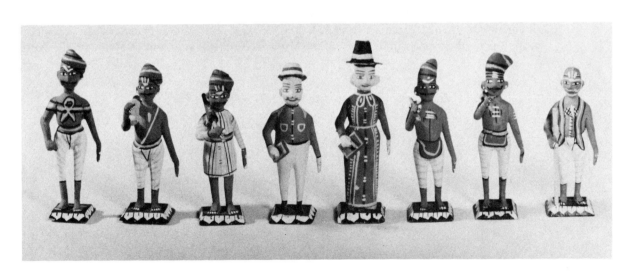

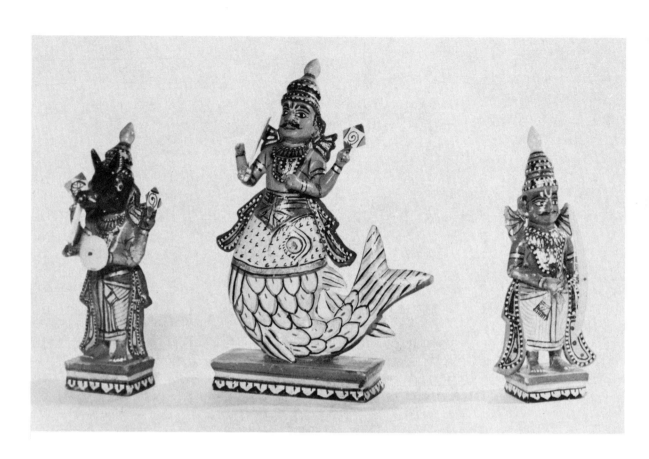

Vishnu avatars. Brightly painted images, 5½ to 7½ inches high, made at Banaras, Uttar Pradesh.

ABOVE & OPPOSITE ABOVE (from left to right): Varāha (boar); Matsya (fish); Rāma, with bow; Narasiṁha (man-lion); Kūrma (tortoise); Kalki (horseman-incarnation that is to appear in the future).

OPPOSITE BELOW: (from left to right): Vāmana (dwarf), bearing parasol; Hala-Dhara (a plough-bearing appearance of Balarāma); King Bali (king of the world and good demon; not an avatar, but an important character in the story of the Vāmana avatar); Paraśurāma (Rāma with the axe); and Buddha.

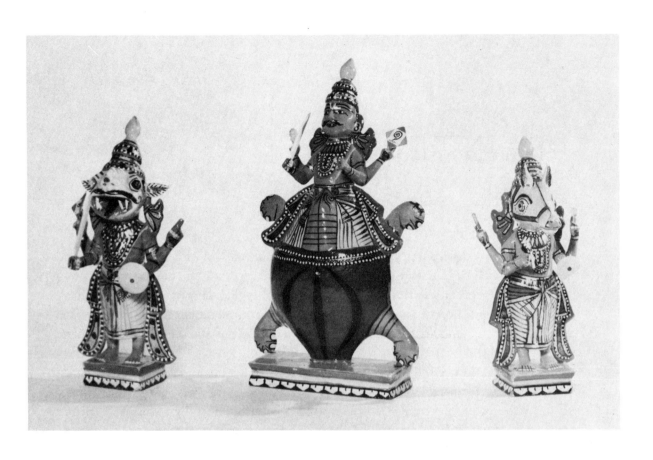

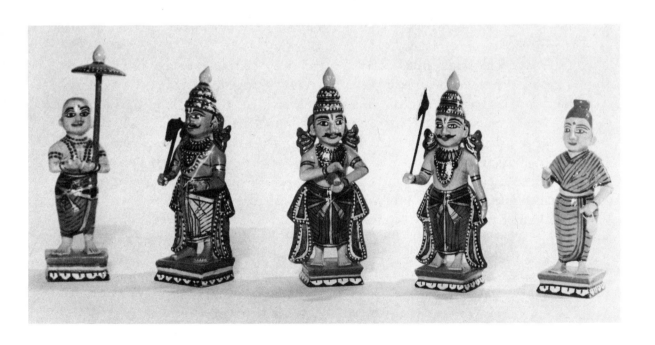

PAINTING

By painting the human body, domesticated animals, stones, leaves, wood and the ground with organic stains, carbon and earth colors, men developed ways to diagram and eventually communicate their thoughts. Painting on mats, cloth, clay fabrications, walls, boards and paper with permanent mineral colors bonded by glue and lime, and the embellishment of boxes, pots, sculpture and sundry objects, have contributed to the furthering of the pictorial process.

The civilization of India evolved its own idiom of painting, strongly influenced by its sculptural primacy. Variations range from the use of a basic visual language to complicated techniques and elaborate imagery. Painted indigenous and Hindu images appear as idealized nature. These "ideographs" represent the painter's inner response to traditional precepts, mostly religious in content, rather than the perception of natural phenomena. The painter executes the image as if leading a hymn in praise of a god. The results are not intended to be occult, but in the eyes of the superstitious such images possess magical power rather than symbolize a higher being or force. Partly because of this conjuring, militant iconoclasts have actively opposed the existence of these images.

Alpanas, an indigenous form of painting, continue to be produced for auspicious occasions and appear on rural village houses, floors and courtyards commonly seen in Orissa, Rajasthan, Bihar and Bengal. Most native Indian painting has developed from similar everyday, humble and modest conditions.

Regional seats of power and sacred pilgrimage centers attracted the skills of painters, who instituted professional religious picture making. Devotional aids on permanent display in these centers, as well as portable pictorial imagery for pilgrims to take home, stimulated prolific production elsewhere. Masks, puppets, manuscript illuminations, dowry boxes and playing cards are among the various artifacts also produced by the painter. In Puri, Orissa, this tradition actively survives.

The Buddhist painting of the Ajanta caves, Jain illumination and Kalighat paintings (age-old styles of regional painting) were also results of indigenous development. These styles are now extinct, but linger on in the scattered practice of

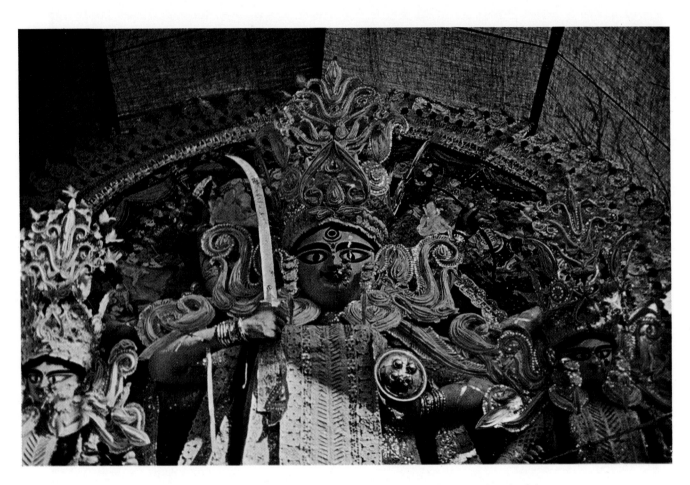

Part of a Durgā *pūjā* image from Nabadwip Town festival, West Bengal, 1961. This detail of the 15-foot-high group shows Lakshmī, Durgā and Sarasvatī bejeweled in *daksaj* (pith clothing), backed by an episodic mural painted at Katwa. The whole is a dazzling synthesis of several media.
(Photograph by R. F. Bussabarger)

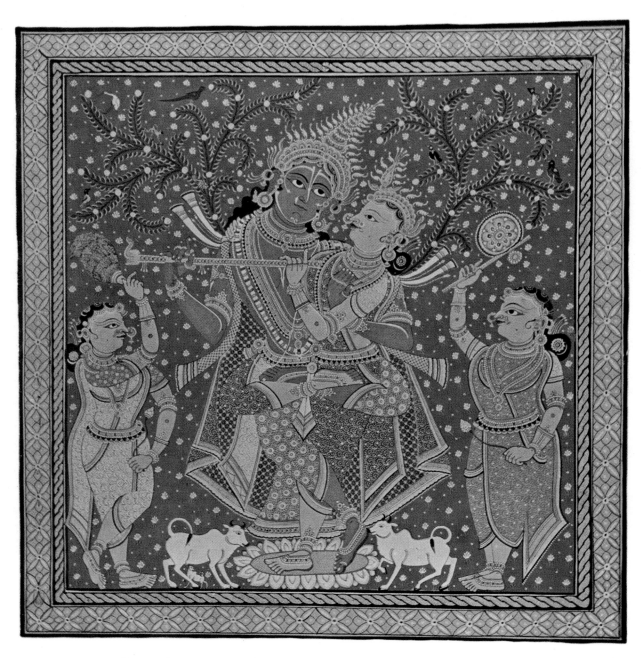

Rādhā and Krishna joined in merriment. The Mathura cowherd flutist falls in love with mortal Rādhā. After he destroys the river demon they rejoice. These schematic *pats* (painted sized cloths) are made at Puri, Orissa. The master painter of the family finishes the faces. The traditionally evolved organic interchange of content and form is unintentionally like that of modern cubism. 22 by 22 inches.

folk painting or have been renewed through the personal idioms of modern sophisticated painters.

During the Moghul period Emperor Humāyūn imported the Persian style. Assimilation of this idiom by the Indian painters resulted in a new and unique Moghul form of painting with imperial and provincial styles. The Hindu Kshatriya Rāj amalgamated native and Moghul forms and with religious themes developed the diversified Rājput styles. The fact that Moghul painting oddly reversed the Muslim prohibition against images was probably due to the international sophistication of the age and to Persian influence. European painting was also introduced into the Moghul court. Portraiture became a major aspect of painting, which the Rājputs also took up. Heroic and religious themes in vivid colors and flat decorative patterns dominate the mode of Indian painting.

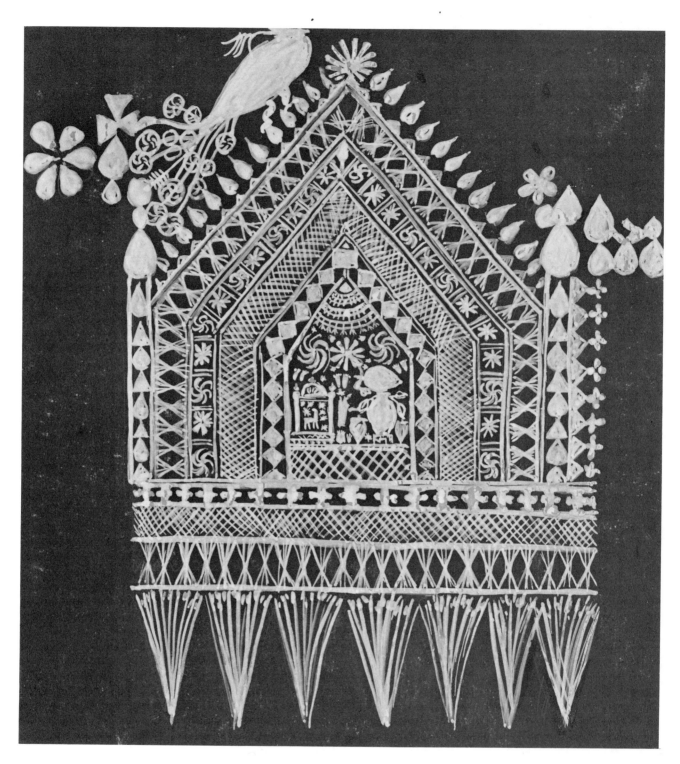

Alpana house painting near Puri, Orissa. An indigenous motif made by the householder from rice paste on the mud walls to aid the fertility of the sugar beet crops and the wellbeing of the family. Drawing after the original.

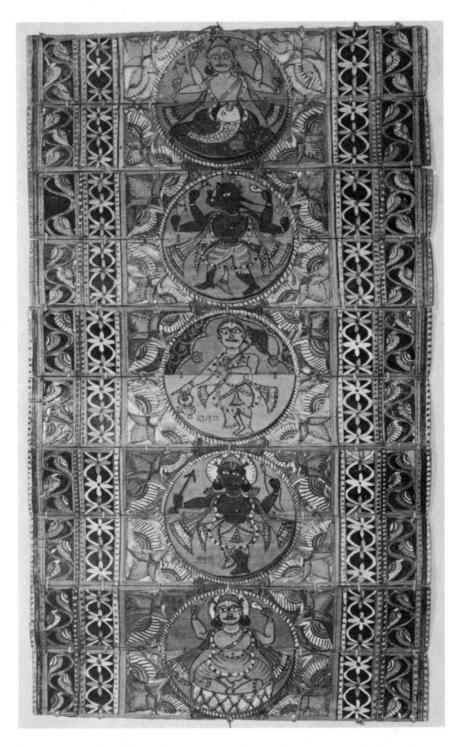

Pothī, a pleated and hinged palm-leaf religious book, written in Oriyā script, with illuminations depicting the avatars of Vishnu. Made by Bharat Nayuk, Baideshwar, Cuttack, Orissa. This ancient book type, traditionally incised and stained with script and line drawings, has also been spontaneously painted and gaily fretted here. The book, open, is 13 inches long; it unfolds straight out from its reversed pleats.

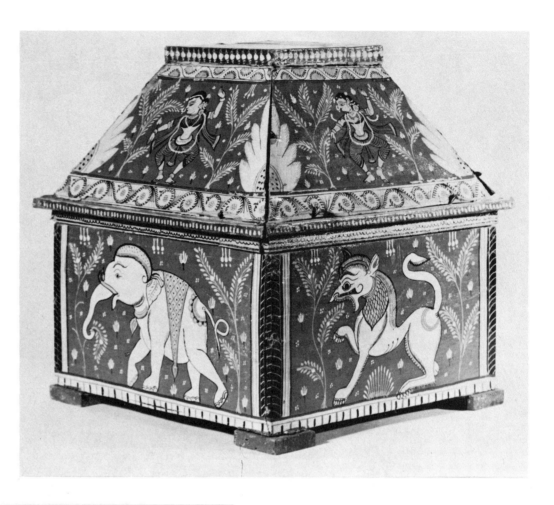

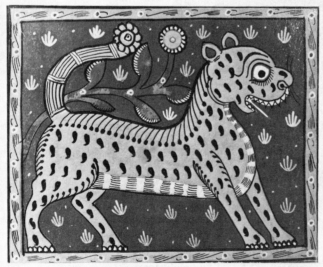

ABOVE: Dowry box auspiciously painted with elephants, lions and dancers. From Puri, Orissa. 14 inches high.

LEFT: Tiger *paṭ* charmingly painted for pilgrims to buy at Puri. $9\frac{1}{2} \times 12$ inches.

OPPOSITE: Bhairava, the "terrible" form of Shiva (son or avatar of the god), wearing a tiger skin and holding weapons, with tiger-dogs at his feet. Contemporary *paṭ* painting from Puri, Orissa. 9×12 inches.

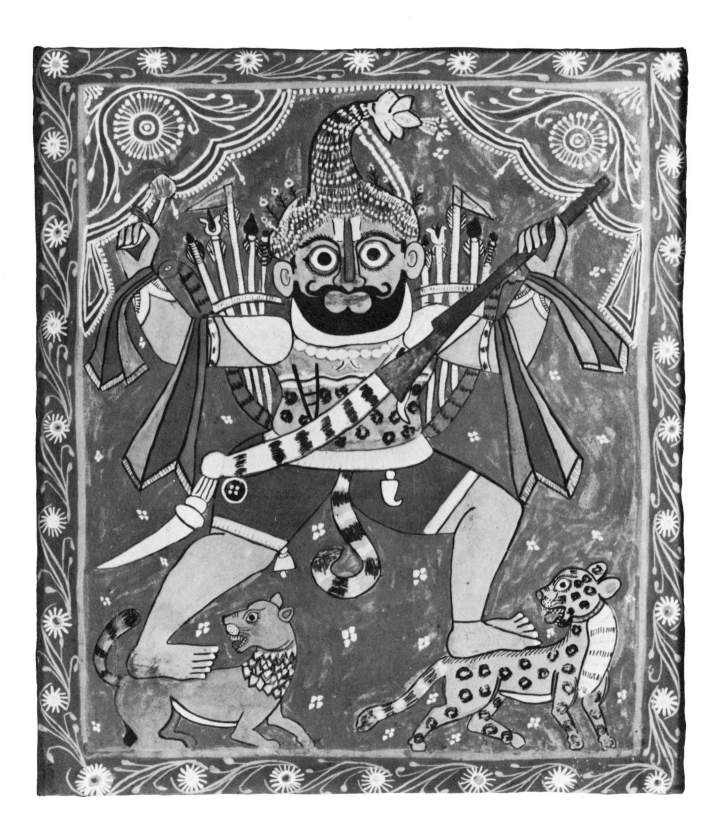

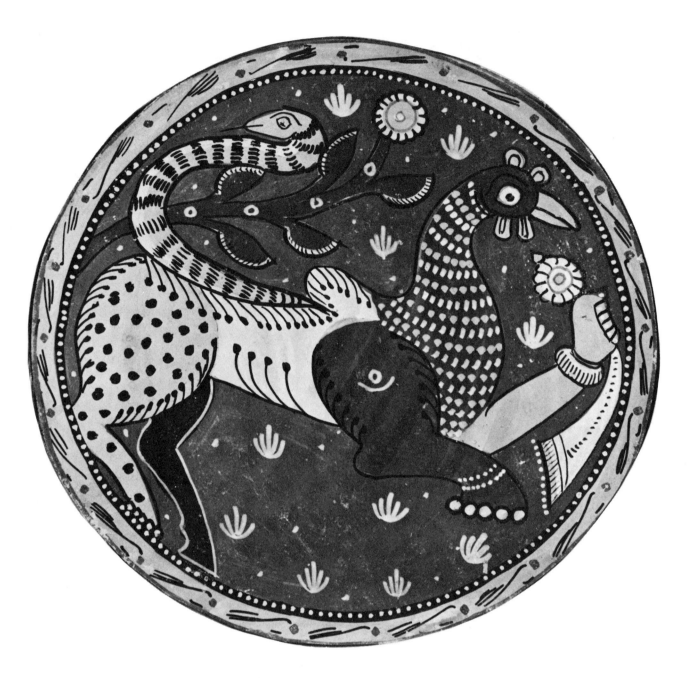

Navagunjar, universal monarch form. 10 inches in diameter. Made by the *paṭ* painters of Puri, Orissa, for religious pilgrims.

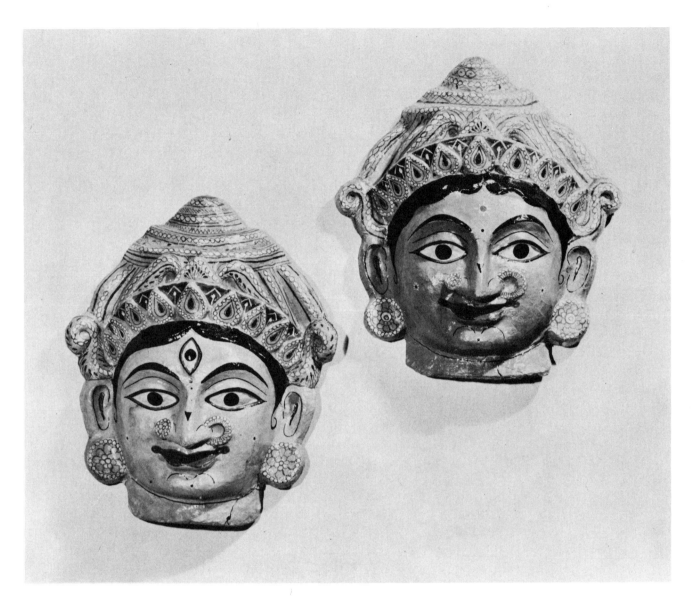

Lakshmī and Durgā painted papier-mâché masks for part of *pūjā* dances. Made at Puri, Orissa. 15 inches high.

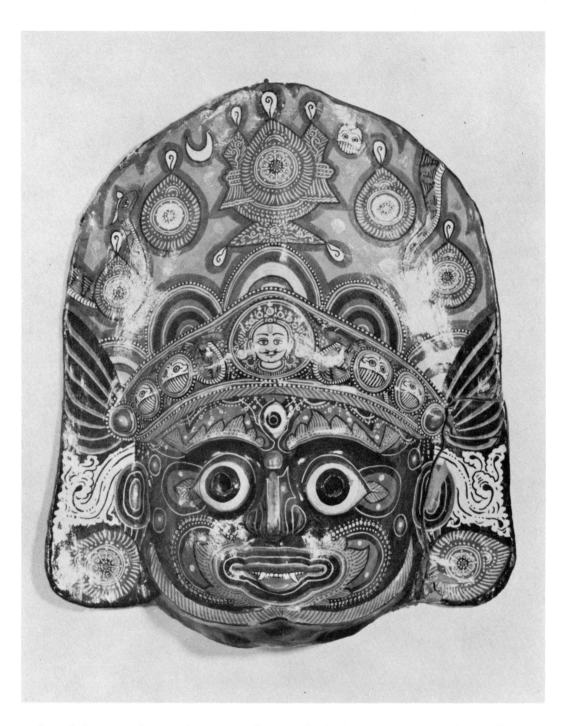

Kālī mask from Nepal. Painted papier-mâché, 15 inches high. Contemporary. The fixedly staring goddess is jeweled with representations of her consort Shiva (center), flanked by apotropaic *kīrtti-mukha* faces and other symbolic motifs.

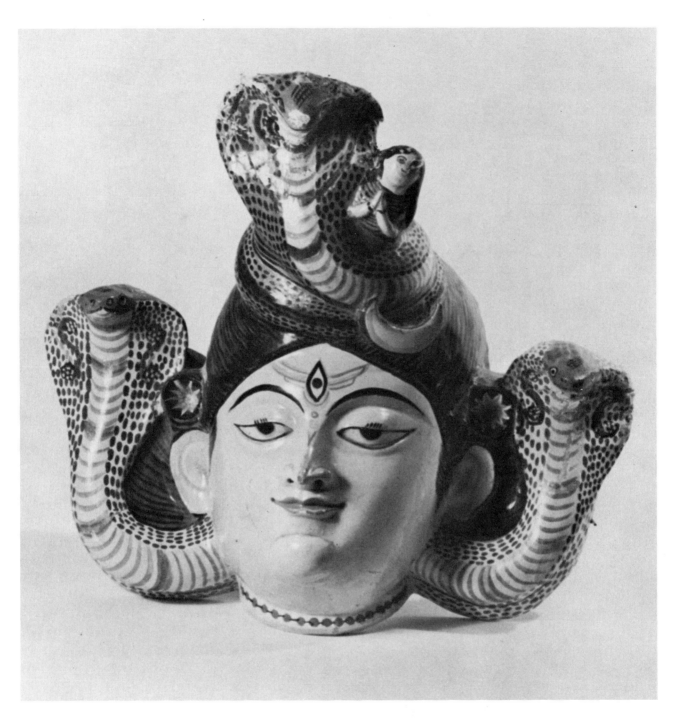

Shiva mask for the *chhou* folk dance. Painted papier-mâché, 15 inches high, contemporary, from West Bengal. Gaṅgā has alighted from the moon on the serpent-haired head of the Lord-of-Snakes.

ABOVE: Costumed puppets with quaintly painted heads who enact the sung and recited story of Amar Singh, a heroic Rāthor of Jodhpur. 23 inches high.

LEFT: Old-style playing card (actual size) showing equestrian *rāja*. Also from Rajasthan.

OPPOSITE: Episode from Firdausī's *Shāhnāma* ("Book of Kings"). Seventeenth-century illuminated book page in Indo-Persian style with Arabic script. In a battle on the Oxus River, Rustum (a semidivine hero) kills his son Suhrab unknowingly. $5\frac{1}{2} \times 10$ inches.

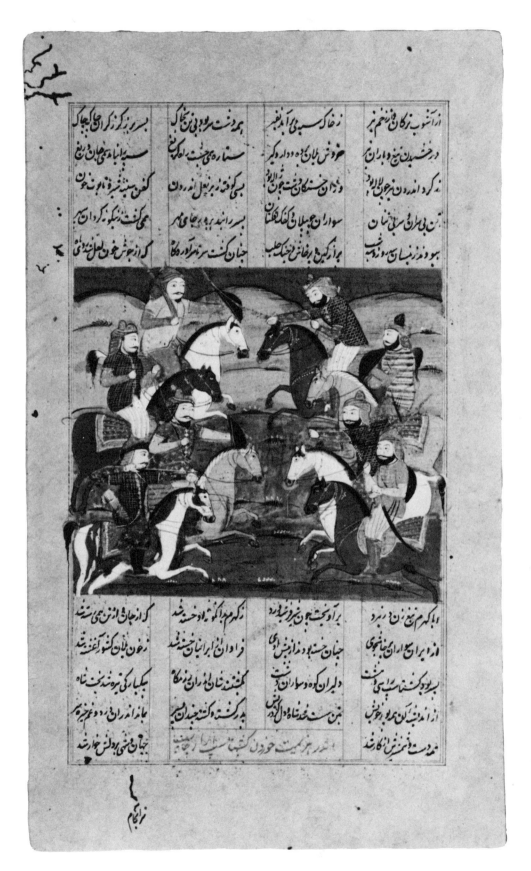

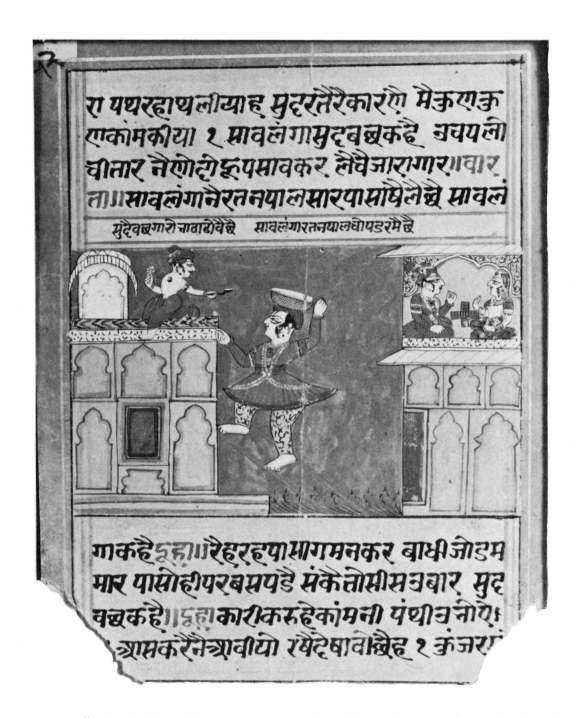

ABOVE: Illumination from Gujerat, circa seventeenth to eighteenth centuries. From a book with illustrations of episodes stylistically suggesting some connection with the earlier Jain miniatures (1100–1600 A.D., illuminations in Jain manuscripts). Actual size.

OPPOSITE: Portrait of an aristocrat. Moghul, seventeenth century. An exquisite and subtly refined painting, suggesting European influences in the flower-holding pose. The border is as noteworthy as the subject.

ABOVE: Portrait (actual size) of Princess Husna-ara (a Muslim name meaning beauty and goodness). Rājput, seventeenth-century style.

LEFT: King Kurrun Singh, son of Raé of Daulatabad and Bikaner, born 1632. Painted in a delicate Rājput style.

OPPOSITE: Abhye Singh ("Lion Without Fear"), king of Jodhpur, 1759–1806, son of Ajit (who was a victim of patricide), painted in full Rājput dress. 6 × 11 inches.

ABOVE: Krishna (painted dark blue), accompanied by Balarāma, is confronting Rādhā and another milkmaid. Painted in the typical Rājput flat pattern of the seventeenth century.

OPPOSITE: Mother and Child gouache by Jamini Roy, Calcutta. Traditional folk stylizations have been transposed into a personal artistic idiom with syncretistic implications; the theme can be Yashodā or Devakī with Bāla-Krishna as well as the Christ Child and Mary. 13 × 22 inches.

FIBER

Organic fibers of grass, bamboo strips, palm leaves, coconut husks, bark, wool and animal hair, silk, cotton, jute and threads of metals, processed and woven by the people of India, provide for the essentials of life and give it splendor and fullness. In this India has developed an exceptionally rich heritage, distinct and unique. There are practically no known processes that have not been employed by its weavers, dyers and plaiters. India's historical prominence for this type of fabrication has been an object of world attention and trade since the days of ancient Rome.

Strands of fiber are the nerves of India. The rhythm of life beats to the rap of the weaver's batten, and exciting chromatic dyes pulsate before the eyes.

Although ambiguous gray-white is common, in many parts of India people daily garb and surround themselves with contrasting colors. At any rate, everyone anticipates the adornment and décor of striking fabrics resplendent in such festivities as *melas* (fairs), trips to the bazaar, weddings, processions, ceremonies, *pūjās*, dance dramas, bard shows and displays of military and political pomp and circumstance.

Cotton *khādī*, silks, elegant brocades and embroidery, complicated tied-and-dyed fabrics, rich appliqué, fluid batik, vibrant block prints, mats, baskets, hangings and clothing incorporate a wide range of motifs. From the direct fabrication process artisans have developed all sorts of abstract designs with a distinct ethnic character. Typical designs of animals, vegetative growth, heroic personages and deities have also been profusely employed. The elaborateness, attractiveness and artistry of the works are almost predictable because of the craftsman's skills and total involvement in the craft process.

Professional craftsmen and their families produce and market various fabrications for the individual or group requirements of both influential and ordinary people. Women of the household and tribal members create these fabrications for their own needs. Users seeking display of status, compliance with cultural and religious practices, personal satisfaction and essential comforts have generated wide demand for such productions.

Unfortunately, admirers are finding that these sensitively made fabrications are

being displaced by machine production. India is, nevertheless, still a major world source of artistic traditional weaving and decorated cloth. Encouragingly, these products are occasionally paralleled by handsome contemporary industrial fabrics, which have also attracted discerning admirers.

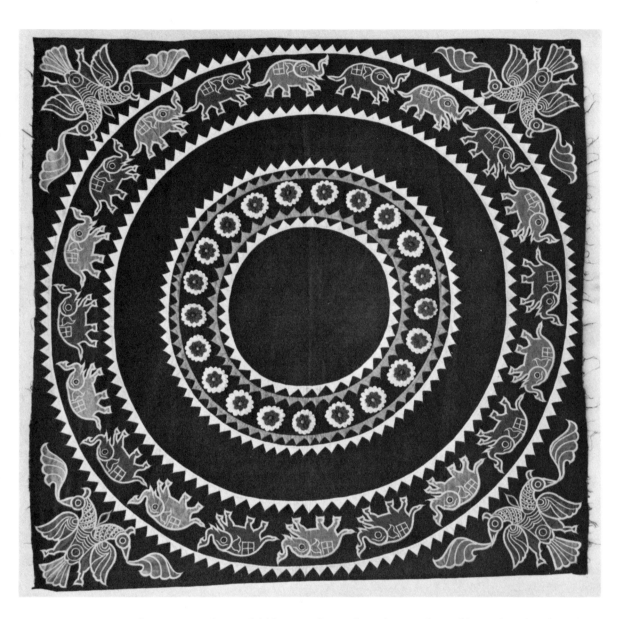

ABOVE: Ceiling center of a *pandal* (decorated tent for religious festivals). Embroidered appliqué in rosette-lotus form with elephant and flaming double-headed bird motifs. 4 × 4 feet. From Pipili near Puri, Orissa.

OPPOSITE: *Bichitrā sārī* detail from Orissa with richly woven tie-and-dye configurations. Contemporary. Full *sārī* 38 inches × 12 feet.

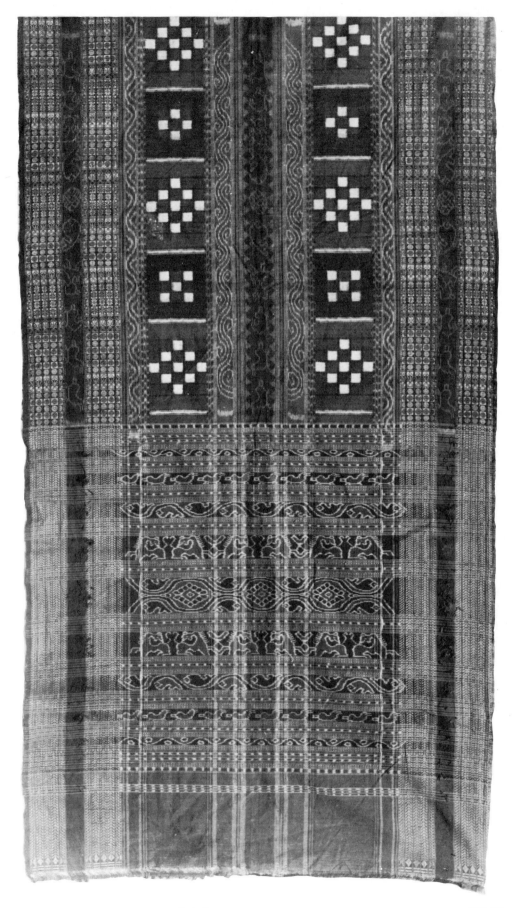

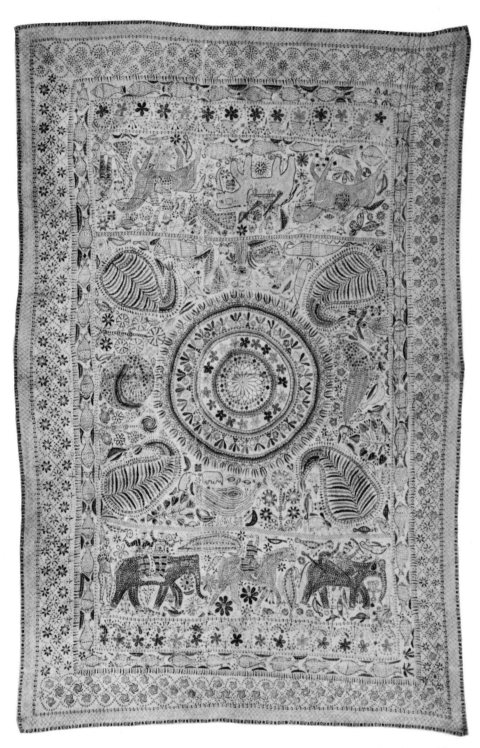

ABOVE: *Kānthā* (wrap or blanket), here in the form of a baby blanket from old Bengal. Embroidered auspicious spirals, swastikas (which facilitate birth), fish, birds, mangos and hunting motifs form a rich pattern on both sides of a matting of used *sārīs*. 60 inches × 40 inches.

OPPOSITE: *Anchala* (front end) of a *sārī* from Baluchar, Murshidabad District, West Bengal, nineteenth century. An extremely complicated and rich blue and gold silk, woven with mango patterns as well as figures in European dress. Full *sārī* 42 inches × 14 feet.

172 FIBER

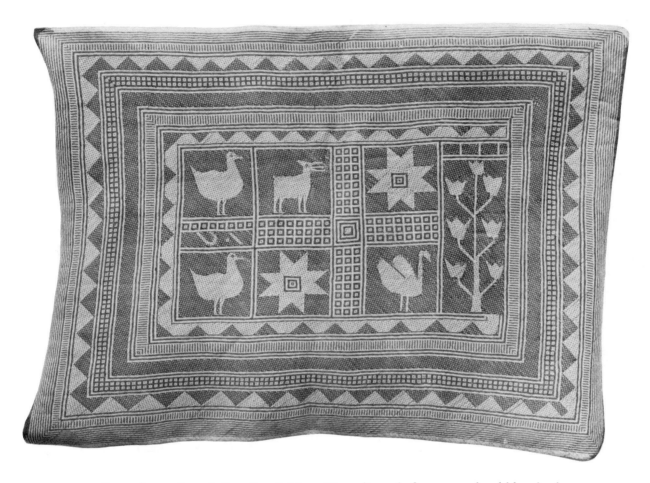

ABOVE: Muslim style mat from Sylhet, East Pakistan (Bengal), made from natural and blue-dyed rice straw, used as a prayer rug and divan cover. 5 × 7 feet.

OPPOSITE: Tiaras worn by brides during Bengali wedding festivals. The directly handled sliced white cork (pith) has been transformed into delicate crowns suitable for the "goddess"-bride. About 5 inches high.

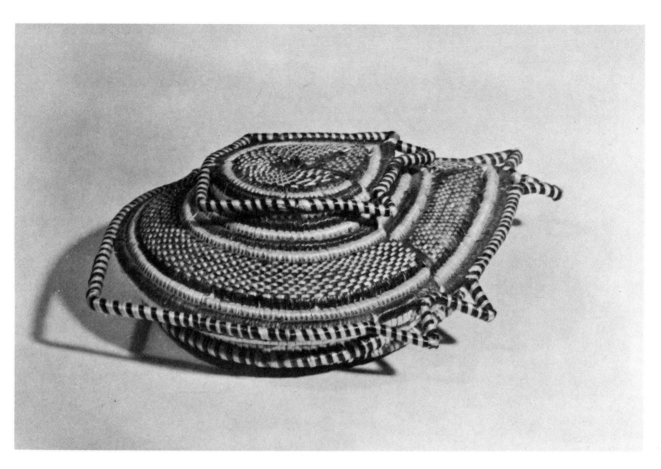

ABOVE: Auspicious fish casket with lid 8 inches long for bride to carry to bridegroom's house. Made from *sikkī* grass in blue, red and natural weave in Mithila, Bihar.

LEFT: A purse with red and blue embroidery and mirror. From Pipili, near Puri, Orissa. 7 inches square.

OPPOSITE: Bamboo tea chest with lid, 24 inches high, in natural and brown-black weave. From Manipur State. Contemporary.

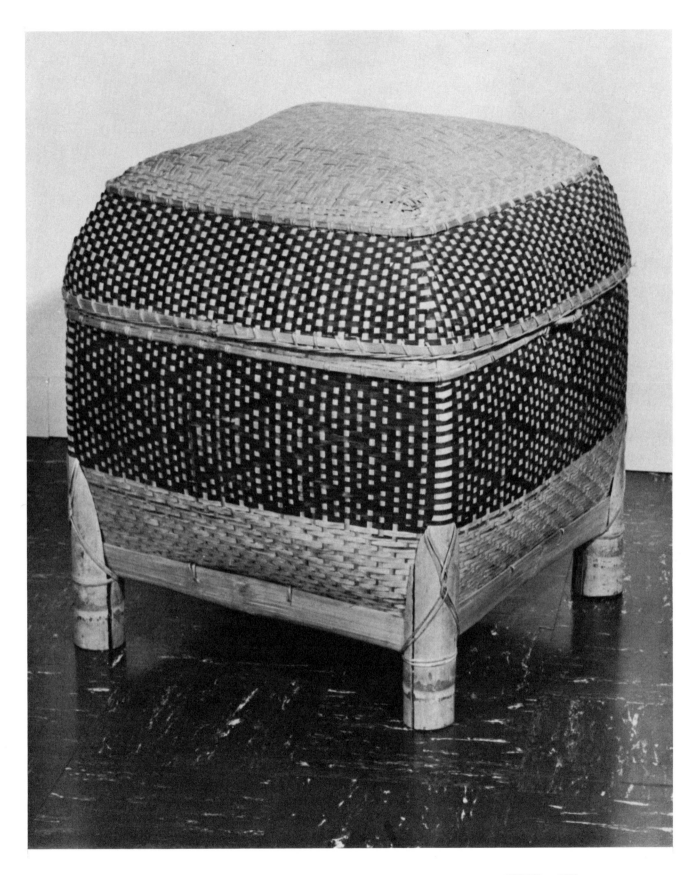

ABOVE: Fan on swivel handle with embroidery and mirror. From Cox's Bazar, East Pakistan (Bengal). Contemporary. 12 inches in diameter.

OPPOSITE: *Vasamalai kalamdar* (wall hanging made with pen), a contemporary example of an old style from Arcot, Madras, with lines painted in iron red, blue and yellow ochre to symbolize the Hindu trinity Brahmā, Naṭarāja (Shiva as Lord of the Dance) and Vishnu. In the temple, from left to right, are Brahmā; Naṭarāja, accompanied by Pārvatī and dancing on the dwarf-like *Apasmāra puruṣa*; and Vishnu. 4 × 4½ feet.

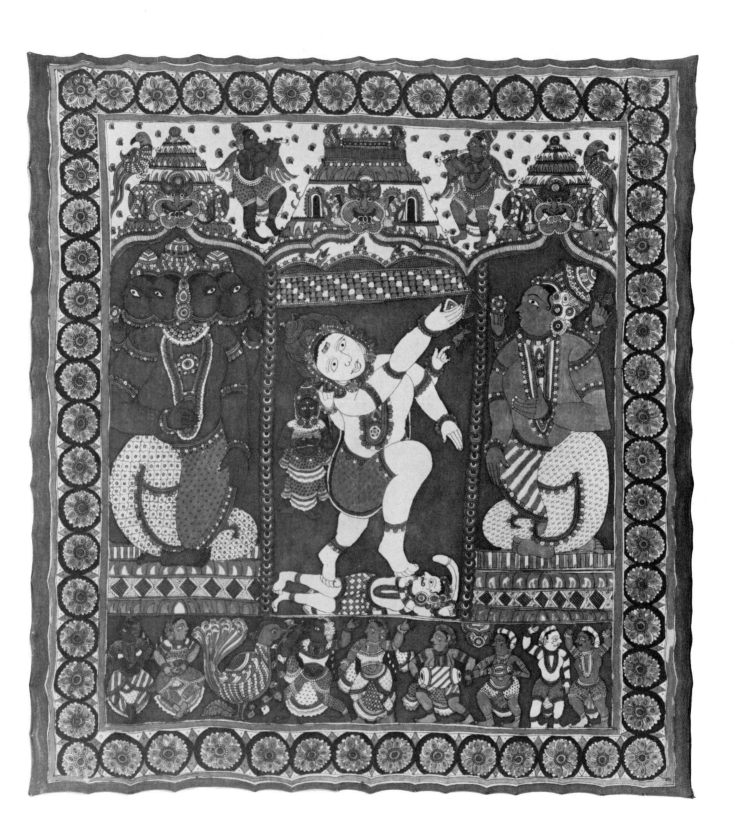

FIBER 177

Palangposh (bed cover) or tablecloth printed from blocks on cotton in reds and browns. Kalam-karī style, Arcot, Madras. 42 inches × 51 inches.

Turban cloth from Andhra Pradesh. The red and natural tie-and-dye threads stop out fanciful contemporary motifs of clocks and airplanes. 42 inches square.

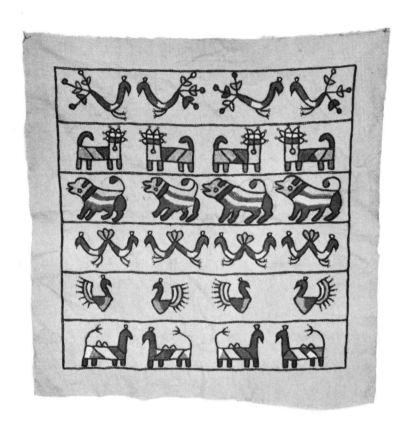

ABOVE: Pillow cover, with fresh embroidery in *rohtakī ordhnī* style from contemporary Mitraon Punjab. 16 inches square.

LEFT: *Jooti* (Indo-Persian style) shoes from Delhi. 12 inches long.

OPPOSITE: Ground cloth, 6 × 8 feet, from old Rajasthan, with formal "garden" pattern. Such cloths are spread out under tents or on open ground for seating.

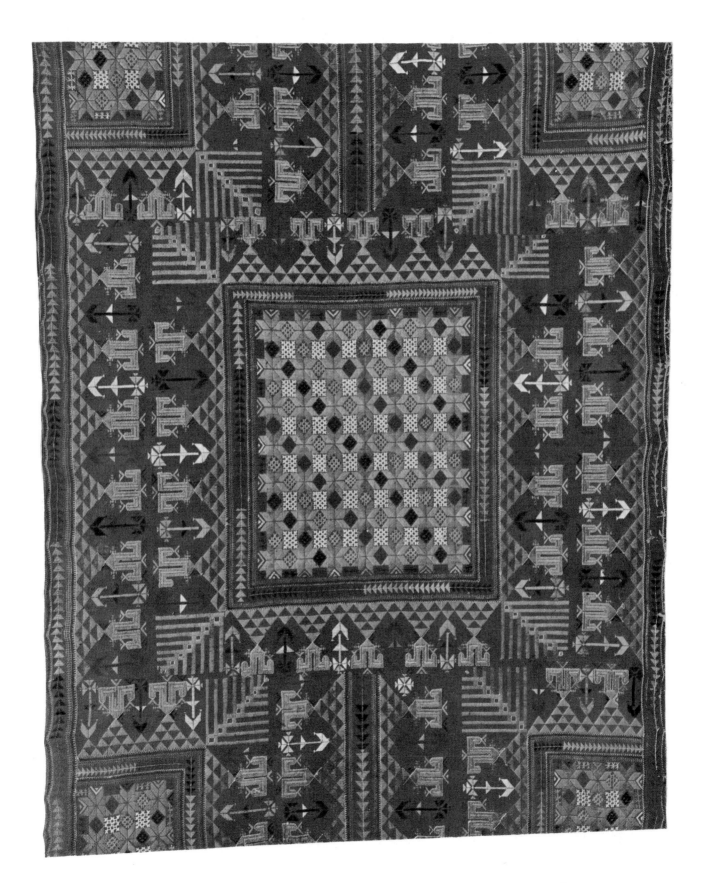

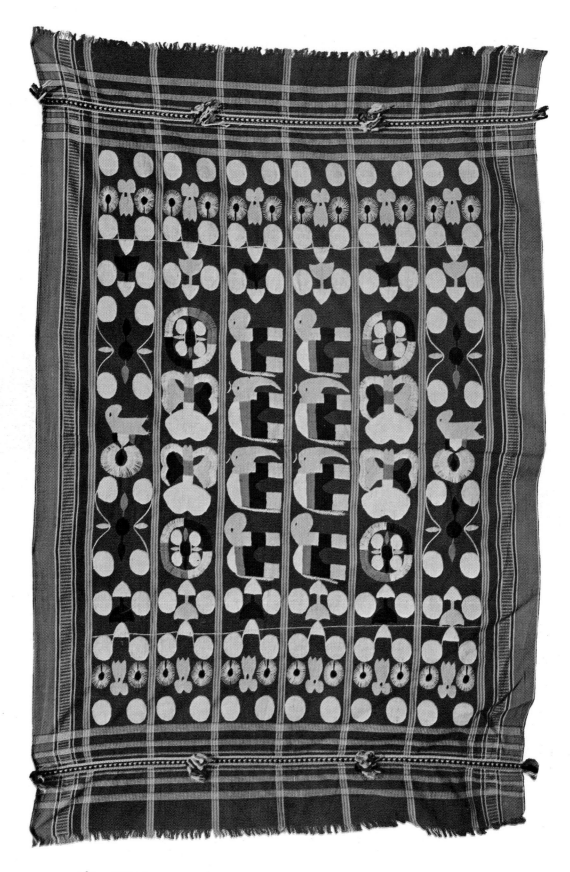

182 FIBER

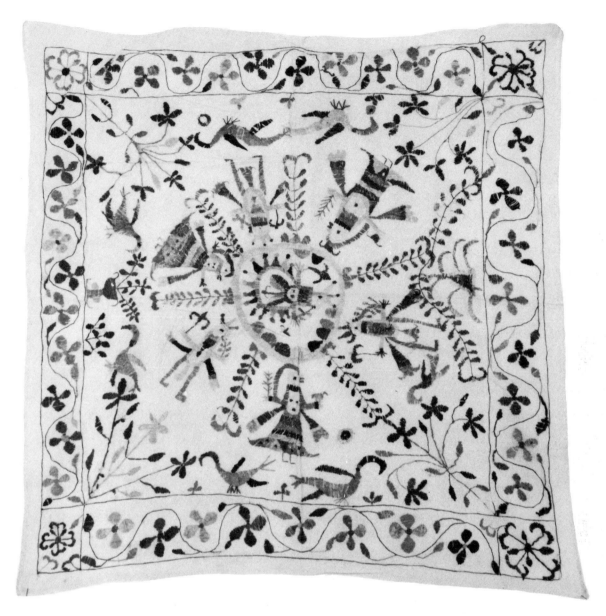

ABOVE: *Chamba rumāl* (handkerchief and wedding accessory) from Himachal Pradesh; old. The multiple Krishna appears dancing with maidens. Embroidered on cream-colored rustic cotton with untwisted silk thread and double satin stitch on both sides. 25 inches square.

OPPOSITE: Naga tribal *chaddar* (blanket), $4\frac{1}{2}$ × 7 feet, contemporary, with fresh embroidered pictograms on hand-woven cotton. From North East Frontier Agency (Naga Hills).

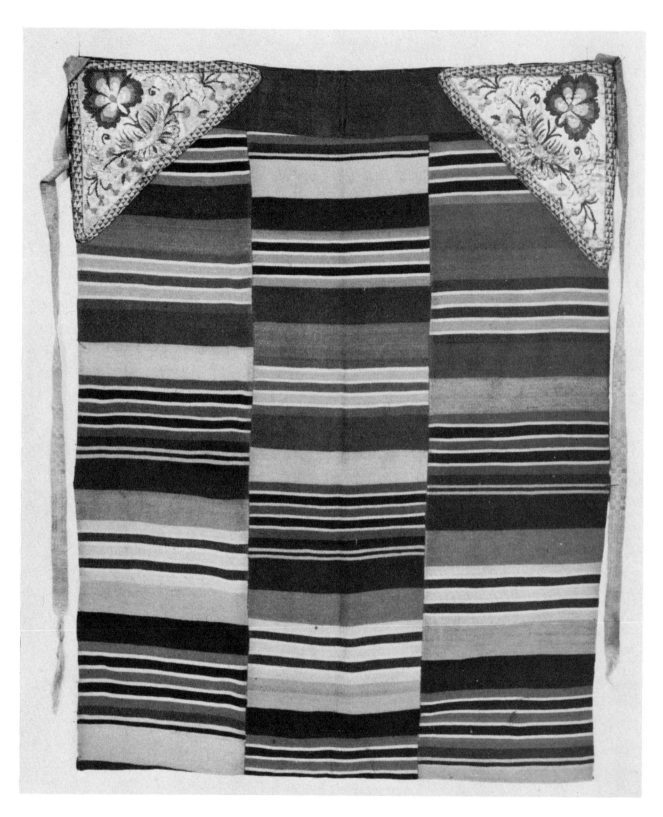

Apron, from hill stations near Nepal and Tibet, worn by women in formal attire. Made from wool, with metal-thread embroidery in the corners. 26 inches × 20 inches.

184 FIBER

ABOVE: Purse facings from Kashmir. Floral-mango pattern (7 × 8 inches) and Hazara style *kakri bagh* embroidery (6 × 7 inches); old.

RIGHT: Contemporary mirror-work handbag from Delhi. 14 inches square.

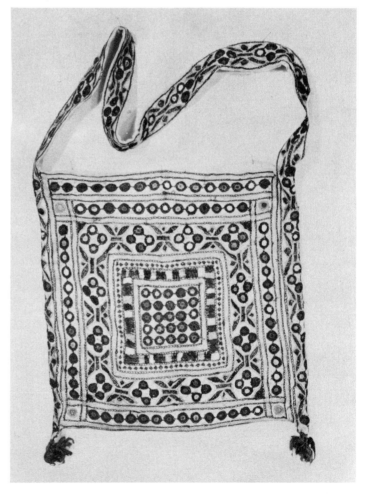

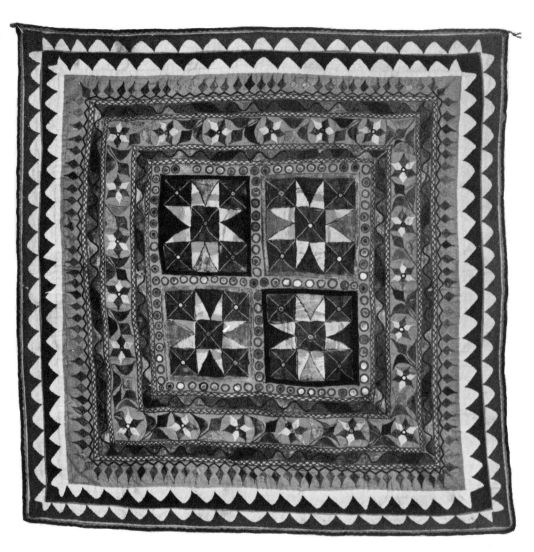

Prayer mats, old, from Kutch. 33 inches square.
Embroidered mirror work.

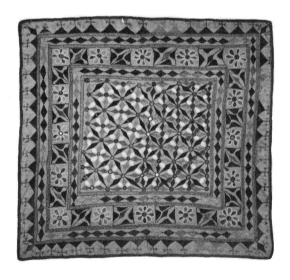

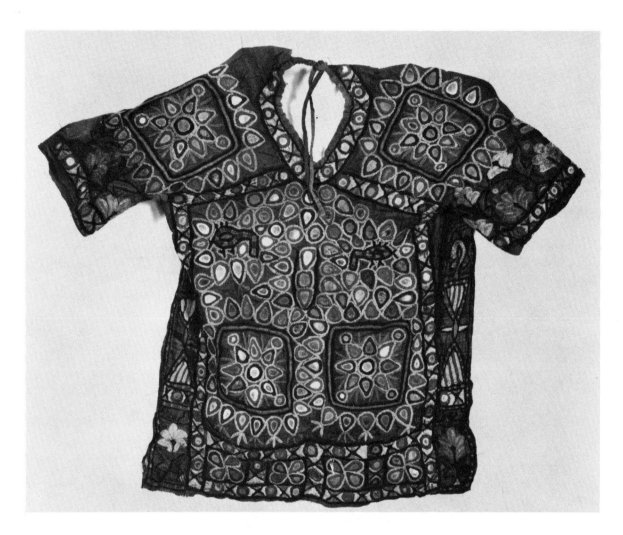

Choli (blouse), old. Embroidered mirror work by the Ahīr women of Kutch. $22\frac{1}{2}$ inches \times $16\frac{1}{2}$ inches.

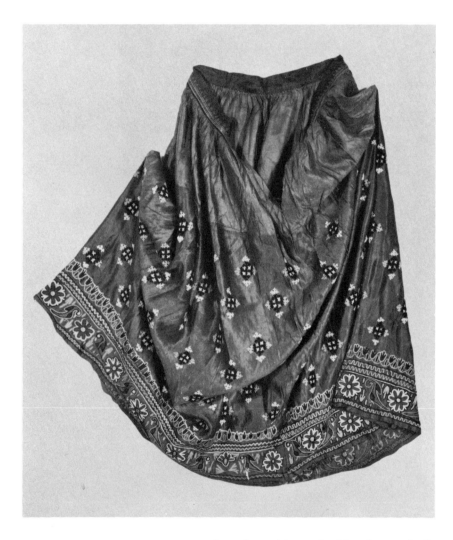

ABOVE: Saurashtra skirt embroidered on red silk in old Kathiawar style. From Kutch.

OPPOSITE: Contemporary *namdā* rug from Kashmir, made from pressed wool and embroidered with fanciful animal designs. 50 inches × 78 inches.

Temple hanging for *mātā pūjā* (mother goddess worship). 5 × 19 feet, block-printed on cotton by the Harijan families of Ahmedabad. Some of these cloths are made by the mordant-madder or alizarine process, in which designs are applied with liquid alum and *kāchukā* flour. The red adheres where alum is applied; the natural color is retained elsewhere. This cloth shows Cāmuṇḍā (on a tiger) and Bāhucharā (on a camel), two forms of Durgā. The figures are surrounded by legends from the *Purāṇas*.

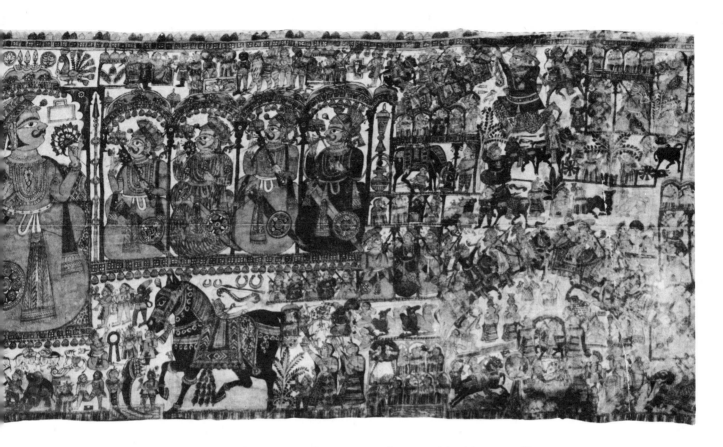

Kāvya (bard) cloth, block-printed in many colors, 4 × 18 feet. Used by itinerant village story-tellers to present the legends of the Rāthor pastoral hero Pābū of Kolu, Marwar, Rajasthan, who is venerated and deified as a protector of cows. Pābū's parents were Dhādhala and a nymph; after his birth he and his mother turned into tigers. The nymph disappeared and Pābū returned to human shape. Būṛo, Pābū's elder brother, inherited their father's realms, and Pābū, with a camel, eked out his existence in the desert. Seven *thorīs* (pillagers) joined him in a series of exploits of revenge on his camel; he eventually acquired a black mare called Keśara Kālī. Pābū married a high-born girl; returning from the ceremony, he rescued a herd of cows stolen from a *charini* (princess) by Jinda Rāva. While Pābū was watering the cows, Jinda Rāva attacked Pābū and killed him.

GLOSSARY

abhaya mudrā: Hand gesture (*mudrā*) of assurance; hands held upward with palms outward.

ābhaṅga: Body position in which the upper part of the body is slightly slanted either to the right or left.

āftābā: Ewer, water pot; has a spout.

Ahīr: Caste of cowherds and milkmen chiefly from the northern part of India.

Airāvata: "Rainbow"; elephant on which Indra rides.

Aiyanar: Beneficent tutelary deity of Tamil peasants.

Akūpārā: The unbounded personified; the boundless sea and the turtle upon which the world rests.

alpana (āli-panā): Auspicious ideographic paintings on wall or ground made with rice paste.

amrita (amṛta): Drink of immortality, nectar.

Ananta: "Endless"; a name of the snake on which Vishnu sleeps. *See* Śeṣa.

anchala (ancala): Front end (hem) of a *sārī*.

anjalī hasta: Hand position of reverence; hands joined in front of body with palms facing each other.

Annapūrṇā: Goddess of food and plenty.

Apasmāra puruṣa: Dwarf demon on whom Shiva (as Naṭarāja) dances for release from bondage of existence and for true enlightenment.

apsaras: Celestial nymph(s).

arati: Fine-wicked ritual lamp circulated around the head of an image. A *panch* (*pañc*) *arati* is an *arati* with five wicks.

aṣṭadhatu: Alloy of gold, silver, iron, tin, lead, mercury, copper and zinc used in northern Indian images.

asura: Demon with divine powers; antigod.

aśvamedha: Ancient royal horse sacrifice.

Atharva Veda: The fourth of the Vedic hymn collections, containing formalized magical lore and mystical incantations.

attar (aṭr) dān: Perfume box or scent case.

avatar: Incarnation of a deity.

Bāhuchara (Bāhucarā): Form of Durgā in western India.

Bāla-Krishna (-Kṛṣṇa): Krishna as a youth or boy; known for his mischievous pranks.

Balarāma: Vigorous and strong elder brother of Krishna.

Bali: Good demon-king who possessed the three worlds but was banished by Vishnu to the underworld after Vāmana covered the three worlds in three steps.

Bāṇā Durgā: *See* Durgā.

baṅglā: Thatched hut, "bungalow."

bāzū: Armlet.

Bhairava: "Redoubtable"; a terrifying form of Shiva.

bhārata nāṭya: The overall name for Indian classical dance.

Bhū Devī: Earth goddess, a form of Durgā; sometimes a consort of Vishnu along with Śrī Devī.

bichitrā (bicitrā) sārī: *Sārī* with mixed or varied pattern.

bidrī: Type of damascene work in which a silver thread is inlaid on a ferrous metal; named for town of Bidar near Hyderabad.

Brahmā: God of creation, absolute being; one of the cosmic trinity.

brahmamūla: The golden celestial germ which produced celestial trees and the gods.

brata (vrata): Domestic religious rites, generally performed by women, sometimes in honor of theriomorphic divinities.

Buddha: "Enlightened"; in Hinduism, the ninth avatar of Vishnu. Probably based on the historic founder of Buddhism, Śākyamuni.

Būṛo: Elder brother of Pābū.

Cāmuṇḍā: Form of Durgā in southern and western India.

Cāndo: Supreme being of the Santals; a form of Shiva in the folktales of Manasā.

chaddar (caddar): Blanket, wrap.

chamba (camba) rumāl: Embroidered handkerchief from Chamba, Himachal Pradesh (Punjab). (Also, a woven mat of palm leaves.)

Chandra (Candra): Vedic moon god.

chari (cari): Same as *māzlā*.

Chitra (Citra): A form of Garuda, king of the bird clan.

choli (coli): Short jacket, bodice or waistcoat.

chhou (chou): Traditional dance of the Adivasis in Chhotanagpur, West Bengal.

Dadhikrā: Divine horse often mentioned in the *Rig Veda*.

daksaj: Ornamental clothing for idols made of *śolā* pith.

Daksha (Dakṣa): Goat-headed god connected with the goat sacrifice. Daksha's human head was cut off by Vīra Bhadra (emanation of Shiva, whom Daksha had insulted). When pacified, Shiva replaced Daksha's head with that of a goat.

Dakṣiṇ-dar (Dakshiṇ-dar): "Door of the South"; quasi-god of the Sunderbunds area, non-Aryan in origin.

dāmpati: Husband and wife donor couple.

dawāt: Ink holder or portable case with receptacle for ink and writing reeds.

Devakī: Real mother of Krishna.

Devī: "Resplendent"; name applied to the goddesses Kālī, Durgā, Pārvatī, Umā, Sītā and others. Śrī Devī is an epithet of Lakshmī.

Dhādhala: Rāthor king (*c.* 1330 A.D.), father of Pābū.

Dhokra: Casters of brass images from Bankura Town, West Bengal.

dīpa: Lamp, lantern (also *pradīpa*).

dīpa-Lakshmī (-Lakṣmī): Lamp held by a Lakshmī image.

Diwālī: Festival of lights, celebrated on the last two days of Asvin and the first two days of Kastik (September–November), with varied regional interpretations.

Dravidians: The non-Aryan linguistic and ethnic groups of southern India (Tamils, Telugus and others).

Durgā: "Inaccessible"; demonic form of Shiva's consort; also called Kālī, Cāmuṇḍā and Bāhucharā. Bāṇā Durgā is a form of Durgā armed with a sword that has a thick-edged blade and a wooden hilt.

Dussehra: Festival (September–October) celebrating the victory of Rāma over Rāvaṇa.

dvārapāla: Doorkeeper.

Firdausī: Persian poet, born *c.* 940 A.D., author of the epic *Shāhnāma* ("Book of Kings").

gadā: Mace, club, bludgeon; attribute of Vishnu.

Gaja-Lakshmī (-Lakṣmī): Lakshmī in association with an elephant (*gaja*) or elephants.

Ganesh (Gaṇeśa): Elephant-headed god, son of Shiva and Pārvatī; lord of departed souls and remover of hindrances.

Gangā: Mother goddess of the Ganges River who bestows happiness and prosperity.

Garuda (Garuḍa): Celestial solar eagle, vehicle of Vishnu or Krishna.

ghaṭa: Pot, jar, pitcher of earth.

ghee (ghī): Clarified butter; signifies fertility.

gopī: Dairymaid, playmate of Krishna.

Gowli Śāstra: Scientific treatise on wall lizards.

grāma devatā: Village god who looks after the welfare of the villagers.

Hala-Dhara: "Holding a plough"; epithet of

Balarāma; sometimes identified as the eighth avatar of Vishnu.

haṁsa: Bird identified as a gander, vehicle of Brahmā.

Hanuman: The learned and strong monkey chief who helped Rāma defeat Rāvaṇa.

Hari: "Remover [of sorrow]"; a name often applied to Vishnu and Krishna.

Hātē-po-konkhē-po: "Baby at her arms"; Assamese bird-mother goddess.

Indra: Chief of the Vedic gods; rain god who rides a white elephant and carries a thunderbolt.

Jagannāth: "Lord of the universe"; form of Vishnu/Krishna worshipped at Puri, Orissa.

jāli: Network (also coat of mail, etc.).

Janārdan: Name for Krishna and other divinities as giver of rewards.

Jānguli: Curer of snake bites, a Buddhist form of Manasā.

Jaratkāru: "Old wanderer, or sage"; husband of Manasā and prince of snakes.

jhāḍ: Illuminated earthen temple in the shape of a tree or bush.

Jinda Rāva: Slayer of Pābū.

jooti (jūtī): Type of shoes or slippers.

jungli (janglī): Pertaining to the forest; wild, uncivilized.

kāchukā: Type of flour used especially in the mordant-madder process of painting.

kakri bagh: "Producing a garden"; an embroidery style of Hazara in West Pakistan.

kalamkarī: Type of painted or printed cotton.

Kālī: Form of Durgā called the "black goddess"; embodies the power of time in the sense of generation and destruction.

Kāliya: Serpent with 110 heads that inhabited the Jumna River; killed by Krishna.

Kalki: Tenth and last avatar of Vishnu, who is to appear riding a white horse at the conclusion of the present eon.

Kaṁsa: Tyrannical king of Mathura; uncle of Krishna, whom he sought to destroy.

Kandeh Rao: Hero and tutelary deity of Khandesh area; a manifestation of Shiva.

kānthā: Bengali stitched and quilted blanket made from old *sārīs*.

karma: One's destiny, viewed as the result of actions performed in former incarnations.

Kārttikeya: Handsome war god, son of Shiva; sometimes portrayed with six heads. His vehicle is a peacock.

Kaśyapa: "Vision"; ancient sage, progenitor of all creatures.

kaṭaka hasta: Hand position in which the hands hold flowers or other symbolic attributes.

kāvya: "Pertaining to bards"; name given to certain cloths illustrated with figures used in telling stories.

Keśara Kālī: "Black hair"; name of Pābū's horse.

khādī: Very thick and coarse cotton cloth made of hand-spun thread.

kīrtti-mukha: "Face of glory"; grotesque animal mask used as an architectural embellishment.

Krishna (Kṛṣṇa): "Dark"; avatar of Vishnu and warlike hero of the *Mahābhārata*. Later legends, which inspired the representations of Krishna in the graphic arts, dwell on his youthful adventures among the cowherds and dairymaids and his love for Rādhā.

Krishna-Līlā: A representation of Krishna sporting with the dairymaids.

Kshatriya (Kṣatriya): Man of the military caste (second of the four original castes).

Kshatriya Rāj: Dominion of the Rājput Kshatriyas.

Kumbhakāra: Potters (a mixed caste).

kuṇḍala: Earring.

kunjo: Bengali clay water pot with narrow neck. Also called *sārai*.

Kūrma: Tortoise, second avatar of Vishnu.

kuśa: Type of grass used in sacrifices.

Lakshmī (Lakṣmī), or Śrī Lakshmī: Goddess of prosperity and beauty, wife of Vishnu.

liṅga: Shiva's phallus (as an object of worship).

loṭā: Small round pot usually of brass or copper but sometimes terracotta; mostly use for water.

Madurai Vēēran: Hero and king of Madurai, worshipped as a village deity in southern India.

Mahābhārata: One of the two great Hindu epics, probably completed by the fourth or third

century B.C.; deals with the battle between the clans of the Kauravas and the Pāṇḍavas.

Mahādeva: "Great god"; a form of Shiva.

Maheśvaramma: "Great goddess"; worshipped in southern India.

Mahiṣa (Mahiṣāsura): "Powerful (Powerful demon)"; combated the gods in the form of a water buffalo.

Mahiṣa-asura-Mardinī: "Buffalo-Demon-Slayer"; a name of Durgā, who killed Mahiṣa.

makara: Composite sea monster; Gangā's vehicle.

Manasā: Bengali snake goddess with powers of destruction and regeneration.

Manasāghāṭ: A pot as an ideograph of Manasā, who may appear in human or serpent form.

maṇḍapa: Hall or porch for worshippers within the Hindu temple.

mantra: Formula pronounced by an officiating priest and worshippers.

Maruts: Vedic storm gods imagined as a troop of young warriors.

mātā pūjā: Worship of a mother goddess.

Matsya: Fish, first avatar of Vishnu, who saved Manu (the Hindu Noah) from the deluge.

māzlā: Large terracotta bowl for feeding cows.

mela: Fair festival.

Mitra: Vedic divinity, personification of friendship and day.

Munadian: Companion of Madurai Vēēran.

muṇḍ-mālā: Necklace or garland of skulls worn by Shiva.

Nāga: Serpent, serpent divinity: a name of Śeṣa.

Nāga-Panchamī(-Pañcamī): "Fifth day of snakes"; snake festival held on the fifth day of Shravan (July–August).

namdā: Coarse pressed (not woven) woolen cloth used as covers for horses and as carpets for seating and displaying wares.

Nandi: Lord of gladness, Shiva's bull vehicle.

Narasiṁha: Man-lion, fourth avatar of Vishnu, who in this composite form slew an evil king who could not be killed by man or beast.

Naṭarāja: Shiva as the cosmic dancer, embodiment of eternal energy.

Navagunjar: Universal monarch form; powerful young leader in mythical composite animal form. *See also* Sharava, Virāṭarūpa.

Navanīta-Krishna (-Kṛṣṇa): Krishna portrayed as a boy with a butter ball.

Nemīnātha: Jain saint; twenty-second *tīrthaṅkara*.

Oriyā: Pertaining to the province of Orissa.

Pābū: Young Rāthor prince, worshipped as a protector of cows.

padmamūla: The earthly germ which produced terrestrial trees and man.

padmāsana: "Lotus-seated"; type of sitting position with crossed legs, indicative of religious absorption.

Padmāvatī: Lotus goddess, a form of Lakshmī.

pāhzeb: Bracelet or anklet with interwoven chains and simple drops which tinkle.

palangposh: Coverlet.

panch arati: *See* arati.

panch (pañc) loha: "Five irons"; alloy containing five metals: copper, silver, gold, zinc and lead. Used for images in southern India.

panch (pañc) pātra: Small vessel from which water is poured over the idol in worship.

panch (pañc)-piṇḍa: Five sacred balls or stones.

pandal: Canopy or tent for rites and meetings.

pan dān: Betel leaf box.

Paraśurāma: "Rāma with the axe"; sixth avatar of Vishnu, destroyer of Kshatriyas (warriors) who had revolted against the overlordship of the Brahmans (priests).

Pārśvanātha: Jain saint; twenty-third *tīrthaṅkara*.

Pārvatī: "Daughter of the mountain"; beautiful and peaceful aspect of Shiva's wife.

paṭ: Cloth or canvas on which paintings can be made.

Pauch: Ninth solar month of the Hindus (December–January).

Peddamma: A name of the great goddess in southern India.

pothī: Book, especially a palm-leaf book.

pūjā: Worship of the gods.

Purāṇas: Canonical works of Hindu mythological literature, composed in their present form not later than 1000 A.D.

Puruṣottama: "Best of men"; name of Vishnu and ancient name of Puri, Orissa, site of Vishnu's Jagannāth temple.

Rādhā: "Success"; dairymaid beloved of Krishna.

rāja: King, prince, sovereign.

Rājputs: "Kings' sons"; military tribes of Rajasthan.

Rākshasas (Rākṣasas): Nocturnal demons who afflict mankind.

Rāma: "Charming"; embodiment of righteousness, seventh avatar of Vishnu; hero of the *Rāmāyaṇa*.

Rāmāyaṇa: One of the two great Hindu epics; attributed to Vālmīki; probably composed between the fourth and second centuries B.C. Rāma, aided by Hanuman, defeats the demonking Rāvaṇa, who has abducted Rāma's wife Sītā.

Rāthor: Warlike Rājput clan.

Rāvaṇa: Demon-king defeated by Rāma.

Ribhus (Ṛbhus): Divine artificers mentioned in the *Rig Veda*.

Rig (Ṛg) Veda: First of the Vedic collections; the hymns of the Aryan invaders of India (*c.* 1500–900 B.C.), compiled from oral tradition. The hymns themselves, as distinct from their commentaries, are also known as the *Rig Veda Saṁhitā*.

rohtakī ordhnī: Woman's mantle or head covering; from Rohtak, Punjab.

Rustum: A major hero of the *Shāhnāma* who unwittingly kills his son Suhrab in battle.

sandhyā pradīpa: "Twilight lamp"; used in religious rites.

sarā: Convex earthen plate, representing an island, on which Lakshmī, Durgā and Sarasvatī are painted for Bengali *pūjās*.

sārai: Same as *kunjo*.

Sarasvatī: "Flowing one"; goddess of learning and speech, wife of Brahmā.

sārī: Woman's dress; a long piece of cloth wrapped around the body and passed over the head.

Savaramma: A name of the great goddess in southern India.

Śeṣa: "Remainder"; serpent on which Vishnu sleeps.

Shāhnāma: "Book of Kings"; Persian epic written by Firdausī in the tenth century A.D.

Shakti (Śakti): Creative energy of the great gods, represented as their goddess consorts.

Sharava (Śarava): Another name for the mythical composite animal (universal monarch form). *See* Navagunjar, Virāṭarūpa.

Shiva (Śiva): One of the cosmic trinity of Hindu gods; credited with 1008 names, he represents the entire universe to his worshippers; he personifies the destructive and regenerative aspects of nature and is commonly worshipped in the form of a *liṅga*.

Shivaite eye: Shiva's all-seeing third eye, the eye of fire, located in the middle of his forehead.

sikkī: A fine grass used by the basket weavers of Bihar.

śilpaśāstras: Authoritative craft manuals with Brahmanical rules, procedures and canonical theories.

Sītā: Wife of Rāma; nature goddess.

śolā: A plant yielding a light white pith used for numerous purposes.

soma: Intoxicating fermented plant juice used in Vedic sacrifices. Also personified as a god.

Śrī Devī: *See* Devī.

Śrī Lakshmī: *See* Lakshmī.

śrīvatsa: auspicious diamond-shaped mark appearing on images of Jain saints.

sruva: Spoon (usually small) for offering idols water to drink.

Subachani (Subacani): Duck mother, goddess to whom women pray for children.

Subhadrā: Sister of Krishna, associated with the worship of Jagannāth at Puri.

Śūdra: Man of the fourth or servile caste of workers and craftsmen.

Suhrab: Son of Rustum in the *Shāhnāma*.

Suparṇa: "Beautiful-of-Wing"; a name of Garuda or of the group of large mythical birds headed by Garuda.

Surabhi: Mythical cow, mother of cattle; the cow of plenty.

Sūrya: God of the sun, one of the chief Vedic deities.

Sūtradhāra: "Holder of the measuring line"; carpenter, builder, architect. As a divinity, a son of Viśvakarmā.

ṭabāq: Round tray, cover, dish, plate.

tawiz: Bowl inscribed with 101 names of Allah invoking protection from ill health and evil.

teh nashān: Deeply engraved damascene work.

thorī: Pillager, dacoit; name applied to the companions of Pābū.

tīrthaṅkara: "Ford preparer"; general designation of the Jain saints.

ṭonṭi-wālā-loṭā: Ewer with a spout.

Tvastram (Tvaṣṭr): "Shaper"; Vedic celestial smith; sometimes identified with Viśvakarmā, sometimes with one of the latter's sons, sometimes with his father.

Ucchaihśravas (Uccaihśravas): "Loud neigh"; Indra's white horse, which came forth at the churning of the ocean.

Umā: Goddess, one of many forms of Shiva's consort.

vāhana: Animal vehicle for various deities of the Hindu pantheon.

Vāmana: Fifth avatar of Vishnu. Coming to King Bali as the dwarf Vāmana, Vishnu asked for all the territory he could cover in three steps; he thereby acquired the three worlds. *See also* Bali.

Varuna (Varuṇa): Vedic divinity, ruler of the invisible world and the night; later imagined as ruler of waters and serpents.

Varāha: Boar, third avatar of Vishnu; raised the earth from the bottom of the boundless waters with his tusks.

vasamalai kalamdar: "Wall hanging made with a pen."

Vasanta Rāginī: "Spring mode"; illustrations evoking the character of this musical mode generally portray Krishna sporting with the dairymaids.

Vāyu: Vedic god of the wind, father of Hanuman; his vehicle is a deer.

Venugopāla: Krishna as a cowherd playing the flute.

vīnā: Stringed instrument similar to a lute.

Vīra Bhadra: Emanation of Shiva in a terrifying aspect; disturbed Daksha's sacrifice and cut off his head. *See also* Daksha.

Virāṭarūpa: Another name for the animal composite, the universal monarch form. *See* Navagunjar, Sharava.

Vishnu (Viṣṇu): "Pervader"; one of the great trinity of Hindu gods; principle of duration and eternity; appears in ten famous avatars. *See* Buddha, Kalki, Krishna, Kūrma, Matsya, Narasimha, Paraśurāma, Rāma, Vāmana, Varāha.

Viśvakarmā: Architect of the gods and presiding deity of craftsmen. *See also* Tvastram.

Yakshīs (Yakṣīs): Tree goddesses whose cult was assimilated into Buddhism.

Yashodā (Yaśodā): Wife of a cowherd, foster mother of Krishna; hid him from the wrath of Kamsa.

yoga hasta: Hand position, with the hands flat out on the lap, palms upward, right palm inside left; signifies mental concentration.

yoni: Vulva; fertility symbol, counterpart of the *liṅga.*

INDEX

Dover Books on Art

Dover Books on Art

GRAPHIC WORLDS OF PETER BRUEGEL THE ELDER,
H. A. Klein. 64 of the finest etchings and engravings made from
the drawings of the Flemish master Peter Bruegel. Every aspect
of the artist's diversified style and subject matter is represented,
with notes providing biographical and other background in-
formation. Excellent reproductions on opaque stock with nothing
on reverse side. 63 engravings, 1 woodcut. Bibliography. xviii +
289pp. 11⅜ x 8¼. 21132-0 Paperbound $6.00

THE COMPLETE WOODCUTS OF ALBRECHT DURER,
edited by Dr. Willi Kurth. Albrecht Dürer was a master in vari-
ous media, but it was in woodcut design that his creative genius
reached its highest expression. Here are all of his extant wood-
cuts, a collection of over 300 great works, many of which are
not available elsewhere. An indispensable work for the art his-
torian and critic and all art lovers. 346 plates. Index. 285pp.
8½ x 12¼. 21097-9 Paperbound $6.95

GRAPHIC REPRODUCTION IN PRINTING, H. Curwen. A
behind-the-scenes account of the various processes of graphic
reproduction—relief, intaglio, stenciling, lithography, line
methods, continuous tone methods, photogravure, collotype—
and the advantages and limitations of each. Invaluable for all
artists, advertising art directors, commercial designers, adver-
tisers, publishers, and all art lovers who buy prints as a hobby.
137 illustrations, including 13 full-page plates, 10 in color. xvi +
171pp. 5¼ x 8½. 20512-6 Paperbound $7.50

WILD FOWL DECOYS, Joel Barber. Antique dealers, collectors,
craftsmen, hunters, readers of Americana, etc. will find this the
only thorough and reliable guide on the market today to this
unique folk art. It contains the history, cultural significance, re-
gional design variations; unusual decoy lore; working plans for
constructing decoys; and loads of illustrations. 140 full-page
plates, 4 in color. 14 additional plates of drawings and plans by
the author. xxvii + 156pp. 7⅞ x 10¾. 20011-6 Paperbound $6.00

1800 WOODCUTS BY THOMAS BEWICK AND HIS SCHOOL.
This is the largest collection of first-rate pictorial woodcuts in
print—an indispensable part of the working library of every
commercial artist, art director, production designer, packaging
artist, craftsman, manufacturer, librarian, art collector, and
artist. And best of all, when you buy your copy of Bewick, you
buy the rights to reproduce individual illustrations—no permis-
sion needed, no acknowledgments, no clearance fees! Classified
index. Bibliography and sources. xiv + 246pp. 9 x 12.
 20766-8 Paperbound $6.50

THE SCRIPT LETTER, Tommy Thompson. Prepared by a noted
authority, this is a thorough, straightforward course of instruc-
tion with advice on virtually every facet of the art of script
lettering. Also a brief history of lettering with examples from
early copy books and illustrations from present day advertising
and packaging. Copiously illustrated. Bibliography. 128pp.
6½ x 9⅛. 21311-0 Paperbound $2.50

Dover Books on Art

GREEK REVIVAL ARCHITECTURE IN AMERICA, T. Hamlin. A comprehensive study of the American Classical Revival, its regional variations, reasons for its success and eventual decline. Profusely illustrated with photos, sketches, floor plans and sections, displaying the work of almost every important architect of the time. 2 appendices. 39 figures, 94 plates containing 221 photos, 62 architectural designs, drawings, etc. 324-item classified bibliography. Index. xi + 439pp. 5⅜ x 8½.

21148-7 Paperbound $5.00

CREATIVE LITHOGRAPHY AND HOW TO DO IT, Grant Arnold. Written by a man who practiced and taught lithography for many years, this highly useful volume explains all the steps of the lithographic process from tracing the drawings on the stone to printing the lithograph, with helpful hints for solving special problems. Index. 16 reproductions of lithographs. 11 drawings. xv + 214pp. of text. 5⅜ x 8½.

21208-4 Paperbound $3.50

THE STANDARD BOOK OF QUILT MAKING AND COLLECTING, M. Ickis. Even if you are a beginner, you will soon find yourself quilting like an expert, by following these clearly drawn patterns, photographs, and step-by-step instructions. Over 40 full-size patterns. Index. 483 illustrations. One color plate. xi + 276pp. 6¾ x 9½. 20582-7 Paperbound $3.50

PAINTING IN THE FAR EAST, L. Binyon. A study of over 1500 years of Oriental art by one of the world's outstanding authorities. The author chooses the most important masters in each period—Wu Tao-tzu, Toba Sojo, Kanaoka, Li Lung-mien, Masanobu, Okio, etc.—and examines the works, schools, and influence of each within their cultural context. 42 photographs. Sources of original works and selected bibliography. Notes including list of principal painters by periods. xx + 297pp. 6⅛ x 9¼.

20520-7 Paperbound $5.00

THE ALPHABET AND ELEMENTS OF LETTERING, F. W. Goudy. A beautifully illustrated volume on the aesthetics of letters and type faces and their history and development. Each plate consists of 15 forms of a single letter with the last plate devoted to the ampersand and the numerals. "A sound guide for all persons engaged in printing or drawing," Saturday Review. 27 full-page plates. 48 additional figures. xii + 131pp. 7⅞ x 10¾.

20792-7 Paperbound $3.50

THE COMPLETE BOOK OF SILK SCREEN PRINTING PRODUCTION, J. I. Biegeleisen. Here is a clear and complete picture of every aspect of silk screen technique and press operation—from individually operated manual presses to modern automatic ones. Unsurpassed as a guidebook for setting up shop, making shop operation more efficient, finding out about latest methods and equipment; or as a textbook for use in teaching, studying, or learning all aspects of the profession. 124 figures. Index. Bibliography. List of Supply Sources. xi + 253pp. 5⅜ x 8½.

21100-2 Paperbound $2.95

Dover Books on Art

THE FOUR BOOKS OF ARCHITECTURE, Andrea Palladio. A compendium of the art of Andrea Palladio, one of the most celebrated architects of the Renaissance, including 250 magnificently-engraved plates showing edifices either of Palladio's design or reconstructed (in these drawings) by him from classical ruins and contemporary accounts. 257 plates. xxiv + 119pp. 9½ x 12¾. 21308-0 Paperbound $8.95

150 MASTERPIECES OF DRAWING, A. Toney. Selected by a gifted artist and teacher, these are some of the finest drawings produced by Western artists from the early 15th to the end of the 18th centuries. Excellent reproductions of drawings by Rembrandt, Bruegel, Raphael, Watteau, and other familiar masters, as well as works by lesser known but brilliant artists. 150 plates. xviii + 150pp. 5⅜ x 11¼. 21032-4 Paperbound $4.00

MORE DRAWINGS BY HEINRICH KLEY. Another collection of the graphic, vivid sketches of Heinrich Kley, one of the most diabolically talented cartoonists of our century. The sketches take in every aspect of human life: nothing is too sacred for him to ridicule, no one too eminent for him to satirize. 158 drawings you will not easily forget. iv + 104pp. 7⅜ x 10¾. 20041-8 Paperbound $3.75

THE TRIUMPH OF MAXIMILIAN I, 137 Woodcuts by Hans Burgkmair and Others. This is one of the world's great art monuments, a series of magnificent woodcuts executed by the most important artists in the German realms as part of an elaborate plan by Maximilian I, ruler of the Holy Roman Empire, to commemorate his own name, dynasty, and achievements. 137 plates. New translation of descriptive text, notes, and bibliography prepared by Stanley Appelbaum. Special section of 10pp. containing a reduced version of the entire Triumph. x + 169pp. 11⅛ x 9¼. 21207-6 Paperbound $5.95

PAINTING IN ISLAM, Sir Thomas W. Arnold. This scholarly study puts Islamic painting in its social and religious context and examines its relation to Islamic civilization in general. 65 full-page plates illustrate the text and give outstanding examples of Islamic art. 4 appendices. Index of mss. referred to. General Index. xxiv + 159pp. 6⅝ x 9¼. 21310-2 Paperbound $4.00

THE MATERIALS AND TECHNIQUES OF MEDIEVAL PAINTING, D. V. Thompson. An invaluable study of carriers and grounds, binding media, pigments, metals used in painting, al fresco and al secco techniques, burnishing, etc. used by the medieval masters. Preface by Bernard Berenson. 239pp. 5⅜ x 8. 20327-1 Paperbound $3.50

THE HISTORY AND TECHNIQUE OF LETTERING, A. Nesbitt. A thorough history of lettering from the ancient Egyptians to the present, and a 65-page course in lettering for artists. Every major development in lettering history is illustrated by a complete aphabet. Fully analyzes such masters as Caslon, Koch, Garamont, Jenson, and many more. 89 alphabets, 165 other specimens. 317pp. 7½ x 10½. 20427-8 Paperbound $5.00

Dover Books on Art

PRINCIPLES OF ART HISTORY, H. Wölfflin. This remarkably instructive work demonstrates the tremendous change in artistic conception from the 14th to the 18th centuries, by analyzing 164 works by Botticelli, Dürer, Hobbema, Holbein, Hals, Titian, Rembrandt, Vermeer, etc., and pointing out exactly what is meant by "baroque," "classic," "primitive," "picturesque," and other basic terms of art history and criticism. "A remarkable lesson in the art of seeing," SAT. REV. OF LITERATURE. Translated from the 7th German edition. 150 illus. 254pp. 6⅛ x 9¼. 20276-3 Paperbound $3.50

FOUNDATIONS OF MODERN ART, A. Ozenfant. Stimulating discussion of human creativity from paleolithic cave painting to modern painting, architecture, decorative arts. Fully illustrated with works of Gris, Lipchitz, Léger, Picasso, primitive, modern artifacts, architecture, industrial art, much more. 226 illustrations. 368pp. 6⅛ x 9¼. 20215-1 Paperbound $5.00

METALWORK AND ENAMELLING, H. Maryon. Probably the best book ever written on the subject. Tells everything necessary for the home manufacture of jewelry, rings, ear pendants, bowls, etc. Covers materials, tools, soldering, filigree, setting stones, raising patterns, repoussé work, damascening, niello, cloisonné, polishing, assaying, casting, and dozens of other techniques. The best substitute for apprenticeship to a master metalworker. 363 photos and figures. 374pp. 5½ x 8½.
22702-2 Paperbound $4.00

SHAKER FURNITURE, E. D. and F. Andrews. The most illuminating study of Shaker furniture ever written. Covers chronology, craftsmanship, houses, shops, etc. Includes over 200 photographs of chairs, tables, clocks, beds, benches, etc. "Mr. & Mrs. Andrews know all there is to know about Shaker furniture," Mark Van Doren, NATION. 48 full-page plates. 192pp. 7⅞ x 10¾. 20679-3 Paperbound $4.00

LETTERING AND ALPHABETS, J. A. Cavanagh. An unabridged reissue of "Lettering," containing the full discussion, analysis, illustration of 89 basic hand lettering styles based on Caslon, Bodoni, Gothic, many other types. Hundreds of technical hints on construction, strokes, pens, brushes, etc. 89 alphabets, 72 lettered specimens, which may be reproduced permission-free. 121pp. 9¾ x 8. 20053-1 Paperbound $2.75

THE HUMAN FIGURE IN MOTION, Eadweard Muybridge. The largest collection in print of Muybridge's famous high-speed action photos. 4789 photographs in more than 500 action-strip-sequences (at shutter speeds up to 1/6000th of a second) illustrate men, women, children—mostly undraped—performing such actions as walking, running, getting up, lying down, carrying objects, throwing, etc. "An unparalleled dictionary of action for all artists," AMERICAN ARTIST. 390 full-page plates, with 4789 photographs. Heavy glossy stock, reinforced binding with headbands. 7⅞ x 10¾. 20204-6 Clothbound $13.50

200 DECORATIVE TITLE-PAGES, edited by A. Nesbitt. Fascinating and informative from a historical point of view, this beautiful collection of decorated titles will be a great inspiration to students of design, commercial artists, advertising designers, etc. A complete survey of the genre from the first known decorated title to work in the first decades of this century. Bibliography and sources of the plates. 222pp. 8⅜ x 11¼.

21264-5 Paperbound $3.00

ON THE LAWS OF JAPANESE PAINTING, H. P. Bowie. This classic work on the philosophy and technique of Japanese art is based on the author's first-hand experiences studying art in Japan. Every aspect of Japanese painting is described: the use of the brush and other materials; laws governing conception and execution; subjects for Japanese paintings, etc. The best possible substitute for a series of lessons from a great Oriental master. Index. xv + 117pp. + 66 plates. 6⅛ x 9¼.

20030-2 Paperbound $5.00

A HANDBOOK OF ANATOMY FOR ART STUDENTS, Arthur Thomson. This long-popular text teaches any student, regardless of level of technical competence, all the subtleties of human anatomy. Clear photographs, numerous line sketches and diagrams of bones, joints, etc. Use it as a text for home study, as a supplement to life class work, or as a lifelong sourcebook and reference volume. Author's prefaces. 67 plates, containing 40 line drawings, 86 photographs—mostly full page. 211 figures. Appendix. Index. xx + 459pp. 5⅜ x 8⅜. 21163-0 Paperbound $5.00

WHITTLING AND WOODCARVING, E. J. Tangerman. With this book, a beginner who is moderately handy can whittle or carve scores of useful objects, toys for children, gifts, or simply pass hours creatively and enjoyably. "Easy as well as instructive reading," N. Y. Herald Tribune Books. 464 illustrations, with appendix and index. x + 293pp. 5½ x 8⅛.

20965-2 Paperbound $3.50

ONE HUNDRED AND ONE PATCHWORK PATTERNS, Ruby Short McKim. Whether you have made a hundred quilts or none at all, you will find this the single most useful book on quilt-making. There are 101 full patterns (all exact size) with full instructions for cutting and sewing. In addition there is some really choice folklore about the origin of the ingenious pattern names: "Monkey Wrench," "Road to California," "Drunkard's Path," "Crossed Canoes," to name a few. Over 500 illustrations. 124 pp. 7⅞ x 10¾. 20773-0 Paperbound $3.00

ART AND GEOMETRY, W. M. Ivins, Jr. Challenges the idea that the foundations of modern thought were laid in ancient Greece. Pitting Greek tactile-muscular intuitions of space against modern visual intuitions, the author, for 30 years curator of prints, Metropolitan Museum of Art, analyzes the differences between ancient and Renaissance painting and sculpture and tells of the first fruitful investigations of perspective. x + 113pp. 5⅜ x 8⅜. 20941-5 Paperbound $2.00

Dover Books on Art

PENNSYLVANIA DUTCH AMERICAN FOLK ART, H. J. Kauffman. The originality and charm of this early folk art give it a special appeal even today, and surviving pieces are sought by collectors all over the country. Here is a rewarding introductory guide to the Dutch country and its household art, concentrating on pictorial matter—hex signs, tulip ware, weather vanes, interiors, paintings and folk sculpture, rocking horses and children's toys, utensils, Stiegel-type glassware, etc. "A serious, worthy and helpful volume," W. G. Dooley, N. Y. TIMES. Introduction. Bibliography. 279 halftone illustrations. 28 motifs and other line drawings. 1 map. 146pp. 7⅞ x 10¾.

21205-X Paperbound $4.00

DESIGN AND EXPRESSION IN THE VISUAL ARTS, J. F. A. Taylor. Here is a much needed discussion of art theory which relates the new and sometimes bewildering directions of 20th century art to the great traditions of the past. The first discussion of principle that addresses itself to the eye rather than to the intellect, using illustrations from Rembrandt, Leonardo, Mondrian, El Greco, etc. List of plates. Index. 59 reproductions. 5 color plates. 75 figures. x + 245pp. 5⅜ x 8½.

21195-9 Paperbound $3.50

THE ENJOYMENT AND USE OF COLOR, W. Sargent. Requiring no special technical know-how, this book tells you all about color and how it is created, perceived, and imitated in art. Covers many little-known facts about color values, intensities, effects of high and low illumination, complementary colors, and color harmonies. Simple do-it-yourself experiments and observations. 35 illustrations, including 6 full-page color plates. New color frontispiece. Index. x + 274 pp. 5⅜ x 8.

20944-X Paperbound $3.50

STYLES IN PAINTING, Paul Zucker. By comparing paintings of similar subject matter, the author shows the characteristics of various painting styles. You are shown at a glance the differences between reclining nudes by Giorgione, Velasquez, Goya, Modigliani; how a Byzantine portrait is unlike a portrait by Van Eyck, da Vinci, Dürer, or Marc Chagall; how the painting of landscapes has changed gradually from ancient Pompeii to Lyonel Feininger in our own century. 241 beautiful, sharp photographs illustrate the text. xiv + 338 pp. 5⅝ x 8¼.

20760-9 Paperbound $4.00

Dover publishes books on commercial art, art history, crafts, design, art classics; also books on music, literature, science, mathematics, puzzles and entertainments, chess, engineering, biology, philosophy, psychology, languages, history, and other fields. For free circulars write to Dept. DA, Dover Publications, Inc., 180 Varick St., New York, N.Y. 10014.